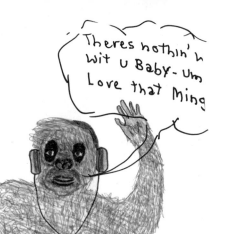

There's nothin' ll wit u Baby- Um Love that Ming

MINGERING MIKE

MW01107588

CONTENTS

YETI BACK ISSUES AND BOOKS

YETI ONE Harry Smith, Terry Riley, James Brown's Original Funky Divas, Alan Greenberg, Califone, Destroy All Monsters, Träd Gräs Och Stenar, Brad Johnson, Pita, Fennesz & Bauer, Robert Walser, Tae Won Yu (photographs), Jana Martin, "A Lo-Fi Metal Primer," "Alphonse Allais, "Downtown 81," James Kochalka. **On the CD:** Iron & Wine (debut recording), Elliott Smith, Nobukazu Takemura, Harry Smith (debut release of his "field recordings"), Califone, Stereolab, L'Altra, Träd Gräs Och Stenar, Screamers, Turn On, Mice Parade, +

 YETI TWO Alfred Jarry, Laura Cantrell, Aceyalone, Luc Sante ("The Birth of the Blues"), Richard Thompson, Trinie Dalton, Steffen Basho-Junghans, Amy Gerstler (poems + interview), Rachel Kushner, Brian Chippendale, Ben Katchor, Marcellus Hall. **On the CD:** Steffen Basho-Junghans, Shins, Keith Fullerton Whitman, Death Cab for Cutie, Califone, White Hassle, Pell Mell, Iron & Wine, Six Organs of Admittance, Takagi Masakatsu, Kill Me Tomorrow, Birdbrain, Carissa's Wierd, The Scene Is Now, +

YETI THREE Unpublished William Burroughs interview, Devendra Banhart, Neko Case, Naomi Yang, R.J. Smith, Jason Miles, Michael Galinsky, Erik Davis, BloodNinja, Henry Flynt, Charles Peterson, "The Apes Guide to the Apes," Eileen Myles. **On the CD:** Devendra Banhart, Henry Flynt, Postal Service, Colin Meloy, Iron & Wine, Jolie Holland, I Rowboat, the Mad Scene, the Lights, Dan Melchior, Ian Nagoski, the Apes, the Robot Ate Me, Blues Goblins, Dream Lovers, Timesbold, Washington Phillips, KRMTX, +

 YETI FOUR Fred Tomaselli, Rev. Louis Overstreet, Stacey Levine, "How to sing along to 'Sweet Home Alabama'," Destroyer, Jana Martin, Peter Doyle, Octavia Butler, Sam Lipstyte, Will Sheff, Jason Miles, Melissa Dyne, Khaela Maricich, Peter Lamborn Wilson, Souled American, Vanessa Vaselka. **On the CD:** Destroyer, Califone, Bright, Okkervil River, Michael Hurley w/ Tara Jane O'Neil, Valet, Fly Ashtray, Plants, Rev. E.W. Clayborn, Theo Angell, the Blow, Souled American, Alela Diane, Somos Marquis Homos, +

YETI FIVE Jeff Mangum, Will Oldham, Blind Willie Johnson, "The marriage made in hell between folk music, dead cultures, myth, & highly technical modern extreme metal," Nicola Bowery on Leigh Bowery, P.G. Six, Unica Zürn, Meredith Brosnan, Hisham Mayet: travel journals from Western Sahara, Kevin Sampsell, BloodNinja. **On the CD:** Akron/Family, Iron & Wine, Karen Dalton, Dean and Britta, Deerhoof, Vashti Bunyan, Tara Jane O'Neil, Anglin Bros, Grouper, Evolutionary Jass Band, Spiritualaires, Kathryn Williams, Cooper Moore, +

 KILL ALL YOUR DARLINGS, by Luc Sante
Essays on music, art, photography, poetry, and life, from a brilliant critic with "burning passion and a prose style to die for" (William Gibson). Introduction by Greil Marcus.

 WINGS. STRINGS. MERIDIANS, by Tara Jane O'Neil
96 full-color pages of drawings and paintings, plus a 15-song CD of live tracks, four-track recordings, and film scores.

 RUSSIAN LOVER AND OTHER STORIES, by Jana Martin
"Tough, funny stories from a writer wise enough to know that wisdom doesn't always come with experience." (Sam Lipsyte)

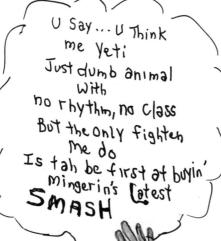

MINGERING MIKE

PUBLISHER & EDITOR
Mike McGonigal

MANAGING EDITOR
Steve Connell

CONTRIBUTING EDITOR
Fred Cisterna

COVER IMAGE
E★Rock

ILLUSTRATIONS
Pedro Lourenço

COPYEDITORS
Dwight Pavlovic
Kathy Lindenmayer
Katherine Spielmann

GRAPHICS GUY
Scott Nasburg

WEBMASTER
Marcus Estes

CD mastered by Tim Stollenwerk

CD manufactured in Canada by CDForge

Book printed in Canada by Kromar Printing

This issue is dedicated to the memory of Bruce Conner,
David Foster Wallace, Klaus Dinger, and Bernie Mac

Ken Holt—please get in touch

Yeti is published 2 to 3 times a year by Yeti Publishing LLC

CONTACT US
PO Box 14806
Portland, OR 97293
yetipubs@gmail.com
yetipublishing.com

VICTORY DAY

From "The Devil's Jump"

by Peter Doyle

WEDNESDAY, AUGUST 15, 1945: It was just after half past nine in the morning, and my working day was nearly over. I yawned as I drove along Oxford Street in Paddington, thinking it was maybe time to stop for some steak and eggs.

A factory hooter sounded, then another. Somewhere a bugle played a charge and nearby a church bell started ringing. Air raid sirens and car horns went off and a raggedy, swelling noise of shouts and cheers and hurrays rose up around me.

An old feller in a dressing gown ran in front of the car. I braked hard, pressed the horn, and made the appropriate gesture. The codger bowed to me, then skipped into a pie shop.

A tram stopped in the middle of the street. The driver got out and shook hands with passers-by. The old feller came out of the shop with a girl in an apron, and the two of them waltzed down the middle of Oxford Street. Another girl ran over to the Chev, leaned over and shouted something I couldn't make out. I wound down the window, and she leaned in and planted a big wet kiss on my cheek, then laughed and danced away. A feller took off his hat and dropped it on the ground, then sat down in the gutter and started crying like a baby.

A little kid ran by carrying a leering effigy of General Tojo. I got out of the car and grabbed his shoulder. "What's the mail, pal?" I shouted.

"The vile Jap bastards have surrendered. The war's over."

It was just as I'd feared.

"Watch your language," I said, and let him go.

I got back in the car, wound up the windows and turned on the radio. I sat there listening as Prime Minister Ben Chifley told the country in his gruff voice that there would be two days holiday to celebrate the peace, and would the men and women of Australia mind terribly not running completely amok.

I started the engine and moved off through the rapidly thickening crowd. Outside Paddington Town Hall a paper salvage bin had been set alight; the flames leaped up to twenty feet high as people danced in a big circle around the fire. The kid with the Tojo effigy had set it alight and was waving it in the air.

Under normal circumstances I'd have downed tools and joined in, but the previous evening I'd got a telephone call from my boss, Mick Toohey, publican, factory owner, and master black marketeer. He'd told me to get up before dawn, take his Chev out to the shed behind his printery at Botany, collect certain items and deliver them to various addresses around town. Then I was to pick up a suckling pig, a few rabbits, a dozen freshly killed chooks, some eggs, bacon, cigs, rum, and a case of genuine scotch whisky from the shed and bring all that to the Durban Club, Toohey's hotel in the center of Sydney.

I'd been less than keen, but Toohey said the State Parliamentary Joint Committee on Rural Bridge and Overpass Reconstruction was having dinner at his pub that evening, and he'd promised the worthy gents something special. If I did the right thing, he wouldn't forget it. But do the run while it was still dark, he'd said, so there'd be less risk of being sprung by the Rationing Commission, the Manpower Authority, the Military Police, the civil coppers, or anyone else who might stand in the way of rugged individualism.

I'd overslept, though, started late, and now I was in the shit.

Five minutes after Chifley's announcement, Oxford Street was completely blocked by crowds of crazy, shouting people. I got off the main street and threaded my way through south Paddington, skirted around Darlinghurst into Surry Hills, and down towards Central, looking for a way to get to the Durban Club, but every major street was thick with people moving in a roaring, swaying mass towards the city center.

I pushed on through, hitting the horn, waving, smiling, begging people to clear a way, then came to a wall of people at the corner of Liverpool and Elizabeth Street. I backed up, and parked the car in a laneway. I took an old overcoat and a kit bag from the back seat, checked that no one was looking, then went to the boot and loaded the pig carcass, the chooks, the bacon, eggs, and the rum and whisky carefully into the kit bag. I put on the overcoat, stuck a rabbit in each pocket, filled the inside pockets with

as many packets of cigs and bottles of whisky as would fit, then took off on foot into the throng.

I made progress for a while, and the kit bag turned out to be a bit of a lurk in itself—I was showered with undeserved hugs and kisses from comely revelers all the way. But the going got harder and the crowd got rowdier and drunker the closer I got to the city center. There were broken shop windows, kicked-in doors, and shopkeepers standing guard inside with axe-handles, ready to beat back looters, while outside people danced in wild circles, their eyes wide and unseeing.

I skirted a brawl between a group of British and Australian soldiers at the corner of Park Street and headed into Hyde Park. I set the kit bag down behind some bushes and took a breather. A young soldier and a girl nipped through the hedge and crashed down next to me. The bloke asked did I have a cig. I slung him a pack. Did I know where they could get a drink? I opened a half bottle of scotch and passed it to him. They both took a big drink, then he put his hand under her dress and she threw her head back and laughed. I reclaimed the bottle and set off again.

A deep thumping sound was coming from somewhere in the park. Then I heard a voice like an adenoidal bookie on the Randwick Flat, half-singing, half-talking: *You were thinkin' while I was sleepin'.* I followed the winding pathway through the park. The dull thump became the sound of a boogie-woogie piano, amplified through a public address system, and a drummer slamming a snare. Then that voice again: *I was snoozin', but you were creepin'.* I came around the corner. A gang of louts and good-time girls were jiving around a piano, drums and saxophone combo. The piano pounder was none other than my old pal, Max Perkal. *But soon I'll be laughin' and you'll be weepin'.*

Max saw me and pointed at his open mouth. He mimed drinking from a bottle, then pointed at me and tilted his head, still playing the boogie-woogie bass pattern with his left hand. I shook my head.

The girls were wearing slacks with bright red or green cardigans; a few of the men had zoot suits like mine. Then I spotted a girl jiving on her own who stopped me in my tracks. I knew Molly Price, though not well. She saw me staring and came jiving over. She was wearing a gray overcoat; her hair was disheveled and her blue eyes were wide and bright, pupils the size of sixpences.

She shouted, "Come and dance with us." I shook my head, pointed to my wrist watch. She smiled slyly, turned her head to the side, looked out at me from behind her hair and then let her overcoat fall open. She was wearing black underwear—and nothing else. She laughed, snapped her garter belt, grabbed my hand and said, "Oh, come on, let's *live!*"

Somebody behind me gave me a push and I was flung into the mob of dancers. Then I thought, why not? I carefully placed the kit bag under the piano, took my overcoat off, folded it and put it on top, and said to Molly, "All right then, sweetheart, let's show these mugs how to cut a rug."

Molly was a "hostess" at the Booker T. Washington Club, the nightspot set aside for black American servicemen stationed in Sydney, and the unofficial headquarters of the local jitterbugs. She had picked up some fancy moves, all right. But when it came to jitterbugging I was no slouch myself.

We jived around for a while. Molly kept her overcoat on, but left it undone at the front, so it fanned out when she swung herself around. A few of the other girls were dressed the same, just underwear or skimpy swimsuits beneath their overcoats.

The high spirits were getting to me. Dancing in the park with a pretty blonde in the middle of the day, good music playing, not a copper in sight—this really is the grouse, I thought.

We danced for what seemed like hours, then ducked into the bushes for a kiss and cuddle which soon turned serious. Molly gently took my hand out from under her overcoat and said, "We'll have to go somewhere else. Somewhere private."

I looked at my watch. "I've got some business to attend to. Will you wait here for me?"

"How long?"

"An hour or two."

She kissed me and whispered in my ear, "Meet me at the Rocket Club at eight. I'll be waiting for you. But don't be late."

When I got back to the bandstand the kit bag had disappeared. There was a bottle of rum on top of Max's piano and he was already half rinsed. Bottles of whisky were being passed from hand to hand. Then someone threw an egg and someone else retaliated. One bloke was jitterbugging with a plucked chicken; another wore one on his head. The pig was long gone.

I got my coat from under the piano. Miraculously, four bottles of whisky and a couple of rabbits were still in the pockets. I put the coat on. A nearby hooligan heard the bottles clinking in the inside pocket and turned to me with an evil grin. "Forget it sport," I said. "These are promised elsewhere."

He had other ideas, and as they say in the court reports, a scuffle ensued. I was outnumbered, and it was only with great determination that I managed to get away with any merchandise at all.

I pressed on through Philip Street. Confetti was raining down from the office buildings, thick as a heavy snowfall, settling ankle-deep on the ground. I grabbed at a piece of paper as it floated past—it was a torn up piece of index card.

Martin Place was the heart of the celebration. Ukulele players, hula dancers, fire-eaters, clowns, and acrobats lined the GPO steps, and all along the wide street people played two-up right out in the open. Hillbilly singers strummed guitars, and pipe bands marched around, each with its own crowd following behind. Orchestras from three or four different radio stations were playing in different corners of Martin Place, and from the harbor came a continuous hooting of sirens and foghorns.

As it got dark, couples started going the all the way in the shelter of doorways. The searchlights came on, lighting up the smoke from many bonfires.

By six-thirty I'd had enough. I took what remained of the illicit goods, namely one rabbit in poor condition, around the corner to Toohey's hotel. But it was locked up and dark. A mob milled outside, drunk and aimless, looking for more booze. Someone was banging on the door to the public bar, yelling "Open up, you bastard. Give us a drink!"

I cut into the laneway, went around to the back door, and rapped on the glass.

A dim light came on inside, and Mick Toohey opened the door. He had a face that could scare littlies—bushy eyebrows, a large, square face and a mouth which was permanently turned down on the left side. The other side of his mouth was theoretically capable of smiling but had rarely been known to do so, hence his nickname, "Misery."

He looked me up and down. "What the hell happened to you?"

"I was beset by ruffians. But I fought tooth and nail to defend your property." I reached into the overcoat, took out the rabbit, held it out to him. It was squashed flat in the middle where a motorbike had driven over it, and the imprint of an army boot was clearly visible on its haunches.

"And the grog?"

"It didn't survive the journey. There was a melee."

"Where's the car?"

"In the Haymarket. Sorry Mick. Things got a bit out of hand, what with the war ending and all."

Toohey looked at me for a few seconds, but instead of hitting the roof he said, "You'd better come on through."

I followed him down the darkened passage. "So where is everybody?" I said. "What about the dinner for the Parliamentary Joint Committee on dick pulling or whatever it was?"

"Cancelled because of this damned peace," he said over his shoulder.

We went out to the back room, where on most nights a high-stakes card game was held. There was no game tonight; the curtains were drawn and a dozen or so grim-faced men were sitting around a circular table under a single weak light. A bottle of Johnny Walker and numerous bottles of beer littered the table.

A few of the blokes nodded my way—a taxi driver named Cyril, a former bookie named Darcy, a worn-out heavy named Ernest. The other fellers completely ignored me.

Mick signaled me to help myself to a drink. I poured a glass of beer, then took a seat away from the table.

Mick poured himself a shot of scotch and said, "Gentlemen."

They turned respectfully towards him.

"This is a black day. For all of us."

There were nods and murmurs around the table.

"We stand tonight on the brink of a troubling and uncertain future. Soon the big-spending Yanks will be gone, and the local mugs will have spent all their back pay." More nods.

"As if that wasn't enough, there's been talk of liberalizing hotel trading hours, and bugger me, I've even heard that certain socialists in the state house have plans to not only *legalize* off-course betting,"—someone muttered "Bloody shame"—"but to *nationalize* it, too!

"Well, the philosophers tell us all good things must come to an end, and I wouldn't want to sound like a whinger. We've had a good war, and blow me down if we didn't teach the damned slanty-eyed saber-rattlers a lesson they'll not forget in a hurry"—some half-hearted "hear hears"—"and each one of us can feel justly proud of the part he played in maintaining the morale of our fighting men and our hard-pressed civilian population through the trying days recently passed, regardless of what the wowsers might have said."

"So let's not get too gloomy, gents. Not *all* the news is bad, after all. I understand that Mr. Chifley intends to keep rationing in place for the indefinite future. I have it on good authority that the coupon system will be maintained for up to five years."

Grunts of approval.

Mick went to the sideboard and returned with a bottle of scotch in each hand. He put them down in front of two of the men at the table, and continued until every man had a bottle.

"So enjoy the peace, if you can. For my part, I'm going to the late Thanksgiving Mass at St. Mary's. If any of you would care to accompany

me, you'd be more than welcome."

Blokes looked at their watches and stood up, muttering about having to get home and feed the cat, or that Mum would be getting worried. Mick shook hands with everyone, gave a reassuring pat on the shoulder or a kingly nod, and said a few words to each of them as they left. When they'd all gone Mick turned to me.

I stood up, saying, "I, er, I have to be at, somewhere. I mean I don't think I can—"

"Come with me," he said.

I followed him out to the passageway and down narrow stairs into the darkened cellar. We crossed the room and came to a reinforced and heavily padlocked door. Mick unlocked it and pushed it open.

Boxes were stacked everywhere—booze, cigs, nylons, toys, shirts and footwear, but also outdated ration coupons, powdery chocolates, rusted tins of bully beef.

Mick sat in the leather chair behind the large desk in the center of the room. "Sit down, William."

There was no other chair. I moved aside a carton of cigarettes and plonked myself down on an old wooden tool chest.

He leaned back, closed his eyes, rubbed the bridge of his nose and sighed. I sat there and waited. Outside I could hear the mob carousing.

Toohey opened his eyes and looked at me levelly. From outside came the sound of shattering glass, but Mick didn't blink. He waited another half minute, then leaned forward, put his folded arms on the desk and said quietly, "What kind of bloke are you, Bill? Really."

"I'm a Souths supporter."

"I mean deep down."

"So do I."

There was another crash of broken glass and a shout went up. A flickering red glow appeared in the glass brick skylight, but Mick's gaze didn't waver.

He spoke slowly and deliberately. "There are two types of people in this world. Those you can trust and those you can't."

I nodded.

"Most people put themselves on the trustworthy team. And they play the part. They'll pat you on the back and tell you you're a great feller. As long as you're buying the drinks, at any rate. But slip over for just a moment and see what happens." He pointed at me, and clamped his teeth together. "They'll kick you to death, and laugh at you while they do it."

I nodded, sneaking a sly look at my wristwatch. It was ten to eight.

He sat back again. "You see, Bill, a lot of those people who *seem* staunch, and who believe themselves to be, really aren't so at all. They've just never been put to the test. The only *real* way to find out what a man's made of is to give him a chance to do you harm, and see how he behaves."

"That's an interesting angle you've got there, Mick, but I—"

"It's a hell of a rub." His voice became lower, quieter. "Which is why I never do it, never give them the chance."

He went silent again. Outside a siren wailed.

"How old are you now?"

"Eighteen."

Toohey nodded. "I knew your father from when we were children together till when he died, in—what year was it?"

"1938."

"Christ, that's gone quick. Your father was a good man, Bill. He was a squarehead—and I say it with great respect—but he was staunch. Your mother too. In my book, the Glasheens are near enough to blood relatives. But what are *you* made of, Bill? Are you loyal comrade or a rat? Are you a man or a boy? I mean, do you have *character*?"

"Well, I'm—"

"Frankly, I don't know. And nor do you. You *couldn't* know. Not yet."

I took another peek at my watch. Three minutes to eight. The Rocket Club was five minutes away, if I ran.

"Well Mick, you've certainly given me food for thought there, no doubt about it, but I—"

He raised his hand and sat forward in his chair.

"You're going to get your chance to find out."

"That's great Mick, but I—"

"I'm taking some time off."

"Oh yeah? Where're you going?"

"Never you mind about that. I need someone to look after things."

"You want *me* to run the show?"

"Not *everything*. Obviously."

He opened the desk drawer, took out a notebook and dropped it in front of me. "I want you to act as my property manager."

I picked up the book. Columns. Names and addresses, amounts written in pencil: ten, fifteen shillings, a quid, thirty bob.

"This is . . . a rent book?"

Mick nodded.

"You want me to be a *rent collector*?"

"There's a damn sight more to it than that. This is a chance for you

to learn how business is really done, from the inside. It's not the sort of chance many of *my* generation were ever given, I might add."

"How many of these . . . properties are there?"

"A couple of dozen—houses and a fish shop. It normally takes a couple of hours to do the whole round. Collect every Friday."

"And, ah, how much do . . . ?"

"I'll pay you a fair commission."

"Up front?"

"We'll sort that out when I return. You'll be keeping an eye on my slot machines, as well. There are some peep shows at Luna Park and a jukebox at the Cross. You'll empty the coin boxes each week. All right?"

"Yeah, I suppose so."

"This will be for three or four weeks, but after I get back, if all goes well, we might see about you attending to it on a more permanent basis. You could do all right out of this."

Then Toohey walked over to the corner of the room, and moved a couple of Johnnie Walker cartons to reveal a battered tin trunk. We lifted it onto the desk and he unlocked it. Some hand tools, sets of keys, spare locks, yellowed tradesmen's receipts pinned together, more battered booklets tied up in rubber bands.

"Everything you'll need is in here."

He took a folded sheet of paper out of the drawer, put it in on top. "There's a lot to tell you, but I haven't time, not tonight. I've written out instructions."

Mick put his hand on my shoulder. "I don't like to do things in such a hasty, unplanned way, but it can't be helped. I'm relying on you, Bill. I hope to Christ I'm not making a mistake."

"Relax, Mick. How hard can it be? When are you going?"

"Tomorrow or the next day. Now pay attention. You're to follow those instructions to the letter. Don't accept either threepence more or less than the exact rent for each property. Understand?"

"No more, no less. Yeah, got it."

"Don't let yourself be conned by any of those bludging tenants. But don't take advantage of anyone, either. Do you understand?"

"Don't con. Don't *get* conned. Check!"

"Now go and get the car, so you can take this trunk home with you." He glanced at his watch. "It's ten past eight. I've got things to do for the next hour or two, so meet me back here at say, ten."

"What about your Mass?"

He waved the idea away. "That was to get rid of the mugs. Off you go now." ○

15

PAPER CUTS
by David Fair

"Jad [David's brother and longtime partner in the band Half Japanese] and I have both always done some kind of art. I used to work in color but as I got older I realized that the colors that I see are not the same as the ones that most everyone else in the world sees. When I look at those colorblind tests where I am supposed to see a number in a blob of dots all I see is a blob. In black and white I can be more sure that what I am making looks like what I think it looks like.

"I started cutting paper I guess about twenty years ago. I liked the bold and crisp line. It translates well to other purposes. It can be silkscreened onto shirts, cut into wood, or reproduced for CD packages or book illustrations. I got serious about cutting paper before Jad, but it wasn't a race. I'm older than he is so maybe I just got there first because I had a head start. His style is different from mine. I almost always fold the paper in half. He almost never does. He has learned some things from seeing my cuttings and I have learned from seeing his.

"I started out cutting with scissors, but now I work with a sharp blade instead. It has to be really sharp or it will snag and tear the paper. I usually fold the paper in half and make something that is symmetrical. Sometimes I change one side or the other to alter the symmetry. Instead of two exact Elvis impersonators I may alter the picture to be Elvis and Col. Parker.

"What I do is not hard for me. I suppose it could be hard if I were trying to do something other than what I am comfortable with. If I were trying to cut realistic versions of famous people for instance, it would be obvious to anyone

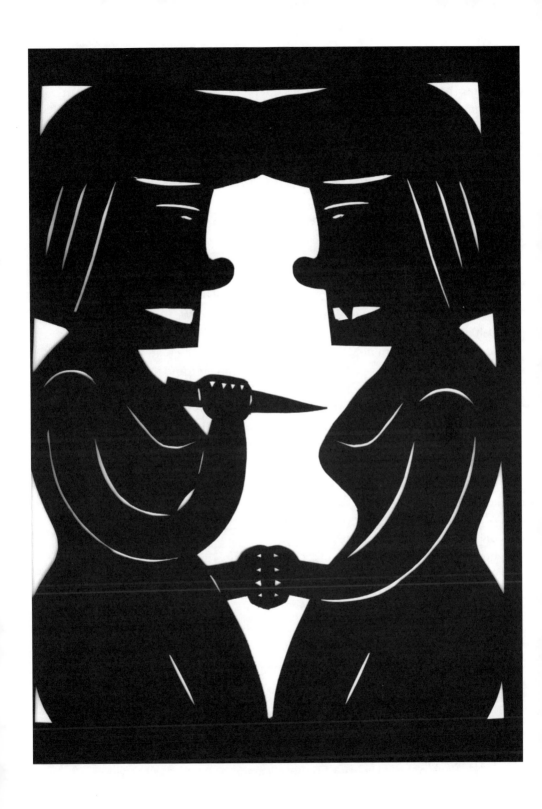

looking at the pictures whether I was successful or not. It's easy for me because if want to cut a picture of the Beatles I would just cut four guys and then write "The Beatles" on the picture. It's not hard for me because I do what I'm comfortable doing . . . Sometimes I draw lines on the back and follow them. Usually I draw rough guidelines with a white pencil and then really draw with the blade.

"[For the soon-to-be-released book with YETI] I have cut about 200 pictures of Bigfoot, Yeti, Abominable Snowman, Sasquatch and Humans. I will now arrange them in an order which will be pleasing to the eye and reveal secret aspects of their relationships.

"[The Half Japanese "big band"] has played a festival in my neighborhood for the last couple years. I hope we will do it again next summer. We played the SXSW festival in Austin last year and I had a lot of fun. We just played DC and Baltimore last weekend and they were great shows. I have a family that I want to be around so I am not interested in going out on the road for weeks at a time, but I hope that we will play a show at a time here and there.

"I damaged my knees in Austin. We played six shows in three days and at a couple of them I dropped to my knees to make a dramatic point. Now both knees are numb and I have had to have a lot of fluid drained. The doctor told me a couple days ago that if the fluid comes back I should have surgery. Well, It's already returning so I guess I'm not done fooling with this yet. I love jumping around and pumping up the audience. This last weekend someone suggested that I sit in a chair while we play. I figured that; basically I'm retired. I only work a couple weekends a year. I guess I should be able to do it standing up. I don't know anything about rocking halfway. [The shows] have gone over very well. It seems almost like we were ahead of or time when we started. And now the times have caught up with us and we are exactly what people want to see."

CREDITS

Pages 17 and 19-22: Untitled papercuts, courtesy of Yard Dog Folk Art.
Pages 23-27: Selected papercuts from the book *Bigfoot* (forthcoming from YETI Publishing)

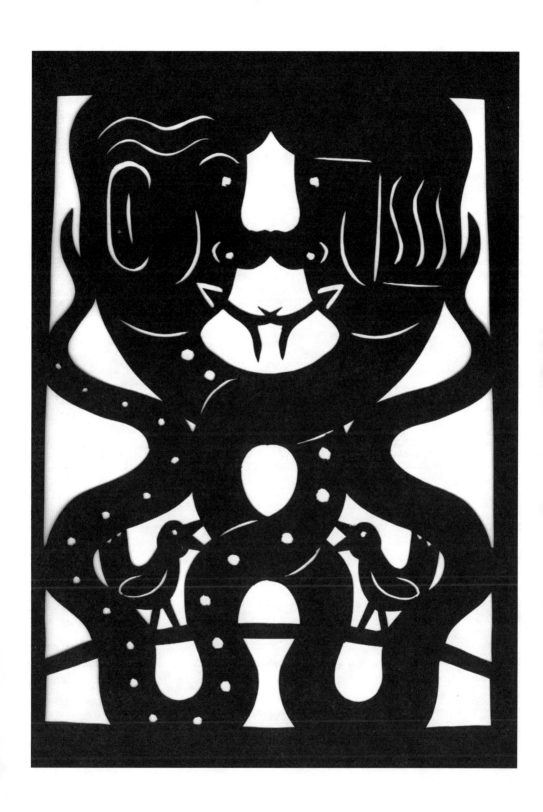

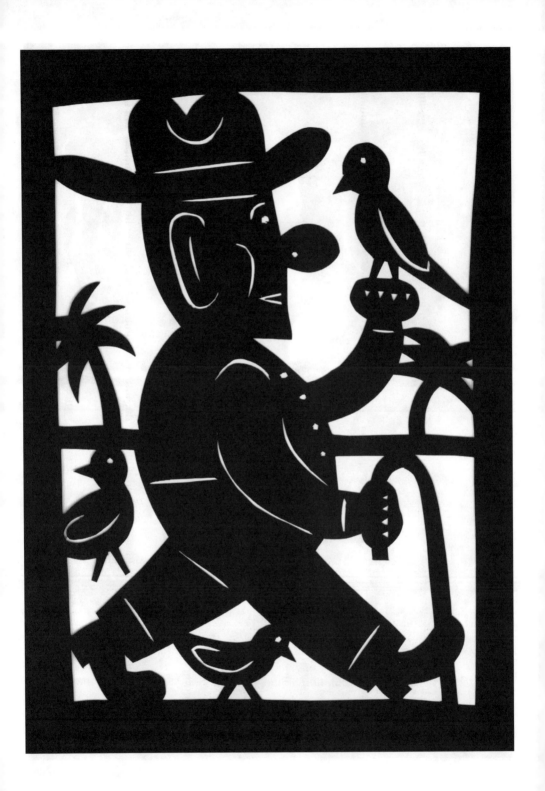

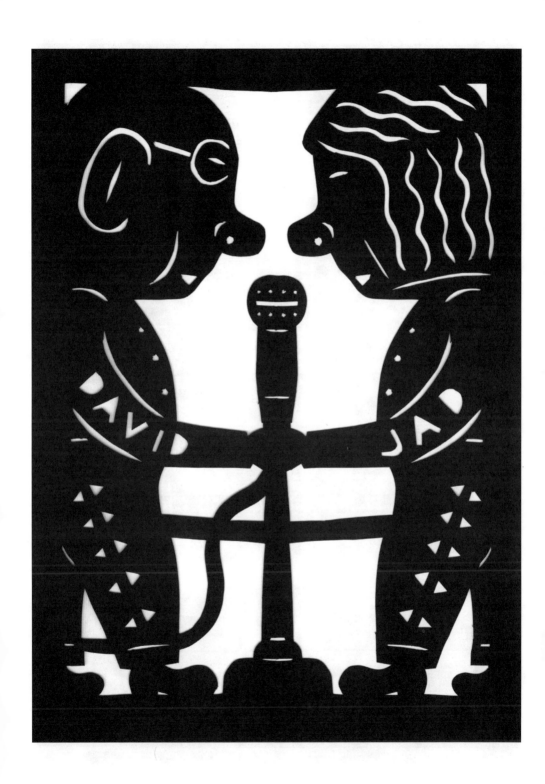

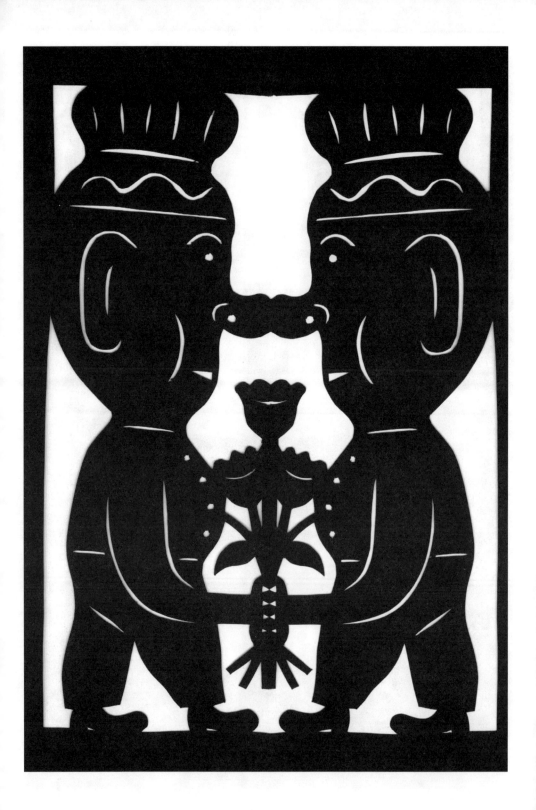

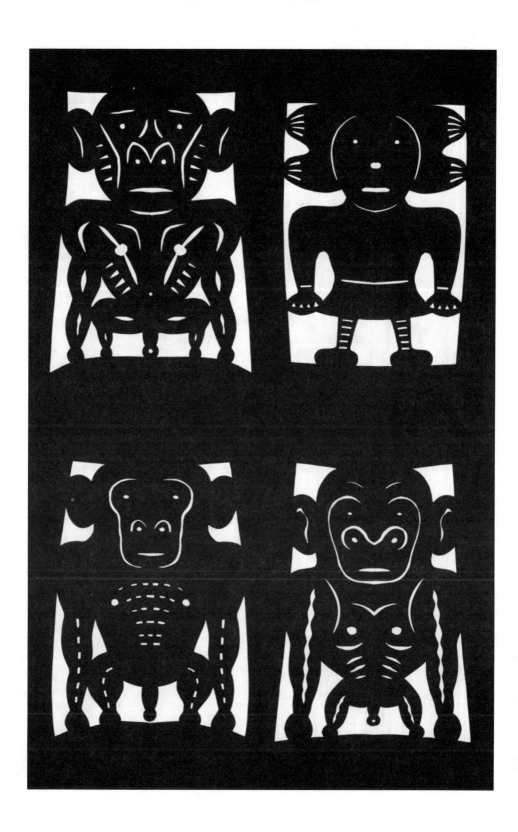

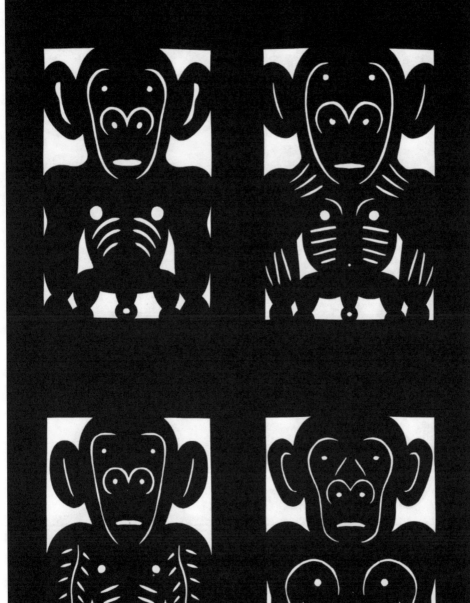

26

ELECTROCUTE YOUR BRAIN

An interview with the Clean

by Mike McGonigal

It's a ridiculous thing to say, of course. But if forced to pick my favorite rock band of all time, I'd likely choose the New Zealand-based group the Clean, including their short-lived stint as the Great Unwashed in the early to mid- 1980s. Formed in 1978 in Dunedin, their first single, "Tally Ho," was released on Flying Nun in 1981. Don't listen to those folks who say that if you own the extraordinary Merge double disc *Collection* that you have all you need by this band—you need to hear everything they have done, and will do. From the 1981 *Boodle Boodle Boodle* EP to the 1990 *In A Live* EP (this band really made exceptional EPs) to the 2001 album *Getaway*. All their solo and offshoot projects are worth tracking down as well. The Clean are composed of drummer Hamish Kilgour, bassist Robert Scott and guitarist David Kilgour. All of them sing, though David is the primary vocalist in the group. They were interviewed via e-mail in August and September of 2008.

You are aware that your music is hugely inspirational to many young and youngish bands playing out and about now, right? I suppose this was obvious after your shows at Cake Shop in New York, NY in December of 2007.
ROBERT: To some degree I was aware of this, as reports filter back and you see that kind of thing on MySpace and such. But it does seem to be quite strong—I guess we had better get back over soon!
HAMISH: Yes—it's cool that people check into our patchy past. We were inspired by what we thought was great stuff, and tried to do it ourselves. I find it hard to get into our old recorded stuff because of being to close to it. But I get a kick out of people digging the stuff.

DAVID: There's always been some kind of interest in the Clean bubbling away in the USA. But, yeah, it seems there is an upswing in interest in recent times. And I was surprised by those three nights at the Cake Shop. There were a lot of young people at those shows, which is always pleasing and surprising. I only wish I had been feeling healthier doing those shows. I was a wreck, mainly due to a month's tour beforehand and coming down with a flu. I just thought I was exhausted, but I got back to NZ and was as sick as I've ever been. I lay on back for a month and honestly thought I was dying there for a day or two!

So, when did you and your brother first start to make music together? How did that come about?

DAVID: As the Electric Bananas, a bedroom band when we were very young teenagers. We had an old tape machine and made mad little songs like "Electrocute Your Brain" and a reworking of "Old MacDonald." Sadly, it seems as if the tape is long lost.

HAMISH: In the 1960s, I played on a cardboard box drum kit my cousin, who was a mod, had made on my grandmother's farm. We made some early recordings on a 1970s tape machine. Before punk broke, we did some home recordings on a cassette machine in the cinder block flat we called home, where our mom paid the rent. We called ourselves the Electric Bananas and had a song called "Electrocute Your Brain." I played knives on a stovetop for percussion—extra cutting and hard metallic stuff. We bought a bad NZ guitar in 1978, a Concorde with push button controls, for $20 or something like that. The case was so bad that we threw it out the car window onto the street as we drove away. David immediately showed more aptitude than I so he became the guitarist. It must have been the fact that he learned how to play "Good King Wenceslas" on the recorder. I had one violin lesson at school and was intimidated by the teacher. I took chanter classes for a few weeks as a precursor to learning the bagpipes. I was more attracted to the drums. I was bullied by a drummer who used to sit on me, and dropped out of classes. I took two classical guitar lessons in the '80s. Self-taught drummer through listening. David is pretty much a self-taught guitarist and pianist.

You made music before you were in the Clean—with Electric Blood—what's the latest on that stuff getting reissued?

ROBERT: We actually have a new Electric Blood coming out on Powertools called *3 Craws* [Scottish for crows]—it's the whole family in one night when on our holidays in Central Otago, quite a bit of it is my dad singing old Scottish folk songs, and there is another waiting for that one to come out.

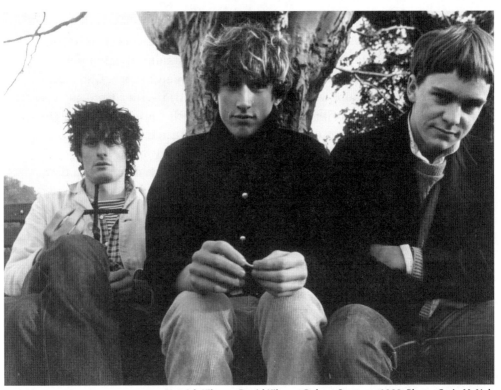
Hamish Kilgour, David Kilgour, Robert Scott, ca. 1982. Photo, Craig McNab

What's the first song you wrote?

ROBERT: She was only the engineer's daughter but she still burnt the toast.

How the fuck did you arrive at that guitar sound? It's so distinctive. Sorry that question is not more technical.

DAVID: I started mucking round with the guitar when I was about 14. I wanted to be the new Dylan. I soon gave up until the punk solution came along. I did take/steal some basic tricks from Alec Bathgate of the Enemy, especially the idea of open Barre chords which I developed into "just hit all the strings all the time" in the early days—though we are very different guitar players. Keith Levine from Public Image, Wire, the Velvets, Hendrix and '60s garage rock also showed a way to go. But I think my style developed out of not knowing what the hell I was doing, so my own style developed. Also being in a three-piece you need a few tricks to fill out the sound. Oh yeah, the Who! As a young boy I was mad on Hendrix and I think he certainly gave me the freedom to be spontaneous. I've always had a great love of droning too! Discovering reverb was like a watershed.

How did you guys meet Robert Scott, then?

DAVID: He flatted with my girlfriend.

ROBERT: I first saw them when they were playing as the Clean in '78;

they were supporting the Enemy. After that I met David as I was flatting with Genevieve, and we pretty much started jamming straight away.

HAMISH: I never saw Electric Blood; Bob had been to early Clean gigs. Bob went to art school with David and his (still!) partner Genevieve—Bob was flatting with Gen when David split back to Dunedin after the Clean had resided in Auckland for a bit. I returned to Dunedin from Auckland and heard what David and Bob had been jamming up—they had written "At the Bottom" together—I played some drums with them and was immediately suckerooed into moving back to Dunedin. And a magical time ensued.

To back up a little bit, Peter Gutteridge was in the band before Robert, of course. How did that come about?

HAMISH: Peter played in the Clean for a year or more; he actually started the group with David. We started leaping ahead musically and songwritingly. And Peter wouldn't practice his bass so we were getting frustrated with him musically. We communicated with him but he wouldn't heed us, so we said we couldn't do it with him.

DAVID: I went to high school with him. I saw him last week; he seems okay.

What's the best thing about being in a band with brothers?

HAMISH: Appreciating his talent and playing while not being in his presence—the abstraction—afforded by recordings—live or studio—with or without me—rather than being in there with him and doing it. I think that through learning to play with David, I've developed a sort of musical telepathy, which I can sometimes get with other musicians—intuition and spinning on a dime, inhabiting interesting places rhythmically. Bob is our (other) brother too.

ROBERT: Wooooooo; I think the telepathy when playing together.

DAVID: That I'm with someone I love. And even though we live on opposite sides of the world, the music brings us together on a regular basis.

What's the worst thing?

HAMISH: We know exactly how to wind each other up. We're both complex and obvious and fucked-up and we can make it a miserable task for Bob to wade through and negotiate. Think the Davies brothers—but the Ashetons in the Stooges seem to get on OK—and they're also a drum/guitar relationship.

ROBERT: Least favorite? Having to be the go-between sometimes.

HAMISH: We spar a fair bit—overtly and subvertly—but life is full of anxiety and tension anyway, isn't it? When you get close to anyone there's going to be a fur loss. I see it with our two cats, who love each other but give each other a good whack every now and again.

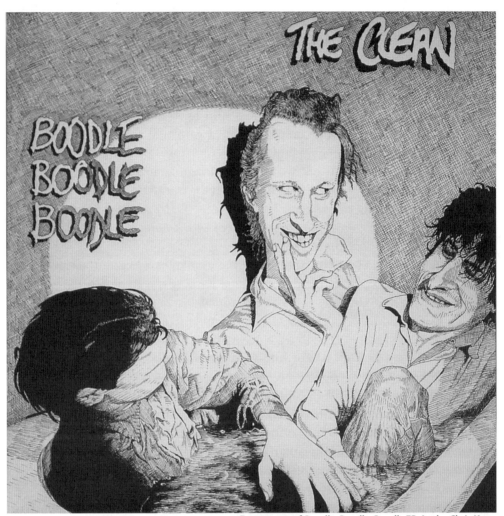

Front cover of *Boodle, Boodle, Boodle* EP. Art by Chris Knox

If someone sings a song, is it basically their tune?

ROBERT: Mmm, good question; yeah, usually if someone sings it they had a major hand in writing it. There is a mixture; I mean, like "Beatnik," I came up with the music.

HAMISH: Not really; we always viewed our songwriting as a democracy—a three-way split.

Do you have a favorite song that one of the other guys wrote?

DAVID: For Robert, "Trapped in Amber" and "E Motel" spring to mind. When Bob's good, he's very good. He gets the message across. I like him when he expresses the pain. As to Hamish's songs—"Safe in the Rain," "Too Much Violence," great love-songs-cum-protest-songs. I'm very fond of Hamish's direct lyrics—not a lot of flowery word play there.

HAMISH: At the moment I like David singing "Dreamlife" off the new album, and Bob's song which is the last number on the album.

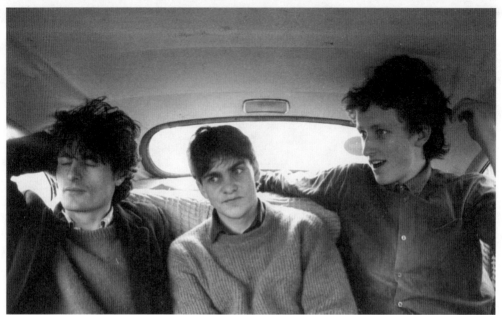

Photo, Carol Tippet

ROBERT: David? Wow there are so many I like—"Drawing," "Getting Older," a lot of goodies on the new one, especially "Dreamlife." Hamish? "Twist Top," "Safe in the Rain," "Whatever I Do"—they kind of merge together, and we all have a hand in each other's tunes that's for sure.

I count at least four Clean/Great Unwashed songs that are about other musicians—Duane Eddy, David Bowie, the "What Happened Ray," and I know there's one other one... Anyway, I love these kind of songs, even a bad Who tune that mentions T. Rex is somehow more thrilling by dint of that reference. What is it about this kind of subject material, do you think? Why did the Clean write so many songs about other musicians?

HAMISH: I get mesmerized by people. Like today, I was watching Heinz Burt and the Tornadoes on YouTube, a live performance with Steve Marriott from the Small Faces at 16 on drums. The kids in the band seemed like extraterrestrials—looking skyward with strange knowing looks—did David Bowie cop something from all this? Also, Johnny Burnette doing "Lonesome Train," or Nancy Whiskey and her crazy band doing "Freight Train"—they're like channeling something that is beyond the ordinary. It's just totally a magic realm. Everything becomes imbued with a sparkling beauty and portent. So, you end up writing songs about these people of channeling elements of their muse.

ROBERT: Well everything is open game as far as I'm concerned. "What Happened, Ray" was written in response to seeing Ray Columbus on TV in the early '80s and wondering what happened to the guy who

wrote and performed all that great music in the '60s with the Invaders. Don't get me wrong, Ray has my greatest respect for what he has done in the past. The Invaders supposedly gave the Stones a kick up the arse when they supported them on a NZ tour back in the old '60s. The "David Bowie" song is inspired by similar feelings. I was responding to his slow slip away from putting out great LPs post-*Heroes*, etc. "Fats Domino" was just gobbledygook; I love Fats. Hamish wrote "Duane Eddy"— "put him on a stage throw him a penny," says it all really, don't it?

When and how did you all enter your dub phase?

DAVID: Hamish brought home a wonderful LP of early Jamaican dub back in 1980, and around about the same time we bought a two-track Revox which has a wonderful slap echo—and whammo, we started playing around with it.

I love the "Point That Thing" dub. You already mentioned Keith Levine— clearly PiL were big dub heads, too.

DAVID: Yes the PiL influence must've been in there as well. I also remember we had some very strong pot when making a lot of that "dub" stuff.

Did Flying Nun really start to release your records?

DAVID: Yes.

HAMISH: We had met Roger in the Enemy days, when the Clean first played in Christchurch. He came to visit us in Auckland when we were touring, and offered us a recording deal. We had also been offered a single deal with Propeller Records, but went with Roger 'cause he was a Southerner. We remain friends today.

ROBERT: Roger saw us and decided someone had to release our stuff so it might as well be him.

What was the New Zealand music scene like at the time? It seems so much bigger than I'm sure it was from here because so many of the bands still sound so great; that music has aged so well. Even little one-off projects like that '60s cover band you were in during the '90s (the Pop Art Toasters) or the Alpaca Brothers, or second tier sort-of acts like Look Blue Go Purple— it's all surprisingly good.

HAMISH: It was a great scene for a while, playing alongside all the Dunedin bands and the Christchurch bands too.

DAVID: It was a very exciting time. An unbelievable outpouring of great music over a very short time.

ROBERT: It's quite amazing the standard—and there were a lot of other bands that hardly anyone got to see as well; I've done a band tree that I will have to send to you.

Was it something in the water?

ROBERT: It's a combination of a lot of things—isolation, not a lot else to do, the music we seemed to enjoy—who knows!

DAVID: Put it down to punk rock and its influence. Also a lot of the main contenders were obsessed about music before they thought of picking up an instrument.

HAMISH: Post-punk, all was good and inspired—magical gigs inspired songwriting and creativity. There is more of a lurking corporate feel these days, but the underground still exists.

What would it take for you to return to New Zealand? Any interest in that?

HAMISH: Sometimes I get hugely homesick—like this summer—but then I couldn't just pick up and go. Then, after the pain and struggle of New York and the *fear* element that exists here—it turns around and unravels its strangely magical qualities along with the cool people that are here. When I first came to New York, it kind of caught me and has been hard to escape. I really miss the land that is New Zealand. Socially, sometimes it's really difficult and fishbowl-like there.

What would it take for you to leave New Zealand? I am aware this is a ridiculous question.

DAVID: A large amount of free cash. I have considered living in the USA in the past but post-September 11 has certainly squashed any such thoughts. I do love visiting the country and have made many great friends there over the years.

What did you mean when you coined the phrase "Dunedin sound"?

DAVID: When I said that—early '80s?—it seemed there was a thread running through all the bands at the time. Without wanting to sound too arrogant, in the early days a lot of the bands took inspiration from the Clean: the guitar sound, simple strong songs, basic caveman beat and the fact that following your own mad scheme of things was the way to go. In saying that, the Clean took local inspiration from the Enemy— great songs, wonderful guitar player, etc.

HAMISH: Guitars predominately played in a classic sense with a primal rhythmic undercurrent and some singing/chanting on top. The Scottie/ Irish thing is in there—and there is something of the Maori/Polynesian/ South Pacific/Oceanic nature of the place and people, too.

Did you guys know Chris Knox before he started the Enemy, then? When I first saw you play, you toured the States in the late '80s with him and even backed him up a bit, if I remember correctly.

DAVID: Hamish was friendly with Chris before anyone picked up in-struments. Mutual music obsession seemed to be a drawcard. I think I met Chris when I was about 14. We had seen the Enemy's first show and

that spearheaded my thoughts of starting a band—then around about this time I met Peter Gutteridge, and hey presto!

ROBERT: I didn't know Chris early on and we didn't play with him much at all. We did do some recording with him. The first live gig I saw was the Clean and the Enemy so that was quite an introduction! I used to put my punk gear on and come in from Mosgiel on the bus [half an hour away] so I was the odd one out in those parts.

DAVID: When the moon was high we would get up and back him doing "Nothing's Gonna Happen" as an encore.

HAMISH: Yes, we had great fun touring with Chris as a solo artist in the late '80s. And I had been friends and hung out with Chris and his gang before punk broke. We all discovered it together. The first time I met Chris he was dressed in a black suit and had short hair and mimed to a David Bowie bootleg with a beer can as a mike. Chris and his friends had huge record collections and were already being cre-

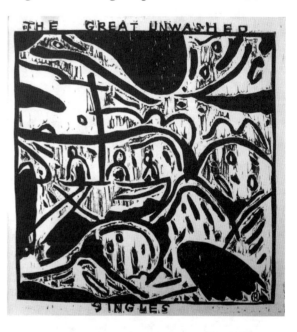

ative, making Super 8 movies and recordings. I tried playing drums for the Enemy; I wasn't really good enough. I wondered at the time if I could be in a band with an ego that was as big as Chris's. It's funny, but both Chris and my brother are Virgos—good creative partners but very different ways of working from my own.

How long were you in the Chills, David, and what was that like?

DAVID: I really only practiced with the Chills, for maybe for three months or so. I loved it but got turned right off by someone in the band getting heavily into junk (and no, it wasn't Martin Phillipps) about the time I joined.

Was that the only time you were in "someone else's band"?

I've played in all sorts of lineups over the years including Snapper and other fun type party bands. I love playing as a backup player, no pressure and I get to play guitar without having to sing and be a frontman, etc. I'm actually about to join Robert's party band, the Club Swingers.

We are gonna play at the Medical School Ball at Larnach's Castle, doing covers. Now that's living!

Speaking of cover bands, will there ever be a Pop Art Toasters reunion?

DAVID: We have been talking about making another EP, like for years now. Maybe, just maybe. Martin lives about two houses away from us so it's possible. I loved playing in that band.

You were top of the charts for a few years there—what was that like? Were you like recognized in the grocery store and stuff?

HAMISH: People started recognizing me on the street and talking about me; I found it uncomfortable and much prefer anonymity.

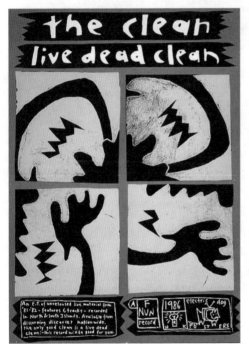

Tell me about how and when the Clean broke up the first time.

HAMISH: I got sick of it. Looking back, I should've just had a break for six months. I was burnt out. I do tend to burn out easily. The first two or three years there with Bob in the band were pretty intense, especially the sudden success that we encountered on releasing "Tally Ho."

ROBERT: David had had enough of the pressure as we were flat out in '82. So we stopped about October or November of that year. We were in Christchurch and pretty soon I had the Bats going and moved back to Dunedin in '84.

1986 promo poster; art and design by Electric Dog

And then the Great Unwashed got started—how?

HAMISH: Peter had worked up a bunch of songs and was living in Christchurch—so we jammed, recorded and then toured.

DAVID: The Great Unwashed kind of ended up being two camps. Peter and I were keen to play and practice a lot, were unemployed and able. Hamish and Ross (Humphreys) had jobs and houses etc., so Peter and I were a little frustrated from the lack of progression, to the point where I had had enough and I left (after a rather shambolic show).

How long were you in Bailter Space?

HAMISH: I was in Bailter Space a few years; it was a lot of fun. I had a great creative relationship with Alister Parker; we played some fantastic gigs and had a very creative time in Christchurch. Bailter Space

played New York recently for the first time in ages and they were great—very cinematic. I got shivers up my spine for some songs; I got a real kick out of hearing how well some songs I co-wrote stood up and seem just as relevant today. It was a hard choice for me to reactivate the Clean and quit Bailter Space.

ROBERT: We got back together for a show in '88 in London as the Bats were playing and Craig Taylor [the Chills manager] somehow talked Hamish and David into doing it as they were both around—and we even got to have a practice.

In recent years the Clean has never broken up per se, right? You guys are just in hibernation? How does that work?

HAMISH: We keep in touch and things just percolate along with decisions made by the three of us when to do things.

ROBERT: We just slow down and do our own thing for a while I guess. And when the wind is coming from the right direction we reconvene.

HAMISH: We hibernate and then we don't hibernate and then hibernate and then...

How do you make your living these days?

DAVID: As a musician—by the skin of my teeth, as they say.

What's up with you right now, Hamish?

HAMISH: I'm flat on my back on a hot NY late summer night. I got let out of work for the Morgan Library art handling a "Babar the Elephant" drawings show that got installed—so I goofed off trying to find a pair of shoes to buy. Then I came home and did some work on some watercolors. My child Taran was elsewhere tonight, so this was valuable alone time.

And you have a solo art show at Eat Records now, right? How much time do you get to work on your art these days? I know it can't be hard to do that with your family and work and stuff...

HAMISH: It's hard to have time to paint. I was recently doing some work for a French decorative painter—insane, repetitive stuff—but it throws me back at my own stuff. I've sold one piece at Eat—a four-sided box of cartoon characters that I drew sitting in a car. It was the cheapest piece in the show (on a piece of yellow string so you could rotate it, suggesting an animation), only $30! An (un)wise Greenpoint hipster purchased it.

How do you make your living today, Robert—as a musician right?

ROBERT: Almost; I have a day job too as a teacher aide at the local school.

And holy shit, man—you are prolific. What's the latest with solo releases and other stuff?

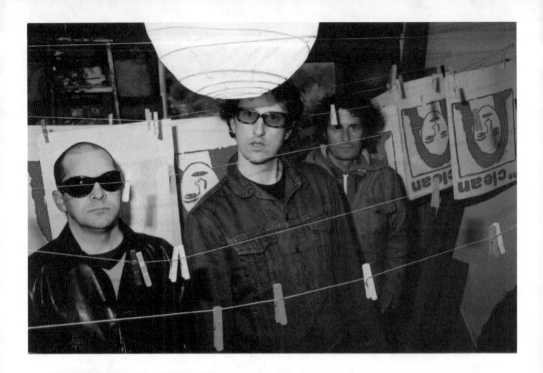

ROBERT: I am finishing off an album with Gina Rocco called *Carry on with the Picnic,* halfway through the new solo album and finishing off mixing the new Bats album—so, quite a bit coming out!

What are your personal future plans?

DAVID: Pay off my house, and more music, more music, more music. Oh I'll squeeze in some surfing too.

ROBERT: To keep on making music and to get better at it, also get a home recording system up and going, have some more painting exhibitions, and get my house fixed up.

DAVID: I've just completed writing a new LP in collaboration with New Zealand-based poet Sam Hunt. I've written about twenty songs to his poems. Sam is also going to do some spoken word for the album. Sam is probably New Zealand's most well-known living poet, if not the most well-known Kiwi poet full stop. Other great NZ poets like James K. Baxter and Hone Tuwhare are sadly dead. I have also written and recorded some of my next solo LP which will be an indulgent, electric guitar soaked work. The Sam Hunt will hopefully be released here in NZ early next year. The new solo LP will see the light of day later next year.

You've been collaborating with former Tower Recordings guitarist/singer Theo Angell; what are your plans for that project?

HAMISH: We'd like to release that stuff; it's called Cloudcraft. Playing with Theo is very easy and synchronistic. We have an understanding; I

think he's a kind of mercurial genius. I can talk about my wildest mind wanderings, and he comprehends, and bounces it back. We've done some magical gigs together—alchemical. We have worked together a lot: laboring, building, carpentering and painting. We have inhabited an array of different characters in our workings and play.

What's the latest with the Mad Scene?

HAMISH: The Mad Scene have an album sitting in Gary Olsen's computer; it needs vocals to finish it. It has a very live, fuzzy, rocking sound. Georgia from Yo La Tengo and Brian Turner from WFMU are on it along with Steve Thornton's monster bass, and Lisa Siegel on drums.

David's now the subject of a full-length documentary film, Far Off Town— Dunedin To Nashville, *by Bridget Sutherland. What was that experience like?*

DAVID: Something that I would normally avoid. I never dreamt Bridget would get funding for the project so I never really took it too seriously when she approached me about it and then she got the funding. I also didn't know her before she got in contact, but there were some distant family connections which made me think she would be okay to work with. It was worrying though, to have a film maker along while I was making an LP. But she was expert at the "fly on the wall" game—had great ability at making everyone feel at ease. Of course I can't watch the movie without skipping large portions of it!

HAMISH: I've only watched a bit of that doco—didn't get to see myself—didn't know Bridget until she started filming at some Clean shows in California, when we played with Yo La Tengo at some shows at the Fillmore.

ROBERT: I liked it; it was fun to see someone else's viewpoint for a change and it put quite a slant on things for me.

And finally, back to the Clean—there's a new album due soon, right? What's it like?

ROBERT: It's hard to say from our perspective, but I think people will be impressed. There's some wacky stuff and some cool pop along with some very bent instrumentals. We have one tune to go; it has been great working with Tex. He has put a lot into it.

HAMISH: The new album is seemingly good—not too long like the last few. It's had a strange gestation and resolution—it's a bit odd, succinct—and seems to have something going on.

DAVID: The usual eclectic bunch of tracks. Krautrock, pop, lullabies, instrumentals, etc. Tex Houston has recorded it and done a fantastic job; sonically I'm very fond of it. ○

AS REAL AS THE REALEST THING WE GOT ON THIS SPIRITUALLY SICK PLANET & EVERYTHING IS GONNA BE ALRIGHT ONCE WE LEARN TO LOVE AGAIN

The Art & Music of Mingering Mike

by Eric Isaacson

In Washington D.C. during the late 1960s, a young man known to the public only as Mingering Mike created his own record label. The records were limited to editions of one. Each had a hand-painted cover and a cardboard replica of a record inside the sleeve, complete with hand-painted grooves that perfectly matched the track listings. The titles of the LPs were classic: *Sitting by the Window, The Drug Store (One of the Many "Shames of the World"), 3 Footsteps from the Altar, Fractured Soul, Home Coming/But When You Drink, Mercy the World, Bloody Vampire, You Know Only What They Tell You, The Dark Side of Regan, On the Beach with the Sexorcist,* and *Life is a Bitch.*

As for the music, some was recorded on reel-to-reel tape by Mike and his cousin, The Big "D". They hammered out the songs' percussion using a comb, which was beat on a phone book, and used their voices to simulate horn lines, guitar, and bass. The results are a beautiful mix of

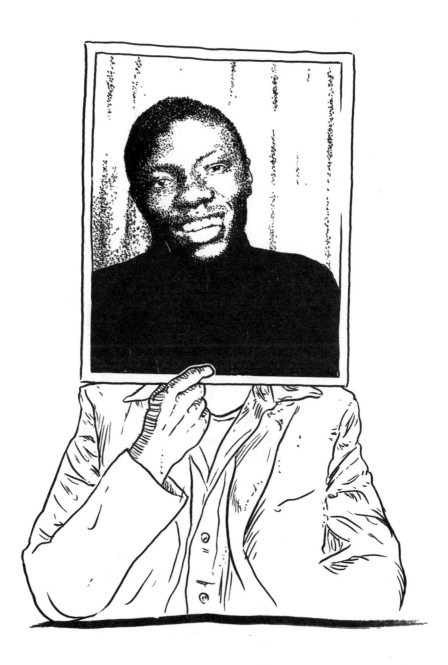

street-corner vocal-group sounds and straight-up soul. Many of Mike's peers—his brother Roland and, for that matter, Marvin Gaye—were hanging out on street corners in front of clubs such as the Howard Theater back then, singing their hearts out, hoping a talent scout would walk on by and say, "Kid, you got what it takes!" Mike's tactic was much more subtle. He stayed in his room and created finished products of his own design. He estimates that he and his cousin recorded well over two hundred songs together. He drew over fifty LP covers and even more 45s. Mike wanted his talents to be discovered by the world at large, but this did not happen for quite a number of years, and not as he ever would have expected.

Many years later, Mike's interest in his own art and music was waning. He had put much of his extensive LP collection and artwork in storage. It remained there for ten years or so. Mike had a good relationship with the people running the storage facility, so he grew accustomed to paying

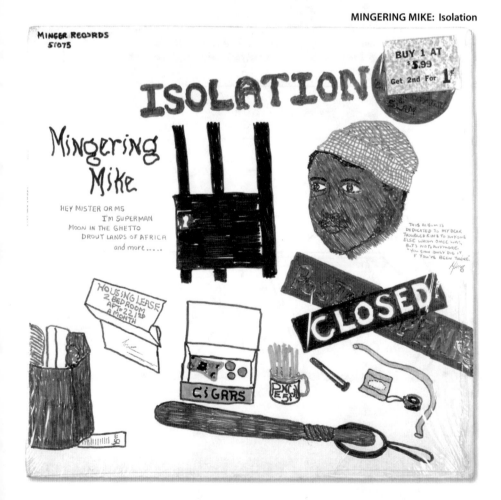

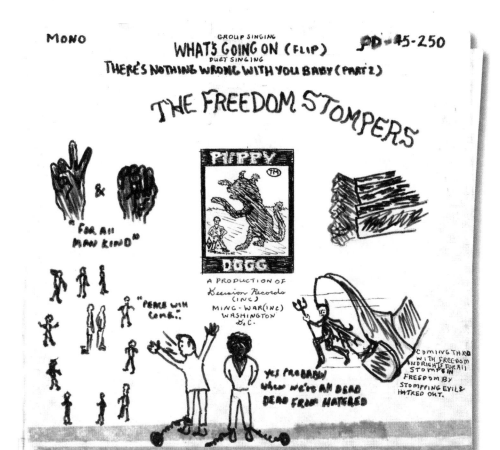

THE FREEDOM STOMPERS/MINGERING MIKE & THE BIG "D":
What's Going On? b/w "There's Nothing Wrong with You Baby (Part 2)"

the rent a little late now and again without any unfriendly repercussions. Unfortunately, new owners took over the facility without Mike's knowledge. After a slight lateness in payment on his part, the music library—what he'd collected and what he'd created—was auctioned off, sold to parties unknown to Mike.

Soon thereafter, a private investigator and DJ named Dori Hadar was rummaging through a flea market in D.C., as he often did, when he came across forty of Mikes hand made LPs. Luckily, he saw the value in them right off and bought them all. Just as luckily, Dori was an ethical person and a talented P.I. He managed to track down the artist and reunite him with his lost work.

Mike and Dori became friends, and Dori soon wound up representing Mike as his agent. Articles cropped up in the *New York Times* and *Wax Poetics* and Dori organized a book of Mike's covers, which also outlined the life and times of Mingering Mike. *Mingering Mike: The Amazing Career of an Imaginary Soul Superstar* (Princeton Architectural

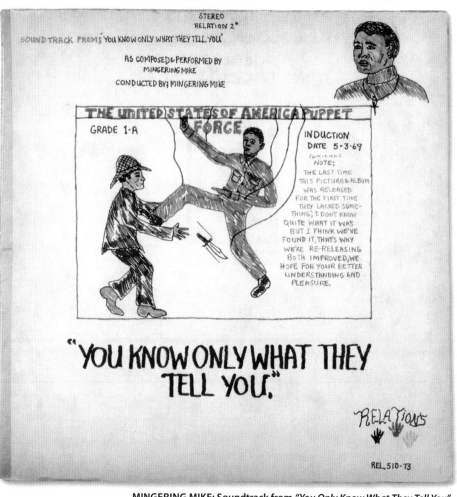

MINGERING MIKE: Soundtrack from *"You Only Know What They Tell You"*

Press, 2007), from which the reproductions accompanying this piece are gratefully borrowed, is a stunning book. It left me speechless when I first encountered it. Within it a whole universe of never-seen or -heard, classic-looking soul music unfolds.

Mike went through many periods in his art and music—periods that mirror the trajectory of contemporary soul singers like Marvin Gaye and Curtis Mayfield. He started out mostly concerned with matters of love and keeping the party going with such records as *Grooving with Mike, Channels of a Dream, What I'm Going to Do,* and *Can Mingering Mike Stevens Really Sing?* Soon into his career, a draft letter from the U.S armed forces entered Mike's life. He opted not to show up for duty, which resulted both in more time spent in his room to create art while hiding from the possibility of a jail term and in more and more focus on consciousness themes in his work, on records like *Getting to*

the *Roots of all Evils* and *Ghetto Prince*. Mike's record covers tackled the Vietnam war and the drug epidemic in the inner city with a heart-felt and straight-up style. As Mike puts it in the liner notes of one of the LPs: *"I'm very concerned with the growing rates of suicides, threats killings, alcoholism, addicts, prostitutes, fake's, frauds, high cost of living, high cost for being sick, death arrangements, child education, adult education, poverty, prejudice, bigotry, the war, and the success of this album."*

Paging through the book, one begins to wish that records had been made of Mike and his cohorts—The Big "D", Joseph War, and Rambling Ralph—back in the day to match the covers. Luckily, some of the tapes recorded long ago were recovered by Dori and Frank Beylotte, a good soul who also exhumed much of Mike's work and belongings after they were auctioned off from the storage facility to the flea market. The record label Vanguard Squad issued a 7" of one of Mikes' best

JOSEPH WAR: Ghetto Prince

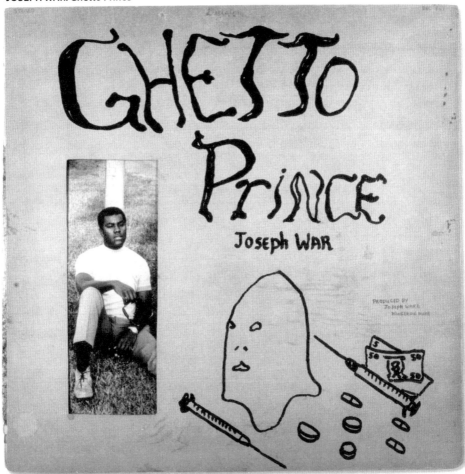

songs, "There's Nothing Wrong with You Baby Pt. 1 & 2," with a beautiful reproduction of his artwork for the sleeve. It's a genuinely romantic song urging a woman to wipe the tears from her eyes and say goodbye to her so-called friends who criticize her for just being herself and to walk proud, because Mike understands her and wants to be kind to her and likes her for who she really is. Beautiful.

Mike's reaction to all the attention his work has recently garnered is one of happiness and tasteful caution. He's happy that the positive messages contained in his work are being received by so many in a world where people don't stop and care about each other nearly enough. He keeps a low personal profile—not allowing himself to be photographed and not appearing in any and every lame media outlet that will have him. Mingering Mike is happy to gain recognition for his work, but doesn't necessarily covet direct attention (there is a big difference between attention and recognition and I do believe the latter is far healthier).

There's talk floating around of a Mingering Mike movie to be produced by the same person responsible for the documentaries *The Devil and Daniel Johnston* and *American Splendor*—two of the better movies of the last 10 years. I hope it happens, because Mingering Mike has something very important to say to the world. It's something that I try to repeat during the occasional dark hour I have now and again and again—something along the lines of Goethe's quote that "A human life remains of consequence not because of what we leave behind, but because we act and inspire and arouse others to action and inspiration and enjoyment."

Originally, this article was to have been a conversational interview with Mike. Unfortunately, the tape of that long late-night conversation turned out to be inaudible. Mike and I tried to contact each other many times after that. But both of us are famously and somewhat purposefully unreachable by phone or e-mail, so a repeat of the interview was not possible. But our conversation confirmed what I knew in my gut since first being bombarded by multiple copies of the *New York Times* article about him, handed to me by five different people who knew that Mingering Mike's art would make me feel less alone in the world. He deeply cares about the state of the world and wishes that people would stop waging wars in far away lands and start taking care of each other here at home. He believes one function of his art is to inspire others to be inspired and to bother to record those moments of inspiration for posterity. He is humble and likable and is still in love with music and all the possibilities it suggests.

Ultimately, Mingering Mike's art stands out because he perfectly sums up this sad limping world's problems with a carefully selected set of symbols such as this one:

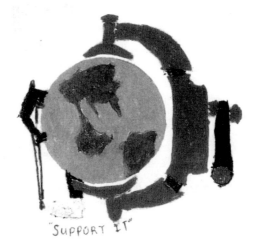

"SUPPORT IT"

Mingering Mike suggests in his work a solution to those problems too—"Support it"—and Mike is brave and honest. If I had to represent the best parts of humanity to an alien civilization using only two artifacts, I would choose Marvin Gaye's *What's Going On* LP and the book of Mingering Mike's covers. It's as good as our species has ever been and makes me proud to be a human being.

Thank you, Mike. ⊙

500 RECORD-STORE NERDS CAN'T BE WRONG!

An interview with the Vivian Girls

by Rob Simonsen

My first encounter with Vivian Girls saw us playing a naked girlie photo hunt game on a video poker machine for roughly eight games prior to them playing their first Portland show. I'd shyly introduced myself and they immediately invited me to play, almost before I'd gotten a sentence out. They then proceeded to bro-down with me like I wasn't some nerdy fanboy who'd just stammered an introduction. In a way, it was the perfect first meeting, as their music acts on roughly the same basis: it's instantly familiar, immediately inviting, and altogether amazing.

The Brooklyn, New York trio take a page out of the Shop Assistants' handbook (by way of Black Tambourine), using layers and layers (and layers and layers) of reverb added on top of catchy three part female harmonies. The guitars manage to sound both punk and jangly, either plowing their way through the songs with the girls barely able to keep up, or slowly keeping time in a shambling, C-86 fashion. There are points where the drums hit so hard it sounds like they must be breaking, points where the music takes backseat as the three of them work their vocal harmonies to sublimely fill the empty spaces, points where you find yourself cursing the world that John Peel still isn't alive to capture their raucous thrashing. It sounds as though their recording equipment was set up in the room adjacent to their practice space, giving it a real garage sound that fits so well with their aesthetic. In a way, we're only able to listen to their world from the outside, like we're in that adjacent recording room—and it is in those brief flashes of greatness that

appear from watching three friends try and tinker it out until it sounds right that give their music such charisma. Sure, they may not be reinventing the wheel here, but they're making that shit spin more true than it has in awhile.

In July of 2008, I caught up with Frankie Rose and Cassie—drums and guitars respectively—at Frankie's apartment. The interview felt more like catching up with old friends than an interview, as becomes pretty apparent with the way the two of them sort of feed off of each other's answers. The chemistry they had going for them was pretty considerable, as well, which makes it all the more disheartening that since this interview Frankie has left the band to focus more on her other project, Crystal Stilts, who are admittedly great in their own right. The Girls have a lot going for them, of course, and with new drummer Ali a world of admirers is sure to spring up in the wake of their album's recent wider release, and a European tour slated for the start of 2009.

FRANKIE ROSE: Ask me anything.
YETI: Alright—how did you guys meet?
FRANKIE: Cassie... that's a Cassie question.
Hey, you said ask you anything!
CASSIE RAMONE: Well, me and Frankie met about two years ago, a few months after she moved to Brooklyn. We met at a kickball game. Our friends play kickball every Sunday at McCarren Park and we both went. Our friend Robert picked us to both play on the same kickball team even though we're the worst two kickball players ever.
FRANKIE: Truly.
CASSIE: Like, we run away from the ball. So I guess that's when we became friends. It was with, like, a huge Pilates ball—the thing could knock you over. So then every weekend I'd be hanging out at Frankie's house because I was friends with her roommates. We'd all go to the Acapulco, this Mexican restaurant, for brunch. It was like tradition for that whole winter—winter, 2007. One day at brunch Frankie asked me if I wanted to start a band, and I said, "Sure!" Then she wrote down my number on a tortilla and called me the next week and we had band practice. We had a few practices, just me and her, but we still needed a third person to fill out our sound, so I asked [Kickball] Katy, my best friend from high school to join, since she was also looking to start a new band. And that's basically how it started.
Are you from Brooklyn?
CASSIE: I'm from New Jersey—me and Katy are both from Richmond, New Jersey.
And where did you come from, Frankie?

FRANKIE: I'm from San Francisco; I transplanted to the East Coast.

Had you been playing for a long time before starting the band?

FRANKIE: I actually moved to New York with the intention of starting a band right away, because I had just left a band behind. So I'd already had a practice space, just by myself. I had already bought a drum set, and I had guitars. I was messing around in the practice space and just playing with different people. It worked out very well with Cassie.

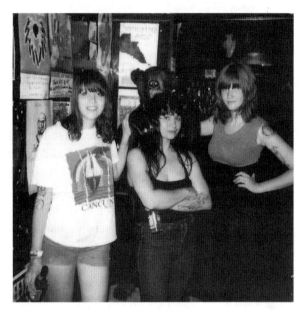

Is there a primary songwriter between you three?

FRANKIE: We all are. Sometimes Cassie will bring in a couple of songs, sometimes I will. Lately we've been all writing together. Or, like, one person writes a part, someone else writes another part, somebody writes the lyrics. It's all different.

You all write lyrics?

FRANKIE: Mostly Cassie writes them.

It's hard sometimes with all the reverb on the vocals to make out what you're singing, but it seems like a lot of the lyrics are kind of twee. Is that true? [Cassie gives me the stink eye] . . . Well, it seems like the indie-pop community has really picked up on your album; indie-pop kids seem to love it. But watching you live, it is way more punk and garage-y, and it seems like that is where your ties are, but then there's this whole other brand of kid that loves it.

FRANKIE: I think that's true. I do like all that C-86 stuff, but I wouldn't say that it's my direct influence. I mean, stuff that is in the vein of, like, Black Tambourine—they were just totally indie pop. I wouldn't say that it's any of our main influences. It just so happens that, for whatever reason, when me and Cassie write a song, it has that combination. And a lot of different groups of people seem to like it. Indie-pop kids....

CASSIE: Punks like it.

FRANKIE: Garage kids. Record nerds. I think it's just a strange chemistry thing. I definitely knew, though, Black Tambourine is a pretty big

influence. I felt, "Aw, we could probably do something like this!" You know, three girls with pretty, melodic voices. Lots of reverb.

CASSIE: When we first started the band we just wanted to be a fast punk band. The first month, all we wanted to do was be a party band. Fast punk songs, that's like the only place that we were going. But then it kind of changed more organically after that—"Let's add reverb. Let's add tons of harmonies." That's kind of how our sound came together.

How do you end up picking your harmony parts? It sounds like when you play live that each of your mics have a different level of reverb on them.

FRANKIE: It's not necessarily supposed to be different. It honestly changes every time we play because it's a different PA.

CASSIE: We're all supposed to sound relatively the same, but it never really works out that way.

It's odd that you say it's supposed to be the same, because I think one of the big appeals of watching you live is that it sounds like you each intention-ally have a different level of reverb, and the way the vocals blend together— it takes it one step further from just being, you know, a garage band.

FRANKIE: Well, hey, happy accident I guess.

Speaking of garage, how did you end up hooking up with In the Red?

FRANKIE: That's a crazy story. We originally agreed to put out 500 cop-ies of our record out on Mauled By Tigers, this really small punk label. This guy started writing us, via the internet.

Record nerd?

FRANKIE: A record nerd. He was a manager of a record store and asked us to bring the record by, and told us we were really great. I was like, "Who is this guy?" He said to definitely bring by a CD-R of the album. We did, and it turned out he was the A&R guy for In the Red. Larry Hardy, from In the Red, heard it, liked it, and really wanted to have it, so he worked out a deal with Mauled By Tigers, and it was as simple as that. He's been really amazing to us for some reason.

How long after you released your record was that?

CASSIE: Before it even came out . . . It's funny, because we agreed to do it on Mauled By Tigers originally because we didn't think anything big would happen with it, and it was kind of like, "Oh, here's a record label, our friends run it, they'll put out our record! Sweet!" But then In the Red was interested in it and we were like, "Oh my god, this is too crazy!"

FRANKIE: And the company we're in, to me, is like unbelievable. Some of my favorite bands are on the label so it's really cool.

Have you seen how much your record is going for on eBay?

FRANKIE: No comment. It's crazy.

CASSIE: The craziest thing to me is our 7-inch, "Wild Eyes" on clear

vinyl, sold for $50. [*To Frankie*] Did you see that?

FRANKIE: Yeah, it's insane.

CASSIE: It's insane.

FRANKIE: Why?

CASSIE: Yeah, why?

FRANKIE: Together, we ask, "Why?"

CASSIE: Because it's on clear? That's still readily available.

FRANKIE: You could send me the fifty dollars and I'll track one down for you. And sign it. Seriously. No, actually, don't do that. It's crazy.

It's record nerds.

FRANKIE: It's pretty weird. I guess people really want what they want, and if they have money . . . alright.

When are the reissues coming?

CASSIE: I think maybe September? Or October? Hopefully.

And you're headed back out on tour? Soon, right?

CASSIE: We're going to go out to Chicago and back. That's like a two week tour. And I think we're going to tour around Gonerfest as well. [*To Frankie*] You're touring with your other band, Crystal Stilts, right?

FRANKIE: Yeah, this next tour is Crystal Stilts and Vivian Girls. It's gonna be crazy.

Any crazy awesome tour stories? Three girls touring together... there's gotta be something from the last one.

FRANKIE: We like to keep it pretty mellow. I do, anyways. I go to sleep really early. I pretty much play, and it's like, "Alright! Good night!"

CASSIE: When we were in LA, Frankie was hanging out with her mom, so me and Katy were hanging out with our friend Vanessa, and we just drove around and had a really fun time. We drove past this fire hydrant that had exploded so it was just this gigantic spray that was shooting up like fifty feet in the air, like a mega-fountain, and the entire street was just flooded with water. That was really cool. Then we went to the Hollywood Walk of Fame and drew around our feet in sharpies and signed our names. What else happened?

FRANKIE: It rained every day on tour. Every day except for maybe five. We did no swimming, no summer fun activities.

CASSIE: Oh, we did go swimming in that hotel. We had a day off between Seattle and Missoula and thought, "Well, we might as well treat ourselves to one nice hotel on this tour."

FRANKIE: I think I finally understand why, I mean, why eventually, bands end up with a tour bus or something. We didn't really have time to do any summer fun things because we were driving most of the time. We did the whole country in five weeks. If we would have done it a little

bit longer we could have stopped more—and in a tour bus, they drive all night. That probably isn't an option for us at this point.

Were you worn out by the time you finally got back?

FRANKIE: It wasn't as hard as I thought it was going to be. I think we all did a good job of psyching ourselves up for it, and before I knew it, it was pretty much over. The Midwest was a little rough. On the way back, the last week—long drives to Provo, Utah.

CASSIE: Playing to a bunch of Mormons.

Any specific shows stand out?

FRANKIE: The West Coast was really amazing. I'm from there, so it was just great.

CASSIE: My favorite shows were in places where I kind of thought nothing would be there. For example, Las Cruces, New Mexico; Colorado; Provo, Utah; Jackson, Mississippi. Those shows were all really fun because the kids are so psyched on shows because bands don't come through there too often. So many rad kids—so open, down to earth.

FRANKIE: Because of the Internet, people know exactly what is going on everywhere else.

CASSIE: At one of our shows this guy came up to us and told us his coworker totally brought us up at the water cooler, like: "Have you heard this band Vivian Girls?"

FRANKIE: Like, at the office?

CASSIE: Yeah, at the water cooler.

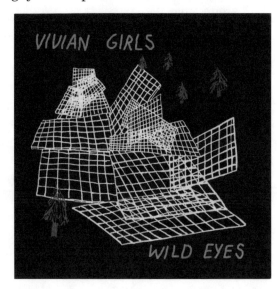

That means you've officially made it.

FRANKIE: Water-cooler hype!

CASSIE: Yeah, and then at Chicago, this dude brought us a CD and told us his dad had made it for us. So cool. This guy's dad really likes us. He made us this CD and it was just The Shaggs' *Philosophy of the World*.

FRANKIE: The whole CD—it was just the Shaggs?

CASSIE: Me and Katy did this crazy drive home from Chicago overnight after that show, because Frankie flew. And it was, like, nine in the morning and I decided to put on the CD and it was just the Shaggs. I was feeling crazy and trying to drive and with that playing it was just making

me feel even crazier.

Wait, was his dad even there? He just sent this CD with his son?

FRANKIE: I bet his dad was just some old garage dude who keeps up on In the Red or something.

Have you psyched yourself up for this next tour?

FRANKIE: I'm terrified, just because I have so much more work ahead of me.

Two sets.

FRANKIE: It's kind of funny, because a lot of bands, bigger bands, people want to see them play for an hour. So I'm just trying to be like, "Okay, yeah, you can do this." Forty minutes… fifty minutes. It'll be fine. We're playing with really awesome, amazing bands this tour. People I look up to a lot.

Any plans on doing a new record?

FRANKIE: Oh yeah!

CASSIE: Eventually. We're slowly working on writing songs for it now, but it's probably not going to be out in, like, over a year.

What was that song you played first at your show two nights ago?

FRANKIE: That was this song by a band called Daisy Chain, this psych group from the sixties that's super cool. It's one of their better songs; that's going to be the B-side of the new single.

I want to hear about Brooklyn—you definitely have a nice little thing happening out here.

CASSIE: It's the best place in the world.

FRANKIE: Yeah, we've got it on lockdown, pretty much.

It's nuts. Between Crystal Stilts, Vivian Girls, Cause Co-Motion!, The Pains of Being Pure at Heart…

FRANKIE: I love all my friends. I love going to their shows. I don't know where all this other stuff is coming from, honestly. We've all just been going to each other's shows forever. Now people have started to notice, or something. Maybe we've all just been motivating each other more?

I think that might actually be it for me and questions.

FRANKIE: Oh, come on, ask us anything!

Fine. Favorite pizza?

CASSIE: Domino's!

Ugh, really?!

CASSIE: I'm weird.

FRANKIE: I don't know. I could give you my favorite kind of pizza. It would be thin crust, pineapple, and jalapeños.

CASSIE: Huh. I've never had that, but it sounds really good. ◐

THE HANGOVER

by James Greer

SIDE ONE

1. Calling out in transit (4:05)

1983: Sam Anonymous had a drinking problem.

* * * * * * * * * *

Brown vinyl of sofa peeled with sticking sound from humid flesh of back and legs as he sat up. Pattern of raised swirls on the vinyl were reproduced on skin: corresponding incarnadine impressions.

2. Your hate, clipped and distant (4:30)

Low whistle of kettle rose in pitch and volume to a piercing shriek that unmoored the murmur of Sam's thoughts. From a tin of instant coffee he spooned a quantity of dark powder. Hands shook slightly as he struggled to fill the cup with sour-smelling coffee. Scratched idly at corner of one sleep-swollen eye: steadied himself against the counter. A ribbon of water lined the front edge of sink where he had sloppily rinsed the mug. When he pressed against the counter Sam felt water seep into the waistband of his boxers.

3. Martyred, misconstrued (3:58)

Her name was Violet McKnight. Five foot two in bare feet. Short hair dyed unnatural red, swept back from lunar face: cranberry strands fell in her

eyes when she made an emphatic gesture. Nose was small, well-formed, eyes color of root beer, narrowed to skeptical slits when challenged.

⋆　⋆　⋆　⋆　⋆　⋆　⋆　⋆　⋆　⋆

Spitting toothpaste into sink Sam noticed with equanimity that the spent paste was streaked with blood from his gums.

4. Not everyone can carry the weight of the world (3:24)

He was twenty-nine years old. In February he would be thirty.

5. Inside the moral kiosk (3:32)

Wave of nausea broke and receded. Sam hunched forward on the couch. Palpating his cheeks: annoyed by growth of stubble. Counting backwards could only manage four days before the fog of elapsed time refused to lift.

6. Shoulders high in the room (3:30)

Weaving unsteadily down the street, he saw her outlined against the black glass of her bedroom window, body limned by a nimbus of yellow streetlight. Later, from the safety of his sofa, Sam feverishly amplified the contours of her adumbrated form until he had produced a solid image: prototype for any number of shabby fantasies.

SIDE TWO

1. Did we miss anything? (3:55)

Sam yawned, stretched his arms, stood and heavily walked across the room to turn over record. Returning to couch: revisited by a coil of earlier nausea unwinding in his gut and feathering upwards. Unsnapped the cap from plastic bottle on the table next to alarm clock, shook two aspirin into his hand, placed with thumb and forefinger carefully in back of mouth, swallowed with effortful gulp.

⋆　⋆　⋆　⋆　⋆　⋆　⋆　⋆　⋆　⋆

What use is experience without memory?

2. We could gather: throw a fit (3:18)

One thing at a time: watching Violet bend towards him by light of a guttering candle.

3. All nine yards (3:05)

Scratched his hair in imitation of cerebral effort. Hoisted himself off the couch and began sorting through pile of clothes on ugly square of brown-and-white carpet.

Love is a crazy and unkempt thing that grows like a wild weed in the heart. It will suffer the cruelest attempts at eradication with quiet strength, and will take root and prosper in even the stoniest soil. True love, like true art, admits no moral influence. Had he read that or was it original?

4. Shaking through: opportune (4:30)

In a fit of frustration ripped the front buttons and stripped off the shirt: but left hand tangled in the cuff: which he had abstractly buttoned moments earlier: and pull as he would: flap as he might: shirt refused to let go. Sat down on the couch and put head in hands, tattered shirt trailing to the floor like captured flag of some defeated army.

5. Up the stairs to the landing (3:01)

World adheres to stringent rules of form and content: these rules, Sam knew from prolonged contact with books and the people who read them, were not frangible. Just as a story must have beginning, middle and end, so a soul must have body to inhabit. Proliferation of the soul's forms would mean rewriting rules of human contact.

6. Long gone (3:17)

Wind picked up, smell of rain. Sam buttoned his overcoat with reddened fingers. The tips of a succession of telephone poles flecked the night sky on the far side of the broad avenue; up the side of one of these scrambled two squirrels.

Black tracery of oak limbs: russet and orange and mustardy leaves: cold rain-scented air: combined to form an impression of remote beauty that reinforced and focused his sense of longing.

Past a red brick house, windows ardent with citrine light. Fragrant gray smoke curled from its soot-dark chimney: leaves of a silver poplar fluttered in the night air, undersides flashing white like a flock of luminous moths.

Fine rain needled his face but he did not mind the wet because in his heart he carried a word —finally!. He held the word before him like a lighted candle to ward off the rain, and the cold, and the black despair of night as he walked towards Violet's house. **O**

FOLK PHOTOGRAPHY

by Luc Sante

The postcard craze that blew through the Western world in the first two decades of the twentieth century happened to coincide with a great democratic proliferation of photography in the United States, thanks to simplified processes and lowered costs. The result was the real-photo postcard, so called because it was printed in the darkroom, in editions usually of a hundred or fewer, as distinguished from the mass-produced photolitho. The real-photo card was typically a product of the small town, particularly the small town isolated on the plains, whose newspaper did not have the capacity to publish photographs, and whose lonely citizens felt an urgent need to communicate with distant friends, who in those days were distant even if they lived only three stops down the railroad line.

The phenomenon began in 1905, when the postal service inaugurated a special rate for postcards (in those days a penny), and began to decline in the late 'teens, when the postcard craze slumped as a result of the war (Germany had the best litho printers and supplied the best inks), although real-photo cards continued to be produced, here and there, as late as the 1930s. There is no way of knowing or even estimating how many different cards were made during that time. A card might have had an edition of one, after all, and that one might have been destroyed years ago. Cards were made by amateurs as well as professionals; many cards are unsigned, and some give no indication of their geographical origin.

The cards document very nearly the whole of their time and place, from the most intimate matters to events that qualified as news. They show people from every station of life, engaging in the panorama of

62

Aftermath of plane crash; near Hillsdale, Michigan, 1912; photograph by A. E. Crawford

human activities—eating, sleeping, labor, worship, animal husbandry, amateur theatrics, barn raising, spirit rapping, dissolution, riot, disaster, death. They can be sophisticated or crude, vivid or dull, beautiful by design or by accident. Their makers could not have seen very many photographs: studio portraits, Civil War scenes in reproduction, the odd train wreck or blizzard documented in the 1880s or '90s. In any case the aesthetic is plain, foursquare, inclusive, unadorned. The result is that the cards often look more modern than the work of their self-consciously artistic contemporaries.

For their makers and their viewers alike, this might as well have been the birth of photography. They had been given Adam's task: everything in the world now could be photographed, which meant that it had to be. This great license and great responsibility mobilized them, an army of artists. In a process not unlike the flowering of the blues, which was taking place simultaneously, they made the most of their localized reach and intermittent communication with the larger world to treat all ideas as common property. In place of conventions they had memories, and perhaps they were aware that they were adding to the stock of memory. If these artists appear as one giant collective entity, then maybe their work is, likewise, a single, massive, patchwork-quilt enterprise, a self-portrait of the American nation.

Crossroads grocery store; location and date unknown; photographer unknown

Fourth Street at night; Pasco, Washington, 1912; photographer unknown

Main Street; Harman, West Virginia, 1909; photographer unknown

Revival meeting; Toulon, Illinois, 1908; photograph by K. E. White

Arcade photograph; location and date unknown; photographer unknown

Fireworks; Alta, Iowa, 1913, photographer unknown

Wand pageant; Zion City, Louisiana [?], 1915 [?]; photographer unknown

Shoeshine stand; location and date unknown; photographer unknown

Play rehearsal; Peru State College, Peru, Nebraska, date unknown; photographer unknown

Movie theater; location and date unknown; photographer unknown

Fire; Baker, Montana, 1915; photograph by Booen

Rough and Ready Cornet Band; Leck Kill, Pennsylvania, date unknown; photographer unknown

THE GAUZE OF EFFECT

Sic Alps & Eat Skull interviewed by
record dudes, and then by each other

by Doug Elliott, Mike McGonigal,
Kevin Elliott, Matt Hartman & Rod Meyer

Sic Alps and Eat Skull are two of YETI's favorite bands. That's not meant as
any kind of radical statement; they're two of everyone we know's favorite
bands right now. We asked them to interview each other. Thankfully and to
our surprise, they agreed. Both groups are based on the West Coast and
have recently released awesome records on the Siltbreeze label—*U.S. EZ*
and *Sick to Death,* respectively. Members of both bands were in the Bay
Area–based Hospitals at one point, and they discuss that as well as the little
genre tags writers try to pigeonhole them with. We're a bit late to a party
already in progress here. So we decided to buffet their co-interview with
some other chats directly with the band members—Matt from Sic Alps and
Rob from Eat Skull—rather than try to pretend that we're super experts
who've been into them since before they even recorded, since before their
respective backlashes got started.

PT. 1: MATT FROM SIC ALPS
INTERVIEWED BY KEVIN ELLIOTT, JULY 2008

Over the last year you've put out a glut of material; it seems like you al-
ways have a well of music to dip from. So how then do you decide what goes
on which release or which songs you give to certain labels, for instance,
giving the songs for U.S. EZ to Siltbreeze?

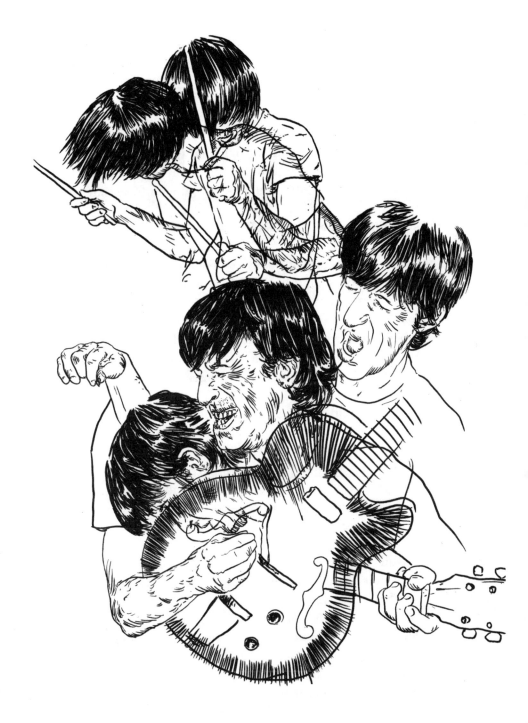

SIC ALPS

MATT HARTMAN: A lot of it is happenstance. The way it boiled out is we got a lot of recording equipment—or actually borrowed some recording equipment—to do the first 12-inch. We were basically sitting on the *Pleasures and Treasures* album, which is the only thing I didn't play on, though I helped finish it. I was trying to shop that around to people that I thought might want to put it out, or might have been able to put it out. One of the first guys I approached was Mark at Omnibus. He told me they weren't doing Omnibus, but he was doing a label with hyper-limited vinyl. And that really wasn't what we wanted to do since it was a full-length and we wanted to keep it in press. So we said how about we record a four-song EP? And he was cool with it, so that's how that started.

Then Gary from Animal Disguise, who knew Mike from the Folding label, asked if he could do a tape for us. So it was like, bam, four more songs. That's how that began. Basically someone would contact us and say, "I would like to do something." And we would say, "Sure." Same thing with Skulltones—they just wrote us, we looked on their website and it was something we were into, so we decided to do two more songs for them. To be honest, we are really like short-order cooks serving up songs for people coming to the restaurant. It's made to order.

And the Siltbreeze record? Was that made to order or something you had already done?

MATT: Well, the original plan was to do a double-album for Animal Disguise, and we had been working on songs with that in mind, trying to just get a group of songs together. This, that and the other happened, and it ended up being a single LP for Siltbreeze. But we knew that by the time we finished it. It was almost a protracted experience because all of a sudden we weren't just short-order—we were creating more of a banquet of songs. And that put a little more weight on it somehow, at least in our minds. So we actually started revisiting some stuff, like we re-did "Gelly Roll Gum Drop." The song was so old; we knew something was not right with it. It was challenging. And now we are kind of wondering if for a little while we are going to go back to our original modus operandi of being label sluts: a hooker, short-order cook.

You guys have both been in a number of vastly different bands over the years, especially Matt. Can you think of anything specifically from those bands that you've learned and filtered into Sic Alps (for better or worse)?

MATT: As far as what the old bands brought to us, it is more of a mechanical influence. Playing in the Coachwhips, I realized that it's a really good idea to be self-contained. And I know John (Dwyer) borrowed that from Providence and Lightning Bolt. For this band, when we start-

ed playing, I knew we had to figure out a way to control the vocals and make sure we can fuck shit up when we want to—if we want to or not. That idea of being able to present the show the way you want it no matter what, bypass the sound guy who has no idea what you mean when you ask to put some reverb on the vocals. You know, "Can we get some reverb on the vocals?" and you get some fucking Ted Nugent arena reverb. There's no time to have that dialogue with a complete stranger. You're sort of always at the mercy of someone interpreting how they think your band should sound, when nine times out of ten they've never even heard of you. You can travel with a sound man, but you can't do that until you're playing 3,000-seat venues anyways. For me it's always been important to keep it at a DIY level, and if necessary be able to play at a parking lot as long as you can find an AC outlet—always be able to keep it that packaged and presentable. I need that control. So you know, maybe eventually we'll get that third member, and it will be a sound engineer.

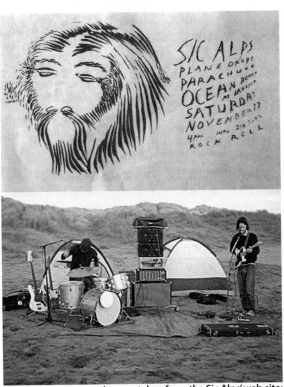

Images taken from the Sic Alps' web site; more at www.sicalps.com/look.html

And sonically? Was it an aesthetic choice to bring in loads of reverb, distortion and feedback to the recording process? That gauze of effect never seems to get in the way, or hide the core of the songs. Do you find yourselves editing through the mixes to achieve that balance or are most of the records a fairly accurate document of what's going on in the room?

MATT: It depends on the project. The "Strawberry Guillotine" 7-inch we did for Woodsist, we did in a day and a half. It was one of those things where you just go with your gut and we were already set on the way it should sound. A lot of times the way it works is that Mike will bring a song in an acoustic form, or sometimes maybe a rough demo. That will

trigger some sort of idea in me. To me "Strawberry Guillotine" just sounded like it needed a wall of hissy feedback the whole time.

So everything more or less gets pieced together by the end?

MATT: The recording process kind of lends itself to that. We only have one microphone and a really small, crappily built subdivision of my garage to record in. So it's often like lay the guitar down, maybe an electric guitar, and get the vocal. Then we keep adding, keep putting a dress on it. Sometimes you get it, though, right off the bat.

Then how did you arrive at the mood for U.S. EZ? *There's less obstruction of the melodies and it's more of a mellow vibe than anything you've done in the past.*

MATT: It's not my life's mission to purposefully obscure a good song with a bunch of noise and crappy production. That sounds cool some-times—and we'll do that sometimes—but I always try to stay sensitive to what's appropriate for the song. So a song like "Massive Place"—that opens the record and had to be an ass-kicker. The riff calls for it. But sometimes the way to make it ass-kicking is to leash it in weird ways. Live, it's much more crushing on the drums. On the record, though, it's a really loud sounding drum that's really far away in order to make the bassline totally dominate. Shit just happens. You drink half a bottle of scotch while you're working on a record and suddenly you're lucky and it sounds cool. By the end of the day you're listening back to the tracks and you're either nodding your head, grooving out and giving yourself a pat on the back or you're just bummed and you go, "Fuck it, let's try something different."

I just thought of this now, but maybe it's more important to keep the light on the subject really focused and let the subject be fucked up as opposed to playing really normal and then fucking the production up so bad that then it sounds weird. It's a more interesting challenge to have a crystal clear recording, and I think *U.S. EZ* is relatively our most hi-fi production given the fact that we record on a 1980 eight-track tape machine. We're as hi-fi as we can get with that machine. Whether I would get much more hi-fi than that I don't know. That's where I really start to get uncomfortable.

You're in Columbus, so this has to be asked. Lately it's been easy for jour-nalists to herd you guys under the same umbrella inhabited by Psychedelic Horseshit, Times New Viking, No Age, Eat Skull, simply for your adherence to alternate fidelities. Do you think this is a fair assessment of what you're doing?

MATT: It's lazy journalism. I've always been a "let it be" kind of guy. My credo has been that I'm going make the music I want to make and

have it sound how I want it to sound. And if people don't like it, it's out of my hands. Once the record gets released, I can't do anything about it. What is curious to me, though, just having read the review of the record in the Columbus paper, it made it sound like it was a lot more distorted, fucked-up and blown out than it actually is. People who read that and buy the record solely based on that review are going to be disappointed. They're going to get the record home and it's going to sound like a Charlie Daniels record. I know all of this is because we are on Siltbreeze, but all those bands have been doing their thing since before they heard us, and we've been doing our thing long before we heard of them. It's funny because I love those bands. I listen to those bands and all the things they do, but it's so much more lo-fi than what we do. That's neither here nor there. It's kind of ironic, though, that we made our most high-fidelity record for Siltbreeze.

PT. 2: ROB FROM EAT SKULL
INTERVIEWED BY DOUG ELLIOTT, JUNE 2008

Did you have a specific idea of what you wanted the band to sound like or was it a more of a progression?

ROB ENBOM: We wanted to start two bands and write tons of songs and record ourselves. One would be a sick California-style hardcore band and the other was going to be a sick California pop band. We knew the hardcore band was going to be called Eat Skull, but we couldn't figure out what the other was called so it turned into one band. More than anything we're trying to make a classic California band while exiled from California in a green hell.

Did what was going on in Columbus at the time affect your approach to songwriting or the band's sound? Was forming Eat Skull in any way reactionary to the scene in the Midwest?

ROB: I do enjoy the Midwest's whiskey-and-wings vibe, but it doesn't specifically have much to do with what we're doing. A couple of songs we play were written when I lived there, but I think they were looking forward to this time here more than being of that time and place. What we do is more about the sun being missing from our lives right now. The songs and sound come about naturally and very quickly from drinking a lot of beer and walking around here in Portland. Rod and I grew up on punk and acid in California. That's where the roots are.

Was it the band's intention to introduce a more hardcore approach (or at least a hardcore influence) into the lo-fi pop sound?

ROB: Hardcore factored in because it makes sense when you are going

crazy. It's also probably mine and Rod's first real musical love. A good hardcore song is just as infectious as anything else. A good hardcore song is an undeniable assault. That kind of energy makes sense to us.

I hear the song "No Intelligence" has an interesting back story to it, something about a disastrous trip up to Seattle. Care to discuss the relationship between Portland and Seattle, or your opinion of Seattle?

ROB: Seattle is a stupid place full of idiots. Every time I've ever played there there has been some kind of psychodrama. It's a place full of rich brats who think they are activists and are obsessed with the WTO riots and nitpicking. Either that or drug addicts. We drove up there last summer to play a show and immediately the shit began to fly. It was absolutely ridiculous and all sorts of these Seattle people should be ashamed of themselves.

With the new album, I think it was Scott who told me it was intended to have two distinct sides, the first half more "difficult" and the second more "pop." Was this just an easy way to break up the different types of songs you guys have? It seems like the singles are split up that way as well.

ROB: The idea was to have a "sick" side and a "death" side, like the tape *94 Mobstas* by C.I.N. (a gangster rap group from Richmond, California). I used to listen to them back in Cali around that time with my dumb friends. C.I.N. loved MGD, but I'm more of a High Life kind of guy. That's where the name of the album came from. But really it was more about making the songs flow in a way that made sense. We picked 14 out of about 25 songs and figured out where they went. We didn't really argue about it much, they just sort of popped into place. I think it's the sort of album where side one doesn't really hit you right until you flip it back after side two. I like records like that.

One of the greatest things about Sick To Death *is the lyrical content. You seem to tap into a very youthful dialect: confusion, "Punk Trips," licking spiders. Where does it all come from? Do the lyrics come before or after the music?*

ROB: Thanks Doug. Usually the song title comes first. There is no separation between the lyrics and day-to-day life here in Portland. The lyrics describe or predict what is already happening. Sometimes they come before and sometimes they come after the music. They always eventually feel predetermined and make more sense than I think they do at first. My uncle told me that Willie Nelson said that when he needed a song he pulled one out of the air above his head. It's kind of like that, but less evolved probably.

Do you all agree on the music in the van? What are some albums and songs Eat Skull love that most wouldn't expect?

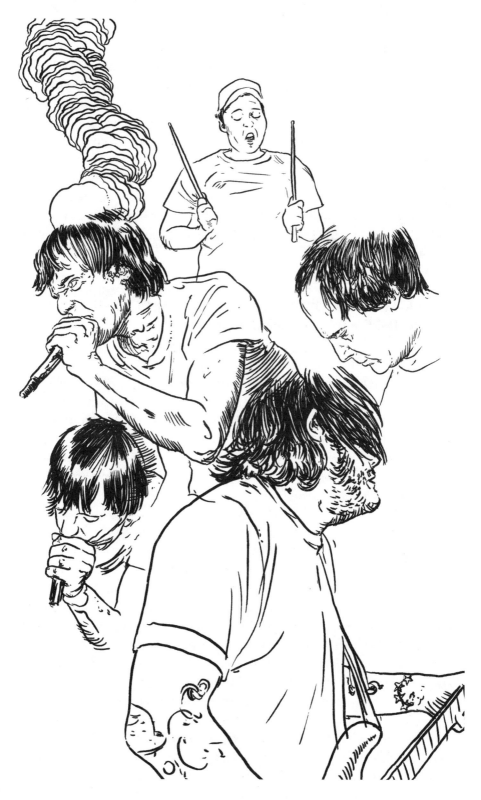

EAT SKULL

ROB: Scott puts on shit like Sun City Girls or Blue Cheer. He's a record collector and has an iPod. I prefer Rupert Holmes' "Pina Colada Song" for roadtrips. I think we all fucking love Buckingham-era Fleetwood Mac (except maybe Scott). I love all his solo albums too. None of that Peter Green shit though. The blues suck. The stereo is broken actually, so I guess we can agree on conversation. I don't know what music people wouldn't expect. I guess people might find it weird that for most of the winter, when we were writing the tunes that ended up being on the LP, all I really listened to in my room was DRI's first stuff and TSOL's *Dance With Me.* People might expect that another big one is Guided by Voices' *Same Place the Fly Got Smashed.* I have, however, never listened to the Axemen.

PT. 3: MATT FROM SIC ALPS VS. ROD FROM EAT SKULL!, E-MAIL THROWDOWN AUGUST 2008

August 4th 2008

MATTHEW HARTMAN: I thought we'd start with a brief semi-off topic in [the band] the Hospitals—given that this thread actually runs through both Sic Alps and Eat Skull in varying ways. Adam Stonehouse as founding member of Sic Alps and two thirds of Eat Skull appearing on their new LP *Hairdryer Peace.* Also, Rod is a founding member (yes?) of that band and appears on the debut 7-inch and LP. Any thoughts on how that new record turned out?

August 5th

ROD MEYER: Hi Matt, alright I finally have a few questions for you. I should start by saying I'm not the most familiar with your music, although I'm listening to *U.S. EZ* right now (Good Job!) and I'll start by answering your first question. Yeah, I play on the first Hospitals single and first album, then I quit playing music for a couple of years. I met Rob about 2 years ago when we did a Hospitals tour of the West Coast and then Europe. He hung out in Portland when we got back and we started coming up with some songs and that's how Eat Skull happened. The new Hospitals record sounds great. Total weed/head record, a lot of work went into it and stress (lost tapes, transferring things from various unmarked cassettes, tape machine breaking, etc.) but in the end I think it came out awesome. I actually wasn't aware that Adam was a founding member of Sic Alps! Actually listening to some of your recordings I can hear a little of that. How much of an influence did he

have on your recording style, if any? Who records your music? How did the Siltbreeze thing come about? What is your opinion on the phenomena of the 50+ dollar eBay single thing that seems to be going on right now; do you think people have lost their minds?

August 5th

MATTHEW: Yeah, initially Sic Alps (from what I remember—oh it was so many beers ago) was a sort of concept project that Mike and Adam started shortly after a brief "Best Summer Ever" tour of the West Coast with John Dwyer-era Hospitals and a band Mike was playing drums in at the time called Big Techno Werewolves. It was more a recording project, though a few Bay Area gigs were played as well as an ill-fated brief US tour that coincided with the "I Am Grass" split 7-inch with California Lightning.

Anyway, shit happens, and then I got involved (almost 3 years ago). Mike and I finished up the *Pleasures and Treasures* record—which was mainly just a few more overdubs and mixes and then putting together a sequence—and then promptly got to work belching out those short run EPs and 7-inches for just about anyone that would ask. But enough with the history lesson . . .

As for recording, the *Pleasures and Treasures* album was recorded on a desk that Adam owned, and so in order to finish that puppy up we borrowed that for awhile. We also got to working on new stuff using that desk, so when Adam came calling needing it back to get back to work on Hospitals stuff we just went on a long search for the same gear— resulting in the purchase of not just one, but two desks. They also happened to be the same model

The Hospitals' Adam Stonehouse, from the Sic Alps' site

desk I'd worked on in one of my previous bands, Henry's Dress. I don't know if there's much influence there really as opposed to a coincidental comfort in using analogue 8-track. This gear definitely takes to super blown out signal (see Hospitals) and is good for creating some musical distortion etc. But it's also really adept at relatively hi-fi recording. I think with Sic Alps we've really enjoyed exploring both. Some of what we do is really blown out, but more recently with *Description of the*

Harbor and *U.S. EZ* we tried to approach it with more of a "hi-fidelity mind". Anyway, we record here at my house in the garage using this "magik" board, one microphone, one tube preamp, one reverb, and one delay/echo pedal. One track at a time.

I'm a little unclear just exactly how the Siltbreeze thing happened. Although it may have its genesis in a show we played with Times New Viking in Oakland. Tom (Siltbreeze's owner/operator) came out for those shows and I think we met then. Maybe gave him a 7-inch or something. Then when we went out to Philly we hung out and decided to do a record together. Awesome guy.

The 50-dollar eBay single—it's a bummer and it's exciting all at once. The one thing I *don't* like is the emergence of the eBay speculator, whose scumbaggery is equal to that of any toe-head working on fucking Wall Street sucking the cock of Satan's Capitalism for a buck. Fuck them. Anybody buying up multiple copies of a limited release for the sole purpose of profiting off of it like a ticket scalper can blow me.

But it's interesting to see the renewed interest of vinyl as a fetishized object as the prevalence of downloaded digital grows. The paradigm seems be shifting so quickly. The only reason we went with such limited runs of records is because at the time no one knew who the fuck we were. We felt lucky to unload 500 copies of a record. To some extent I think it's the pendulum shift, albeit in this day and age it seems to shift more violently than ever. I remember as the mid '90s turned into the late '90s it seemed every Tom, Dick, and Harry had a 7-inch out—a real glut happened and vinyl seemed to completely lose its merit. The 7-inch became the demo-tape and so on. Anyway, I wanna keep the music in print and available so long as there are people out there that want "the object" as opposed to the iTune. To that end, we did the *Long Way* compilation.

August 5th

MATTHEW: A couple more questions. As for the Eat Skull aesthetic, you guys seem to be deeply rooted in the tradition of what could almost be described as "no-fi." I know for me there's a musicality that exists in poor fidelity. What drives you guys to do things this way? Economics? Ease of production? In my mind it's almost a political decision, a conscious effort to stay in the margins where inevitably you connect with like-minded people who understand that music is an art form and very personal expression as opposed to the nice clean mechanical robot sound of Pro Tools and Auto-Tune voice correction and all this soulless dribble that comes out of the mainstream. At the same time, I've

heard the argument that poor fidelity is just a ruse to hide a lack of ability and/ or talent. Any thoughts/comments?

August 6th

ROD: [*In response to eBay question*] Yeah, we just re-pressed our second single and have plans to reissue the first one. It's been cool having them at shows and letting people who want to hear the music have them first, while keeping an eye out for the weird sweaty guys buying up six copies at a time. The "no-fi" or "lo-fi" thing is only partially intentional.

August 7th

ROD: Hey Matt, weird—I think I sent you an unfinished email. Anyway, the "lo-fi" thing isn't really intentional, although a lot of the music I have always liked has had that aesthetic, we actually use the same board (Tascam 388) as well; did you know that "Sweet Dreams" by the Eurythmics was done on that? A lot of our songs were done on 4-track or boombox and then transferred, monitoring back through shitty cheapo home stereo speakers that had no low end hence the wall of trebly static. A lot has to do with having no money to afford halfway decent shit, although we just got some decent monitors so our next record will sound like fuckin' Radiohead in comparison. We're aiming for a much clearer thing with the new songs, but I can't see us changing our sound too much, compressed Pro Tools music sucks and makes me feel bad.

August 10th

MATTHEW: {I was at 88 Boadrum} Cool. Well, do you think that's enough??? It's hard to do this via email huh? I'm sure there's other things we could "talk" about but I'm so preoccupied with shit right now that it's hard for me to hang onto the thread.

August 11th

ROD: Hey Matt, I think that might be enough, yeah it's hard to do this email interviewing thing, been pretty busy these last few weeks. One question I wanted to ask that should have started the interview was influences. I hear a pretty big '60s pop thing going on in your music, what are you into? Last question: Coldies?

August 12th

MATTHEW: Oh yeah, definitely. I think between Mike and I we have a shit-ton of '60s influences that pile in with all the other stuff we dig. I

mean, even really basic "classic" stuff like the Beatles, Kinks, the Who, the Zombies—real pop song craftsmanship is big in our book for sure. Plus some of the hazier psych damage and experimentation. Syd Barrett is a big one. Soft Machine. Hendrix. It's funny because I think we really take from our whole of music experience, and at our age that's a lot of music absorbed. '50s, '60s, '70s, '80s, '90s, '00s. Jazz, rock, country, noise. Anything that was ever done with heart and soul, and not just some flavor of the week nonsense—although we came really close to once covering a top forty Fleetwood Mac hit from the '80s. Christ, the list is really endless.

Coldies? Is this some slang that I missed? Just today there were some thuggish kids standing outside my neighborhood liquor store asking me if I would buy "Black Hand" or something like that. I literally had no idea what they were talking about. I guess it was some kind of tobacco or cigar or who knows, but whatever it was they were too young to buy it. When I told them I didn't know what they were talking about, one of them chimed, "What the fuck, man? Don't you speak English?"

PT. 4: A VERY BRIEF CHAT WITH ROB FROM EAT SKULL, AUGUST 2008

How did you wind up in Portland—and why did you stay? For the freak-folk scene?
ROB: I needed somewhere to go, and had friends here. And more seemed to be moving here for a while.
Rob already explained how you both started to work together in his talk with Matthew—but how did you meet up with Beren?
ROB: We needed a drummer and put up a Craigslist ad talking about Moe Tucker, Raincoats—things like that. It was cool because she was the only one to respond, and she's great!
...And Scott?
ROB: None of us really remember; we already knew him but didn't find out he had a bass and a practice space for a while. Somehow we got that going... probably out playing shuffleboard with Mark and Parker who are the synth/percussion duo 'Eye Myths' - I slept behind their couch at the time.
How did you guys come to record the way you do?
ROB: It was what we had to work with and what we already knew how to use. We started with a 4-track that Rod had and we did the first five songs as soon as we worked them out because it was sounding good and we wanted to put out a record right away. Later we got an 8-track

that was the same model as the one that Adam uses for the Hospitals, because it was familiar to us and we already mostly knew how to use it. Most of *Sick to Death* was recorded and mixed in a pretty grim atmosphere and it probably sounds the way it does partially because of that atmosphere and partially because we didn't have good monitors to listen to.

What do you like best about being in this band?

ROB: It is personally rewarding and I enjoy playing in a band with my friends.

...The least?

ROB: It limits the possibilities for your time.

Are you happy with your work on the new Hospitals LP? What was being in that band like?

ROB: I like my contributions; they added the element that I always had in mind for the band from when I first joined back when Ned was in it. Being in the Hospitals was psychological but fun.

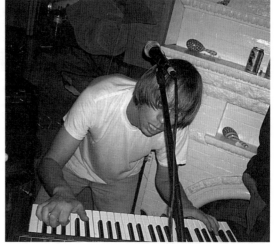

Rob Enbom. Photo, Emily Rose

Is the Hole Class tape going to be released as an LP? I thought I'd heard that somewhere. What do you think of that stuff?

ROB: We've been planning it. We have to finish one more song for it. I think it's great stuff.

What does your family think about your music? Are they supportive?

ROB: They didn't like it at first but as we all get older they are cool about it.

When/ how do lyrics come into play in your songwriting 'process'?

ROB: I like it when songs mean something or when they mean a bunch of things.

What is the last song that you listened to over and over again (on purpose)?

ROB: Code of Honor, "Attempted Control"

What is your idea of the perfect song--and why?

ROB: If you hear it at the right place and time then it's like loving a pet.

Are you a nervous person?

ROB: Should I be? ◗

WHO'S NOT WHO IN THE DOWNTOWN CROWD

or: Don't Forget About Me

by Tim Lawrence

It's becoming commonplace to note that New York City in the 1970s and the first half of the 1980s was a place of remarkable musical innovation across a range of sounds. During this period, hip hop evolved in the boroughs and then made inroads into the city; punk, new wave, and no wave transformed the aesthetics and culture of rock; the jazz loft scene that unfolded in venues such as Ali's Alley consolidated the sound of free jazz; the minimalist music/new music of La Monte Young, Steve Reich, and Philip Glass, who were also based in the city, mounted a concerted challenge to the serial and post-serial music establishment; and contemporary dance culture was forged in private parties and public discotheques. I made my first trip to New York City in 1993, aged twenty-six, and had a great time. But just to think: if I had been old enough to visit twenty years earlier.

Inasmuch as they've been written about, New York's music scenes of the 1970s and 1980s have for the most part been characterized as being segmented, with punk, disco, orchestral music, and so on unfolding in discreet isolation. But during the last couple of years more attention has been paid to the actual location in which these sounds have developed — that location being downtown New York. Exploring downtown as a territory in which music was developed between as well as within a series of aesthetically inventive scenes, Bernard Gendron detailed

the rock-compositional exchange that took place between some of the key players at the Kitchen and the Mudd Club in *Between Montmartre and the Mudd Club*, which was published in 2002. Applying that critical analysis to the equally permeable art, literature, and theatre scenes, and inviting Gendron to contribute a chapter on music, Marvin J. Taylor edited a collection titled *The Downtown Book* in 2006. ("Rarely has there been such a condensed and diverse group of artists in one place at one time, all sharing many of the same assumptions about how to make new art," Taylor noted.) And in late 2007 Stuart Baker published another edited collection, *New York Noise*, which was organized around the photographs of Paula Court and included short essays by downtown artists and musicians such as Laurie Anderson, Glenn Branca, David Byrne, Rhys Chatham, Peter Gordon, and Ned Sublette. With Gendron working on a book-length study of downtown, interest in the location, rather than any singular sound that might have developed in downtown during the 1970s and 1980s, is on the up.

The geographical focus on downtown has been significant for at least two reasons. First, it has helped to highlight the way in which the aesthetic innovations of the 1970s and the early 1980s were connected through and maybe even enabled by social and economic conditions, and, in particular, were related to the flight of manufacturers out of what was then known as the Cast Iron District. Along with artists, sculptors, writers, filmmakers and theatre directors, composers and musicians started to move into downtown New York during the 1960s and 1970s because industry had moved out and the cost of living in these ex-industrial spaces was artificially low—and even lower in adjacent neighborhoods such as the East Village. As artists and musicians arrived, a network of galleries and performance venues began to emerge, of which the Mercer Street Arts Center, which housed alternative rock and compositional performances, was one of the most influential. Other venues opened in these loft spaces as well as cheap-to-run clubs—so the empty CBGB's took off when the building that housed the Mercer Street Arts Center collapsed, and the rock bands that had been performing there headed over to the Bowery. The concerted innovation lasted for as long as rents remained cheap, after which the artistic communities dispersed, and the creative impetus dissipated.

The analysis of downtown as a cultural location has also enabled an approach that shifts towards an appreciation of the way in which downtown New York during the 1970s and early 1980s was a space of social and creative flux that often cut across genre. During this period of downtown history, artists and musicians lived as neighbors, bumped

into each other on the streets, and started to form unlikely collabora-
tions that were often cross-generic in nature. Laurie Anderson com-
mented in *New York Noise*: "There weren't any boundaries or categories.
We all worked on each other's pieces and it didn't matter that one was
a dance-like thing and another was a sculpture-like thing . . . The defi-
nitions came later." Contributing to the same collection, the drummer
Don Christensen noted: "It seemed like the painters, filmmakers, per-
formance artists, musicians, dancers all went to the same bars, events
and concerts and socialized together." David Byrne maintained that
"awareness of what was going on outside your own field" was unusually
high. And he added: "There was, as rumored, a nice rubbing together
between disciplines during the later part of that time—borders were
definitely fuzzy, which was inspiring."

I've been drawn to these "fuzzy borders" in my own work. In my first
book, *Love Saves the Day*, I set out to write a history of what I took to
be the marginal, irretrievably different culture of disco, but during my
research I became struck by the way in which disco wasn't hermetically
sealed off, but was instead grounded in a complex range of aesthetic
and social exchanges. Situated on the same block as the Kitchen before
it reopened on Prince Street, the Loft typified the way in which pre-dis-
co dance culture between 1970 and 1974 brought together R&B, funk,
soul music, African and European imports, Latin music, and also dance-
able rock—a fusion that was called "party music" before the term disco
came into usage around 1974. In addition, the crowds that danced at
downtown dance venues such as the Loft, the Gallery, and the Paradise
Garage were resolutely mixed. (Coming out of the countercultural rain-
bow alliance of the late 1960s, David Mancuso, the influential party host
at the Loft, typified the outlook. As he told me: "Nobody was checking
your identity at the door.") And while rock became quite hostile to dis-
co during the second
half of the 1970s, in
downtown New York
this antagonism was
really directed at
the commercial mid-
town and borough
end of disco—the
disco of Studio 54
and *Saturday Night
Fever*—and not the
kind of socially and

The Paradise Garage team. Photograph by Peter Hujar. Courtesy, the Vince Aletti Collection

aesthetically progressive dance culture that was evolving in downtown venues. Rather than end with the homophobic, racist, and sexist backlash against disco that swept through the United States during 1979, *Love Saves the Day* concluded where it had opened: back in downtown New York, where the dance scene experienced a new burst of energy when the private party and post-punk scenes overlapped and took club culture in new directions.

I dug deeper into the milieu of cross-generic downtown while researching my second book, a biography of the musician Arthur Russell, an Iowan-born cellist who spent time studying orchestral and Indian classical music in San Francisco before he moved to New York City to enroll in the Manhattan School of Music in 1973. Friendly with Allen Ginsberg from his time in San Francisco, Russell moved into the poet's East Village apartment shortly after arriving in New York and soon started to hang out with the composer-musicians who were congregating downtown. Rhys Chatham was already there, Peter Gordon and Ned Sublette arrived a year or two later, and along with these and other composer-musicians, Russell helped turn the compositional scene into something that was notably open to cross-generic work. Russell was a key figure in this movement, having booked the pre-punk outfit the Modern Lovers to play at the Kitchen while he was Music Director between 1974-75, and this turned out to be a pivotal moment in the rich crossover that took place between compositional music and rock during the second half of the 1970s and beyond. Russell ended up living in the East Village until he died of complications arising from AIDS in 1992, and during his twenty-year stay he worked not only in compositional music but also folk, straight-up pop, new wave, disco, and various forms of heavily syncopated music, including hip hop. Because he didn't progress from one sound to another, but instead attempted to work with everything at the same time, Russell helped reveal the way in which downtown could function as a fluid space in which a wide range of sounds and scenes explored their possible connectivity. And because Russell didn't just engage with these sounds and scenes as if they were discreet, but instead continually looked to form connections between them, he consolidated the idea that downtown could operate as a space of hybrid interaction. The book attempts to draw out the way Russell was an exemplary but by no means isolated figure within the interacting, collaborative network of downtown New York, and is accordingly subtitled *Arthur Russell and the Downtown Music Scene, 1973-92*. Ultimately it's not really a book about him. It's about him and them, which is how he would have had it.

Even though downtown disco and the disco-friendly Russell con-

tributed to the reinvention of the way music could be made and experienced, they're not even referenced in other accounts of downtown. With Russell, it's reasonably easy to work out what's been going on. However broadranging and collaboratively minded he was, Russell was finally an individual, and a complicated, publicity-shy, awkward individual at that.

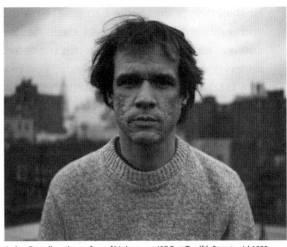

Arthur Russell on the rooftop of his home at 437 East Twelfth Street, mid-1980s.

Gendron quite reasonably notes that when he wrote his chapter on the downtown music scene, as well as the downtown section of *Between Montmartre and the Mudd Club*, he simply didn't know about Russell because Russell left so little evidence of his work. But disco ended up becoming a whole movement, and it wasn't only founded in downtown, but also developed its most socially and aesthetically progressive expression in downtown as well. Venues such as the Loft, the Gallery, Flamingo, the SoHo Place, 12 West, Reade Street, the Paradise Garage, and the Saint formed the backbone of a culture that pioneered turntablism, as well as the practice in which DJs and dancers combined in a call-and-response pattern to produce an extended and improvised musical tapestry across the course of a night. None of these downtown disco venues have been referenced in the recent flurry of books on downtown music culture, and the suspicion follows that someone like Russell has also been overlooked not simply because he was shy, but because one of his most important interventions was to explore the relationship between the downtown compositional scene and disco. Whereas the likes of Glenn Branca and Rhys Chatham have been rightly lauded as key players in the downtown scene thanks to their exploration of the crossover potential between new music and rock, the parallel investigation of new music and disco, or disco and new wave, which was one of Russell's areas of interest, has been omitted.

The elision of disco in the recent wave of books about downtown is entirely predictable, if only because this has become established practice in music criticism. In Richard Crawford's impressive *America's Musical Life*, for example, disco doesn't get a single sentence in a book that runs to nine hundred pages, and this kind of amnesia has become standard.

Responding to an article I completed recently about the pioneering DJ and remixer Walter Gibbons for the *Journal of Popular Music Studies*, an anonymous reader noted that disco is "the most understudied of all pop music genres of the recent past." The reader continued: "Punk, rock, rap, jazz, even folk, enjoy the sort of cultural capital that disco, lodged as it is at the bottom of our 'cultural escalator', has never acquired." The failure to be taken seriously can be traced to the germination of disco in downtown New York of the early 1970s, where the culture struggled to find wider acceptance because it was so explicitly ethnic.

The exclusion of people of color from the downtown music scene wasn't systematic during the 1970s, but it might as well have been. As George Lewis of the AACM (the Association for the Advancement of Creative Musicians) recounts in his book *A Power Stronger Than Itself*, musicians and composers of color found it almost impossible to establish a presence in the compositional scene, where they were pigeonholed as exponents of jazz, i.e. African-American music that should be performed in bars and clubs, and not concert venues. Struck by the way whitening of rock's downtown arteries, Lester Bangs authored an article titled "The White Noise Supremacists" for the *Village Voice* in April 1979, in which he rallied against "the racism (not to mention the sexism, which is even more pervasive and a whole other piece) on the American New Wave scene"—something he'd "been bothered about for a long time." When David Mancuso tried to open the Loft on Prince Street in SoHo—the original focal point of the downtown rock and compositional scenes—local artists joined forces with the *SoHo Weekly News* and told him where he should stick his queer nigger crowd (who were identified as a threat to rising real estate values). Very few people of color lived in SoHo and TriBeCa, although the representation was much higher in the East Village, where long-term residents (rather than recent arrivals) contributed to the unfolding of the Latin scene in venues such as the Nuyorican Poets Café and the New Rican Village. But in contrast to the Latin quarter, which was very much apart from the rest of the downtown scene, even if it has yet to earn a mention in accounts of "the downtown era," disco was also openly gay, and met additional resistance because of this. While individuals such as Jean-Michel Basquiat and Keith Haring, as well as Andy Warhol and Allen Ginsberg, were relatively easy to integrate into SoHo and its surrounds, the thousands of black gay men who were dancing at the Loft, the Gallery, the SoHo Place, Reade Street, and the Paradise Garage amounted to an altogether freakier presence.

One of the reasons why disco continues to be sidelined is because

downtown New York of the 1970s and 1980s is portrayed increasingly as a space of struggle and violence, in which musicians figured that a mix of insanity and aggression were necessary to survive. As Lydia Lunch writes of the "downtown era" in Taylor's edited collection: "Anger. Isolation. Poverty. Soul murder. The connective tissue where the cultural division of art, film, music, and literature was cauterized, creating a vast insane asylum, part Theater of Cruelty, part Grand Guignol. All Dada, all the time." Someone like Russell wouldn't have identified with Lunch's description of downtown—which she also describes as the "blood-soaked bones of New York's underbelly" that was akin to "a filthy spectre who refuses a final exorcism." And the likes of Russell, as well as the predominantly black gay pioneers of disco, might not have sided with what the art critic Carlo McCormick maintains was "a politics not of engagement but of estrangement." Open to everything except the nihilistic and the aggressive, Russell had warmed to Ned Sublette's queer cowboy song "Cowboys Are Frequently Secretly (Fond of Each Other)," yet he also objected to another song Sublette worked on at the same time with the poet and performance artist John Giorno that included the lines *I don't recommend to anyone to be alive / And I can't imagine anyone wanting to be alive / Except if they're completely deluded.* As Sublette told me: "Arthur thought that was terrible, not because of the music, but because he disagreed with the sentiment."

My argument isn't with authors of the recent wave of publications about downtown New York, because they've revealed progressive connections and collaborations that had been all but lost in the rush to generic orthodoxy. Nor is my argument with the downtown rock scene, which opened up to forms of cross-boundary work and social openness that hadn't been at all obvious even five years earlier. Rather, I want to begin to question the cultural terrain upon which rock and a range of new music/rock projects have come to dominate the literature on downtown music culture. A certain set of names re-

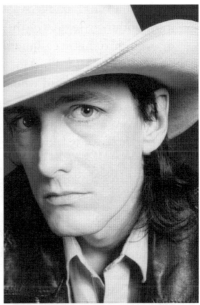

Ned Sublette in 1986. Photograph by Marsha Resnick. Courtesy, Ned Sublette

cur again and again: rock-oriented composers such as Glenn Branca, Rhys Chatham, Laurie Anderson, and Philip Glass; rock-oriented musi-

cians such as Richard Hell and Patti Smith; and rock-oriented bands such as Blondie, the Bush Tetras, James Chance and the Contortions, DNA, the Lounge Lizards, the Ramones, Talking Heads, Teenage Jesus and the Jerks, Television, and so on. Some musicians get to be talked about who don't fit into the rock matrix—I'm thinking here of Peter Gordon's Love of Life Orchestra, as well as hip hop practitioners such as Fab 5 Freddy and Afrika Bambaataa. But other downtown music scenes, including disco and the East Village Latin scene, also counted, and their erasure remains somewhat bewildering.

I want to take Laurie Anderson and David Byrne at their word and believe that the most exhilarating thing about downtown during this period—the lesson of downtown for now, perhaps—was the potential for interaction—the forging of social and sonic alliances. After all, as Peter Gordon told me, and as has been reported elsewhere, Brian Eno arrived in downtown in the mid-1970s talking proudly of his "fight the funk" pin—which could be translated as "fight black music." Within a couple of years he was working with Byrne, Weymouth, Frantz, and Harrison on the funk-driven album *Remain In Light*, and he deepened that aesthetic on the rhythmically-layered *My Life In the Bush of Ghosts*. One critic described that album as "[a] pioneering work for countless styles connected to electronics, ambience, and Third World music." If Eno's "fight the funk" badge was discarded in downtown, it follows that the most enduring legacy of the territory might be its level of inter-generic or even rhizomatic collaboration. Downtown's new wave, disco, and new music scenes all rallied for aesthetic and social change, and they were all the more powerful when they didn't simply dwell on difference but

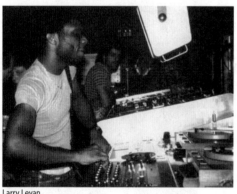

Larry Levan

began to explore points of common interest—which happened with increasingly regularity from around 1979 onwards.

With this in mind, I would like to add a provisional list of names of musicians who contributed to the swirl of sound that made downtown such a dynamic and irreverent place to live in the 1970s and 1980s, as well as a place where musicians from a wide range of backgrounds and tastes could work—even if their presence has yet to resonate as forcibly as it might. And so I would like to name: David Mancuso (the host of the now thirty-eight-year-old Loft, which developed the most influential and perhaps most

progressive party template of all); Nicky Siano (the DJ at the Gallery, and the first DJ to perfect the art of mixing and use three turntables); Walter Gibbons (the DJ at Galaxy 21, who began to mix between break-beats ahead of DJ Kool Herc, and who pioneered the art of remixing); Larry Levan (the DJ at the SoHo Place, Reade Street and the Paradise Garage, and perhaps the most influential remixer and DJ of all time); Bob Casey, Richard Long, and Alex Rosner (the sound engineers who, along with David Mancuso and Larry Levan, helped forge the contours of contemporary sound system technology in downtown venues); Armando Galvez, Howard Merritt, and Richie Rivera (the DJs at Flamingo, the white gay private discotheque, which was situated on the corner of Broadway and Houston Street); Jim Burgess, Robbie Leslie, and Tom Savarese (the DJs at 12 West, where a white-leaning-to-mixed gay crowd danced by the abandoned piers on the West Side Highway); Wayne Scott and Roy Thode (the spin-

ners at the Cockring, one of a number of bar-discotheques located in the West Village); Alan Dodd and the other DJs who span records at the Saint, where a slice of Fire Island was transplanted onto Second Avenue); Will Socolov (who ran Sleeping Bag with Arthur Russell and established the link between hip hop and dance); François Kevorkian (the remixer who blended together disco, R&B, dub, rock, and jazz into a heady downtown sound); Julius Eastman, the black queer experimental composer who also enjoyed hanging out in sex clubs such as the Mineshaft, and who died of AIDS;

Julius Eastman

Puerto Rican performers such as Mario Rivera and the Salsa Refugees, Brenda Feliciano, and Conjunto Libre, who all played at the New Rican Village; and of course Arthur Russell, who wrote a song that could double-up as a plea to those who are inclined to leave black and Latin dance culture out of the downtown mix. That song was titled: "Don't Forget About Me." ○

Tim Lawrence's biography of Arthur Russell, *Hold On to Your Dreams: Arthur Russell and the Downtown Music Scene, 1973-92*, will be published by Duke University Press in the autumn of 2009.

PHOTOGRAPHS
by Ted Barron

"In my photographs, I have alway tried to respond to where I am, to what is in front of me. Sometimes this is deliberate, through a location or a destination. Often I find the details of what is most interesting in the periphery or on the margin, slightly out of view.

"I've lived in New York City now for the better part of twenty-five years. Some of these photographs date back to those early years, and others are more recent. In all of them, including those not made in NYC, I was initially attracted to the raw materials of what make photographs work for me. First and foremost, it is light. Usually when making pictures, the way I navigate myself through the city or the landscape depends on where the light falls. Sometimes, the places with the most light are imbued with the deepest darkness (the California Desert), and inversely, from the shadows there is frequently a radiating light.

"After finding or not finding light, I search for content. It's everywhere when we look, yet elusive if we look too hard. The photograph here, "Truck on a Box on a Box on a Truck" was made in September of 2001. It was my first trip back into the Manhattan from Brooklyn after 9/11. I made several more ominous and obvious photographs in lower Manhattan that day, but this is the only one that interests me. It's a visual pun or riddle that certainly didn't occur to me in it's inception. In the end, the photographs are always about myself. They are an inventory of fleeting and reflexive moments in time, space, and life."

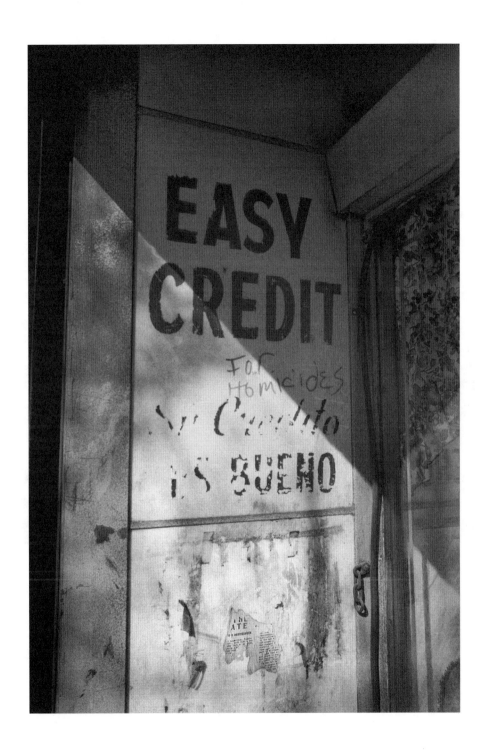

Easy Credit for Homicides

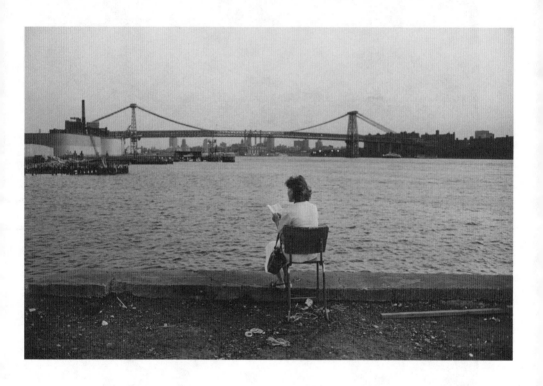

Reader

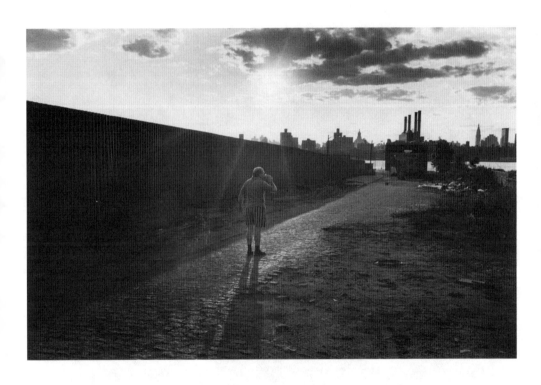

Epiphany

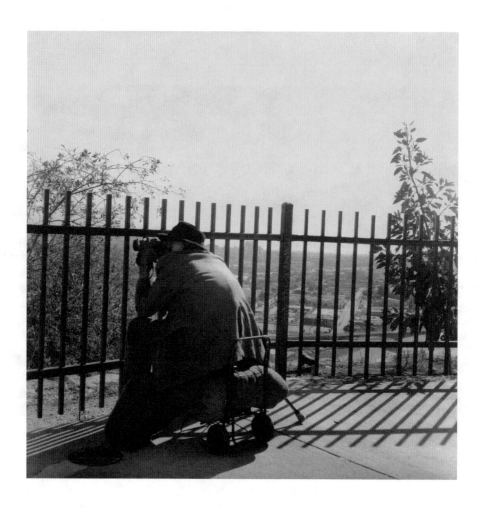

Lookout

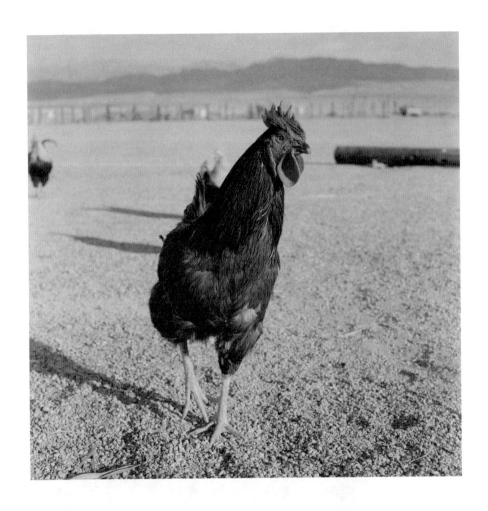

Chicken

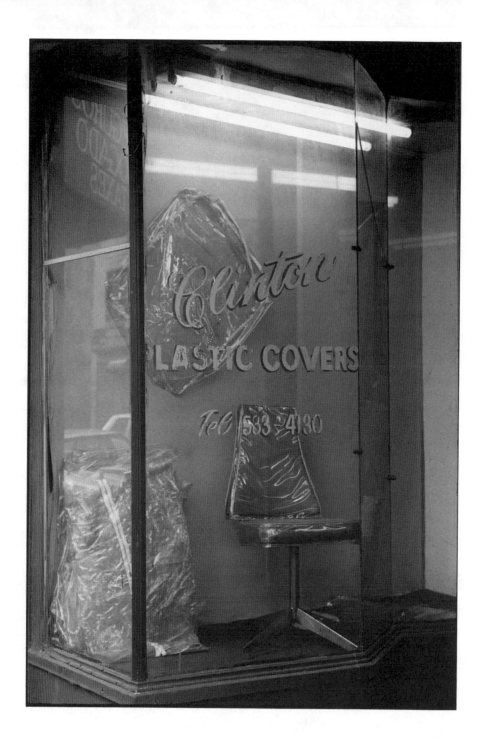

Clinton Plastic Covers

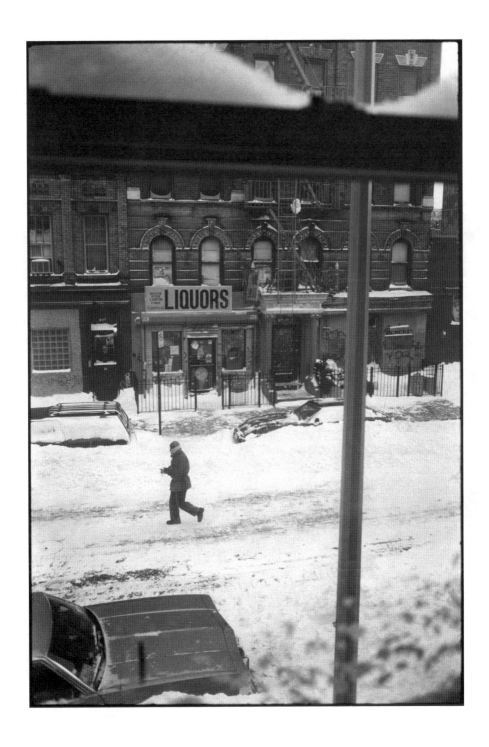

Snow on Grand Street

Box on a Truck on a Box

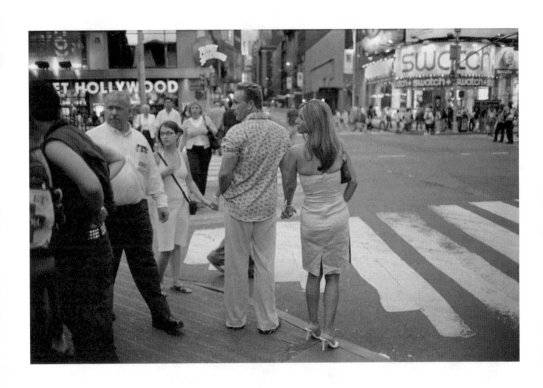

Times Square #3

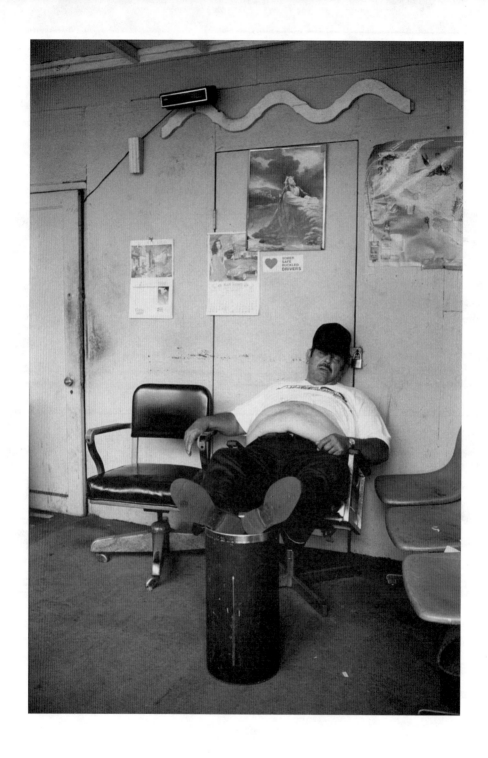

Car Service

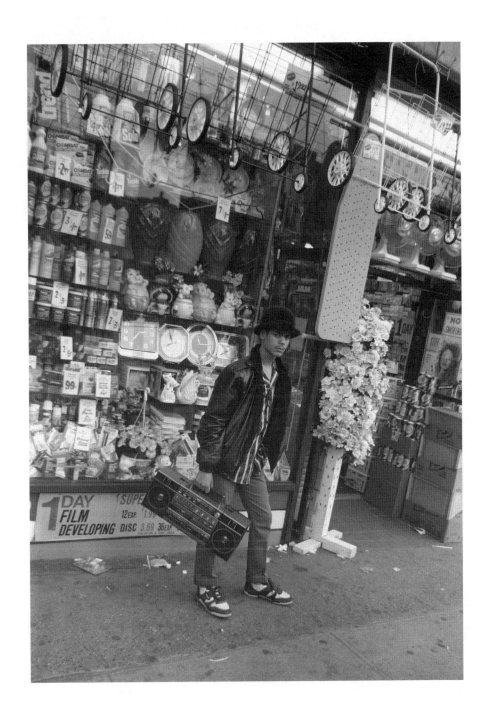

Delancey Street

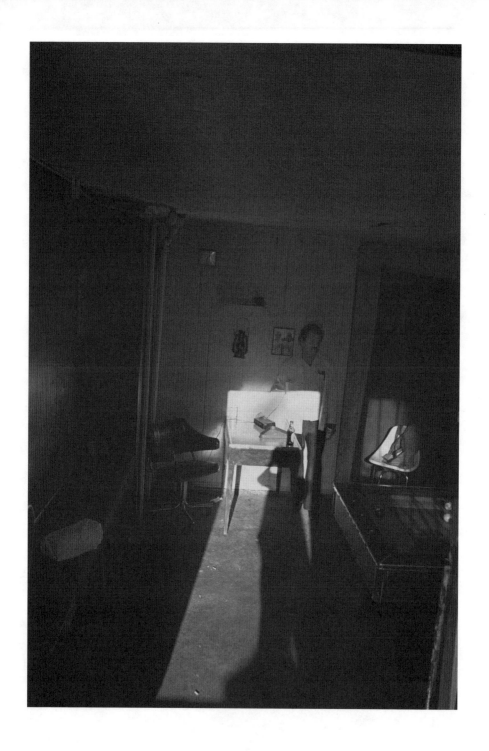

LES Social Club

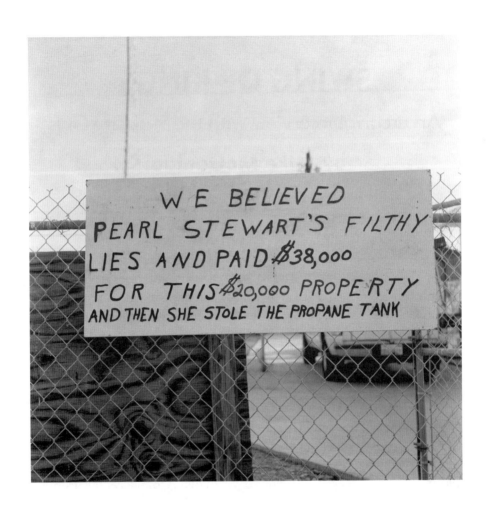

Pearl Stewart

SWING OF KINGS

An archival interview with the Sun City Girls

by Mike McGonigal

The music of the Sun City Girls (1981-2007) was a heady, diverse and lovingly fucked-up mixture of arcane musical styles. Brothers Rick and Alan Bishop—bass and guitar, respectively—and percussionist Charles Gocher Jr. delightedly pushed the boundaries of music, art, and good taste. Their music swung from crazed improv to cowboy ballads, South American folk songs to Asian drone music, crazy lounge songs to creepy classic rock, spaced-out jams to prank-ish punk. They not only presaged entire genres before they existed. The Sun City Girls were what happens when the melting pot explodes: miscegenation in every dimension, man.

I'd like to quote at length from a show review that Grux from the band Caroliner wrote for the great fanzine *Bananafish*: "The drummer just kind of talked to people, gave them all kinds of weird things to think about. He twirled drumsticks in circles around their heads. Almost like Japanese dancing or something. The guitar player was using a globe on a pogo stick. It didn't work really well . . . He was going 'Rraaarr, rrgghh, aarrgh . . .' The bass player had a mop that he was using like a horse, doing these jigs. He had a copy of *Car and Driver* and treating it as pornography, holding it up sideways, smiling, saying things like 'Heh heh, there's a good one. Look at the spread on that . . .' And in the background, they were playing a tape of weird guitar sounds and laughing and people shouting and firecrackers. It sort of went, 'szzzeeooo bhhh heeheehee ghghgh wawoo ooo haahaa pfoouh kabhhh.'"

That drummer in question was, of course, Charlie Gocher (pronounced

go-shay), a ridiculously talented musician and artist. On February 20, 2007, Alan and Rick posted the following in the news section of their web site, suncitygirls.com: "With deep regret, we must announce that Charles Gocher passed away yesterday in Seattle due to a long battle with cancer at the age of 54. He is survived by the two of us who adopted him as a brother 25 years ago and his many friends around the world. He will be missed more than

Charles Gocher. Photo, Ken Holt

most could ever know. Our thanks to everyone for their support and encouragement during the past three, very difficult years. Many of you were not aware that Charles was ill and that's because he wanted it that way." A bit later they added the following: "As many of you have suspected, Sun City Girls will no longer exist as a performing entity. Nor will any new recording projects be created utilizing the name Sun City Girls. There are many unreleased recordings and videos that will surface when time permits to release them."

The bulk of the following interview was conducted in the group's "bunker" in the Ballard section of Seattle—a huge office, practice space and sometime living quarters—in early 2004. I wrote a cover story for the *Seattle Weekly* using the interview, but the bulk of it has not been published before. A few questions were answered later by Rick and Alan via e-mail. I'm told that this is one of the only times that Mr. Gocher ever spoke "on the record," and he never talks a lot in the piece, but it's always great as you'll see. I've mixed it up a bit and removed my own voice. Now you can just read the best part—the brothers, connected.

"If you can comprehend polyrhythmic murder to the tune of ignorance is bliss, you know that there will never be a critic who will ever be qualified to critique this."
—Sun City Girls, "X+Y=Fuck You"

INSTANT ARCHAEOLOGY

ALAN BISHOP: Our grandfather was an oud player. Being surrounded by Arabic music growing up and hearing it a lot really helped to lay the groundwork for our interest in not only Middle Eastern music through the years but in music from Southeast Asia, South America, everywhere else.

The oud is a difficult instrument to play. A lot of Lebanese and Arabic people, it's such a part of the culture that they grow up playing it, and the zither. He was born in Beirut, in Swayfat, which is the Druse stronghold of the region. Druse is referred to in books as a mystical Islamic sect, which I think in the archaic history of it is still mystical because the true religion of the Druse is closed off. It's inside, unless you're pure and you commit yourself your whole life to it. It's really hard to find really solid information on the Druse, although we've researched it as much as we can and interviewed family members. In its fundamental form, it's not happening in the States, unless it's happening where I don't know.

It was a big influence, just growing up listening to the music and seeing my grandfather perform—he used to play double-reeded flute. People would sing Arabic songs a capella; there were always these Lebanese relatives blowing in from out of town to visit all the time, and they'd come through and at times there would be large gatherings of music and singing and food.

BRIGHT BEGINNINGS, DARK SURROUNDINGS

CHARLIE GOCHER: I told you [*addressing the interviewer, in the process of interviewing him*] a few months ago that I don't do interviews, and you said you can respect that—but actually you were lying!

ALAN BISHOP: Where did we meet? It was at an open mic, and you [*nods to Charles*] sat in on Funky Grusky's drum set, right? In 1980, '81? The first time I really talked to Charlie and got the chance to interact with him is when I was running an open mic and he came in to sign up one night. He was a solo musician. It was at a pizza parlor open mic, Tony's Pizza. I was about 22, and I had two nights a week, running this open mic. I was making a living running this open mic; in the early

'80s in Phoenix you could easily live on six or seven hundred bucks a month.

So, Charlie did a solo performance. He wanted me to dim the lights, and he had a flashlight going through the bottom of a wicker chair which had a pattern in it. It would create this ceiling effect, and he'd use it against the wall. He had a prepared tape, and he did some vocals, maybe even some scat singing

RICK BISHOP: It might not have been the same show at the same time, but I recall at an open mic, you (addressing Charlie) were standing on the chair, balancing on one foot and scat singing and you were conducting. You were freaking me out man! We wanted him to join the band right then, and didn't even know he played drums!

CHARLIE: I read a pop bio about Harry Houdini and it inspired me to make it seem like I was breaking out of manacles and a straightjacket. I played the drums like that—and I still do. It's an escapist reality, in a way!

ALAN: His performance was totally unlike anything we'd seen, and it blossomed into creating environments to where every night our show would be happening. It was just a group of friends; we'd get together and conspire these projects. We'd have punk bands and industrial, free jazz, beat poetry, anything weird: freaks up there ranting at the crowd. We'd have a hundred people in there on a Tuesday or a Wednesday. Our first drummer was named Joe Musico—that was his real name.

RICK: [Joe] was a great drummer but he was John Bonham school all the way: loud, hard and tight.

ALAN: We've always recorded ourselves, right from the beginning. I could pay someone to work 40 hours a week, and with our backlog of unreleased recordings, it would take them two years to archive 'em correctly. And that's just the audio, not the video! You could call it obsessive, but it's a combination of trying to make sure that we'd get things on tape because we kept doing new things all the time and we wouldn't go back to the old things. So just to kind of keep a record of what we were up to in case we wanted to rehearse or something, and be able to remember songs we'd write and forget about.

Anyway, Moe Tucker was living in Phoenix with her husband and five kids at the time.

RICK: Three kids . . . Oh, there was a baby, I think there were maybe four.

ALAN: A friend of ours approached Moe about starting a band in December of '81, and she hadn't played in like twelve years, since the Velvet Underground, and she had just been getting into correspond-

ing with Jad Fair at the time, and we got together and played for like seven months. Rick joined the group [Paris 1942] and then she left her husband and went to Tucson.

RICK: We got along really well with Moe, and her kids were great, but her husband was a prick.

ALAN: We did a lot of improvising—I liked playing with her because she has that sort of Bo Diddley tribal tom tom beat that's fun to play bass with and she was as easy to deal with as you could imagine and just consistent every time.

NOT IN MY LEAGUE

ALAN: That whole tour with JFA in 1982 was when that started to happen. We got a really confrontational response. We were experimenting with so many ideas completely outside the realm of what people coming to see JFA would expect to see; we weren't just an opening punk band. We'd see a lot of flyers on that tour advertising us as three chicks from Arizona; they thought it was an all-girl hardcore band! We'd come out and we'd be doing free jazz and we'd be solid noise or prepared

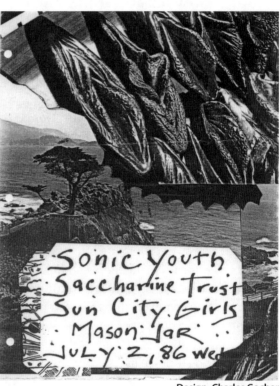

Design, Charles Gocher

tapes and theater and being really extreme in just about every aspect of our game. We would polarize the crowd—people completely into us but the other half of the crowd that would completely loathe us. It was about showing punks who thought they were so alternative just how alternative it could get, and they couldn't deal with it.

We weren't really aware that we were doing anything particularly groundbreaking at the time. We were just doing what we do and letting all of our emotions fly out at people every night on the stage. And we've never really cared about what people thought because in order to do what we do we have to be completely involved in the moment and

to not worry about it and to express ourselves.

We never consciously choose one thing to focus on. We're simply always doing all kinds of things all the time and working in new ideas all the time. Most of our records are not done as a record in the studio at the same time; they're made by going into the archives to edit things together for a project because we record all the time. So it's not just like we go into the studio to record one record, and then release it. That's not how we work. We've done it a few times . . .

SOFT FRAGILE EGGSHELL MINDS

ALAN: Sometimes that [accusations of Orientalism] is a disappointment, because you want people to react honestly and different people might have felt that at times. That's why I was so upset at the situation in San Francisco a couple of years ago with that band Heavenly Ten Stems—an all-ethno cover band with people from bands in SF . . . We've been attacked because people don't understand us; people get on stage to try to fuck with us.

RICK: It's not a good idea to do that.

ALAN: We'll always kick 'em back into the crowd. And we'll kill 'em. We don't know what we're gonna do because sometimes we're not in our mind when we're up onstage—we're in another world. There was a group of drunk Marines in '84 on tour that were yelling and screaming at us—I don't know what they were calling us, probably sand niggers, we got a lot of that on that tour. They'd call us "fucking Arabs" and yell "you suck" and we would just turn the jest on and get angry musically, turn everything up and play walls of noise, like what Musica Transonica would play now. We would do that for twenty minutes, and they always backed down.

It gives you a sense of righteousness when someone invades your space, that you can do whatever you want to. I know that in my own sense of justice, that person is out of their league and in my domain now. So whatever I do it's legal and correct. It's an interesting dynamic, especially when you're out of your head or semi-possessed or in some sort of trance and in another dimension in the middle of an intense expression of music or whatever. People get intimidated and they really don't fuck with us anymore; we kind of miss it.

RICK: It's not like we always go out of our way to make shit happen. We don't know what's going to take place, and that's what makes it worthwhile. There have been several confrontations with idiots over the years, though most of the people that come and see us now are there because they want to be, because they don't know what we're

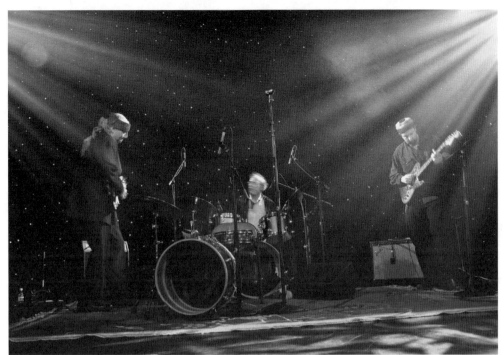

Photo, Mark Sullo

going to do, and they know that anything can happen at anytime. But sometimes things may get a little out of hand because somebody in the audience just can't handle anything out of the ordinary . . . so they react. They usually end up wishing that they didn't react. Not only will we turn on 'em, but the audience will as well. For us, we enjoy the unknown elements that manifest and it's really no major dilemma. We have escaped injury on a few occasions in the distant past. I personally am very aware of what's going on around me on stage ever since that heavy brass doorknob whizzed past my head at an incredible speed at a 1985 show in Phoenix.

ALAN: People need to be challenged and if bands go out and perform what people want that's OK because most bands do that for the most part. We never really bought into that, because we're more concerned with what we want to do than what other people want us to do. And that wins! That is the fire that keeps us rolling, that is really the key for us to be interested in doing this. And if we didn't have that interest, why would we be together for 22-plus years?

CHARLIE: If everybody doesn't like it, then we must be doing the right thing, because it makes it a win-win situation.

ALAN: People who are seriously into what we do are willing to give us the benefit of the doubt, to deal with the wild card. And I think that's the coolest thing about it, that for those few people that are out there, we provide the ultimate entertainment for them, because they have no

clue what is coming next, and they are interested in that. We're gonna challenge the listener, because we're challenging ourselves. And we're the hardest people to challenge; we're the ones we have to push. Because without that, we can't evolve.

A MAN IS AN INSECT IS A FLAME

ALAN: We have a nice, comfortable situation here in Seattle now, with lots of friends and contacts and musicians we play with. If you're in

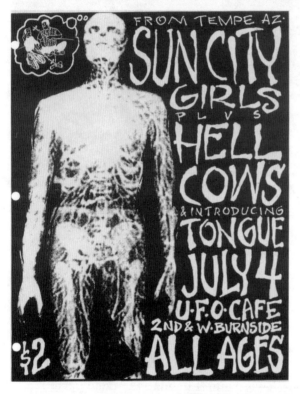

networking, you have to do it; if you miss one good friend's show five times in a row, that's not the proper way to network—so we're kind of out of the networking game. You could go see friend's shows seven nights a week or you could stay in, doing what you want to do then really choose the times to witness and partake in collaborations or whatever. We have the whole scope from our family: support, disdain, everything. It extends to people that we work with and people that you know casually who find out you're in a group and want to come see you and there's always that dynamic going on at all the shows too because we have so many casual acquaintances. We've learned to edit who we mention certain things to in each social circle.

We may play Bumbershoot [a large arts festival in Seattle] this year. We can control how we want to be perceived at any given time. We have friends in positions in society who could help us. And sometimes we do cash in those chips, but a lot of times we don't, simply because life is a little bit easier to deal with when you can pick and choose how you want to be interpreted instead of just throwing all your cards on the table and building up some sort of larger fan base based on the result of getting to that point which means you really have to make

yourself available to people. And we've controlled that to where we could actually concentrate more on our work than on advertising and hype because to us the work is much more important and much more interesting. And our daily lives are much more interesting not having to deal with individuals who for the most part we really don't have much in common with.

So we tend to associate ourselves with people that we're more like. Therefore, not only do we learn more from people and we evolve quicker because we're surrounding ourselves with people we respect and who we can learn from, we accomplish more on a day to day level than if we were to occupy ourselves with more of a public persona getting involved with people to try to cut deals and make friends and to scratch each other's backs because that's the way the music industry works. We really don't have much in common with most of the population.

FLESH BALLOONS OF TIBET

ALAN: Once you start to travel, you can get addicted to travel.

RICK: There was one time when we traveled all three of us. Charlie came along in '89 along with our friend Manfred on a six-month trip in Asia. We started in Thailand and then we went South through Malaysia into Sumatra, and then Java and Bali. It was unbelievable. Unfortunately, there's not much documentation of the trip. It was great because we were all free-wheeling it out there.

ALAN: Customs agents and official people—we weren't looking or traveling like the normal hippie backpacker scene. And we were questioned as to whether we were agents. But we had a loose agenda, spending every day making every discovery that we could and getting ourselves into some strange situations. There was a point where Rick and Manfred left for Nias Island in the middle of Sumatra and then Charlie and I went further into Sumatra to see a couple places. We split up and headed to Jakarta and Charlie and I read a little article in the paper that a ferry went down coming back from Nias Island and there were no survivors, and this was just about the time they were supposed to come back!

RICK: We were planning on taking that boat, but we took the next one. And we assumed that Alan and Charlie thought we were dead, so we raced back to Jakarta. We showed up and there they were. We just shared some stories and smoked some weed, and went on our way.

CHARLIE: It was really frightening, because we figured everybody went down with the ship . . .

ALAN: The whole trip was based around finding music and meeting

musicians and playing places. We would play for people using whatever was at hand; we had a few small instruments that we'd bought along the way. We would use other people's guitars and we'd play acoustic sets on hotel porches and we'd just talk, hold court and talk about politics, current events. We're always aggressively looking to meet people and hang out, sort of acting like the correct kind of ambassadors.

CHARLIE: Children would flock around us, forty kids at a time, like the Pied Piper of Hamlet or something. They'd take the day off and just follow us around, wherever we went. It was kind of weird. That's how we wound up on the porch and doing "House of the Rising Sun"—at some outdoor party with a bunch of kids hanging out.

RICK: And then finally we just ate all the children; it was great!

EYE SOCKET MANIFESTO

ALAN: Philosophy is an ever-changing landscape in itself as well. Collecting more experiences and pushing yourself as much as possible to the limits of experience gains you further evidence of truth.

RICK: I actually don't think we have a particular philosophy, though manifestos certainly have been penned by Alan and Charlie. We simply want to continue coming up with new ideas and ways to perform to keep it interesting for us. We like the idea of challenging audiences, even if it's just listening in a different way or presenting them with a completely alien idea of what a "performance" can be. But we challenge ourselves much more than that.

CHARLIE: The word itself means accumulating what truth means, the search for truth.

YOUR BIBLE SET OFF MY SMOKE ALARM

ALAN: Our interests in terms of our outlook on life, our philosophies, our awareness of the way that the world is evolving in current events and personalities in their knowledge and appreciation of culture and music and just like-minded individuals who are more willing to consider open possibilities because most of society is not willing to consider multiple interpretations of any one idea or event. How many people do you speak to on a daily basis who comment on a news item that give you any more new information other than what they've been dictated to by the major media? Hardly any! And I'm interested in people who have a new twist, have an imagination or have insight into potentially inside information—whether it's buying a bottle of water at a store or why an event happened in the major media.

Take Osama Bin Laden, who you made a joking reference to earlier. The thing that's funny about that is that the only people really able to hide Osama Bin Laden are the people who are looking for him. They're the ones with all the tricks, all the technology, all the money, all the power, and they're the ones with the ability to hire him and to fire him and to use him as a scapegoat and to fool the public about him—create doubles or whatever they need to do because since the beginning of time the mass public has never been hip to what really goes on in the power centers of global rule elite, and that's the bottom line. I wish we were important or powerful enough to hide.

It's counter-productive to live your life in the fullest way then bog yourself down with too many individuals who are going to just bring you down to a

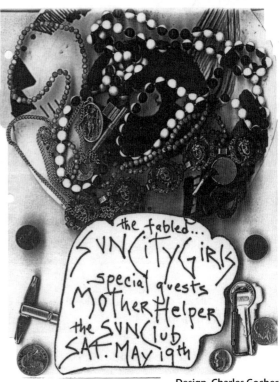

Design, Charles Gocher

level that you've already transcended. And it's not worth the price to pay to get more money or attention to have to deal with people who are really in a sense of their abilities to perceive and to be intuitive, far inferior. It sounds maybe a little bit conceited, but why concern yourselves with inferior casual relationships when you can concern yourselves with superior casual relationships that you can learn from. It's the best way for us to go.

ETERNAL INVESTIGATIONS

CHARLIE: We have an interest in animism and polytheism, Greek and Roman paganism.
ALAN: We're much more interested in the outer religions, in animism and folk religions. I think a lot of it comes from just being interested in the cultures as well. We're always scanning our ideas from so many different places, we ingest them and regurgitate them in ways that are

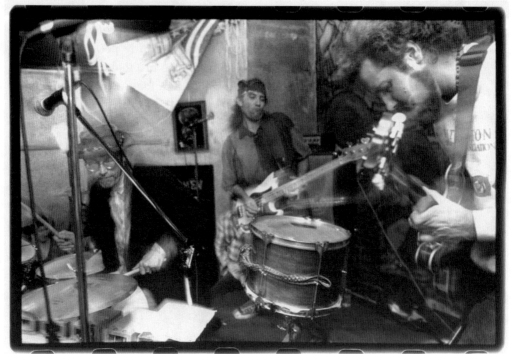

Photo, Ken Holt

a little bit unorthodox. And we tend to combine ideas as well and create different hybrids of things—you could interpret that as alchemy as well.

RICK: I prefer to consider my beliefs as magical as opposed to spiritual or religious. If you study the history of magical practices throughout the ages, and do not limit yourself to any particular culture or magical system, it is possible to become part of the greater magical current. Many people will follow only Crowley, others will study Alchemy only, some may be fond of just Yogananda or Dali. These are just very small links in an extremely lengthy chain. To work with the entire chain is the greatest of weapons. Once this is achieved, you'd be amazed at what can be accomplished. How do you get there? Hard work, determination, and endless study and practice (perhaps over several lifetimes). It's not rocket science or brain surgery—it's way beyond both!

As to my interest in Kali? I really can't explain it to anyone in a way that would make sense or have any meaning. For me it's personal. And keeping my particular thoughts and feelings about it to myself, preserves the power that it is. I keep myself open to all gods and demons, all spirits, good or bad—keep them succubi coming! I may sometimes invite them in, but I will also welcome their intrusions. A lot of wisdom can be gained this way, but only if one believes that these entities ex-

ist in the first place. The extra attention I pay to Kali is because she has made contact on many occasions. She sought me out, made regular visits. Now she's family!!!

ESOTERICA OF ABYSSINIA

CHARLIE: The whole Sublime Frequencies thing is allowing people to travel to where the music is without having to physically locate yourself there. We listen to it like the Sumatran folk recordings, and it's like going back to a certain special location.

ALAN: It serves that purpose for us. I wish I could view it the way someone from outside the project would. But we're trying to create something that we wish somebody else would have done but we're doing it ourselves because nobody's doing it.

The *Sumatra* CD was from tapes I collected there 14 years ago. The *Radio Java* and *Bali* discs were recorded by myself with added excerpts from an old friend of ours, Manford Cain, who travelled with us to Asia in 1989. He passed away in 2000 and his parents gave me all of his recordings. It's more of a dedication to him by including it. I assembled and edited all three discs. The Burma DVD was filmed by Rick and I with some ornamental footage included from Rob Millis from the Climax Golden Twins, who was with us in Burma two years ago. The three of us have a combined fifty-five hours of material on video from that trip alone—and probably thirty hours of audio as well! Rick edited the Burmese DVD. Hisham Mayet filmed the Moroccan DVD and basically edited the thing as he shot, although Rick did the final editing and worked a bit on the sound. Hisham and Rick are my two partners with the SF label.

RICK: Editing the DVD releases on Sublime Frequencies has been a minor challenge from the start. The first two (Burma and Morocco) were edited from camera to camera which can be difficult due to the "hit and miss" nature of it, though they turned out quite nice. I now can use the computer to edit with the Libya DVD; it has become both easier and more of a challenge at the same time because there is much more you can do when using even a simple editing program.

It all starts out, however, with good footage. Alan and I are lucky to have many hours of footage from India and Southeast Asia so it's a matter of going through it all and determining what can be used (avoiding the shaky footage or "earthquake cam"). Much of the earlier footage was just unusable at first, not really considering that we would be making films when the footage shot. But now there are ways to take average footage and manipulate it (slow it down, speed it up, cut it up, add au-

dio, etc) to where it can be released, or become good fodder for a one-time showing somewhere (as will be in NY, Louisville, and Chicago in April–May). And our other partner in crime, Hisham Mayet, has a ton of additional footage, primarily from North Africa and Thailand that we hope to be working on in the near future.

THE SHINING PATH

RICK: Now, when we travel, we know that we're "on the job," trying to get the best and most unusual footage we can in order to continue releasing DVD projects. We will most likely continue to use the "no-narration" approach which is in direct line with our film philosophy (no spin, no agenda . . . just pure sound and vision, to be interpreted and further researched by those who choose to). We don't want to educate anybody—that's up to them! I won't rule out dialogue, narration, or subtitles on future releases but I wish there were more documents without a narrator. I'm not an idiot. I can figure out what's going on most of the time. Many other people are not idiots. They can make up their own mind about how to interpret non-narrated film.

A narrator is a distraction and there is always an agenda in narration which "guides" the viewer. These are people from another place who have much the same basic lives as anyone else. Why not completely superimpose yourself into their world without some schmuck (even if it's the most well-intentioned schmuck) telling you what's going on! One of the best films I've ever seen is an Ethiopian documentary from the 1970s—I think; I don't know the title but I taped most of it off of PBS 20 years ago and did not catch the title at the start of the film—without a shred of narration featuring sight and sound of urban and rural life, music, ceremony, traffic in the city, people talking and walking, wildlife in the countryside: *fantastic*! Completely refreshing. Also, *The Naked Prey* has a similar feel. The best parts of all ethnographic film—*Herdsmen of the Sun* by Herzog and *Divine Horsemen* by Deren being two of the best—are the moments without narration.

ALAN: "Extra-geography" was a term Charles Fort used in his writing on occasion to describe unexplainable phenomenon outside of the accepted dimensions and perceptions of science and the common man. I use it as a generic place name to describe cultural areas—which have vibrant folklore and music—that are beyond the will of most to entertain as "valid" points of reference to study or merely want to learn about. For example, Niger, Benin, Oman, and Nagaland are extra-geography because most people don't know anything about them. Yet I could argue that people in those four areas of the world are as valid

and perhaps superior to any others who breathe when it comes to creating music of expressive beauty. I get a bit cocky with it at times to stir people up but that would be another link to my SCG lineage—something like: "Most people don't know shit about music anyway—even many who've been playing it all their lives! They need to commandeer the extra-geography!" It's just another weapon to use as a jousting rod when I'm on a high horse.

The only item we've released that is truly valid to state that question about ["exploitation"] is the Sumatra disc since it's a collection taken from locally produced cassettes from the '70s and '80s in Sumatra. I tried to look up the labels and the artists and could not find any of them anywhere. Now, maybe they'll contact me. Look, as soon as these CDs start selling like the new Outkast release, I'll personally fly over to Medan and start handing out benjamins to anyone who even *looks* like these people!

GOD IS MY SOLAR SYSTEM

ALAN: There is a weird energy. I am convinced that we are conjuring certain entities at times that we channel. We have the ability to channel and we create fields of energy at certain times, not always. It's a conditioned situation.

RICK: This has been happening with us working together since the open mic days. And it's not that it's planned.

ALAN: The elements have to be brought out. We have to be focused and we have to be on the same level.

CHARLIE: There was a story about Malachi Favors, the bass player from the Art Ensemble of Chicago, who died recently. Somebody asked him how old he was because he was close to 80 when he died. And he said he was like 48,000 years old, and I believe it. I think everybody's 48,000 years old, or older, because nobody is really certain when the birth of civilization happened. Favors was a conjurer. And he found those things inside himself, whether it's genetic or African ancestor worship or animism or whatever—but it's not that far-fetched, you know. When you go out looking for those parts of your interior that are there, music seems to be like a pretty good way of finding them.

RICK: We're very aware of the energies we can generate amongst ourselves when we're playing. But we don't really know what will happen until it materializes onstage and many times some of the exchanges between us can be pleasantly surprising even to us. Again, that's what makes it great. Many emotions can be triggered during our sets, from us or from the audience—love, hate, fear, joy, terror—it just depends

on what's happening. Dark energies make their appearance from time to time but most times there is a balance. Some would call it spiritual or sacred, perhaps in a shamanistic way. I consider it magical.

ALAN: The root feeling is sacred, yeah.

CHARLIE: A lot of rituals are about transcending the situation and growing from it. Western culture has always had that democratic spirit, where everybody's got a free voice and everybody is allowed to be an individual. But in this day and age, that idea kind of comes up bankrupt.

ALAN: People are subtly wired to behave in certain ways and a lot of what we can accomplish is to rewire that engineering—really we've all got the short end of the stick in society. We're not allowed to express ourselves in truly free ways because if we were the entire organizational system of our society would be completely different. It's really based on control, yet there is that illusion built in that there is freedom and that there is not as much control as there really is. We know that it's not true and we express that in both subtle and obvious ways.

CHARLIE: It's like an unconditional curiosity, trying to amp up the life somehow.

ALAN: I get a lot of crazy thoughts when I listen back to some of the

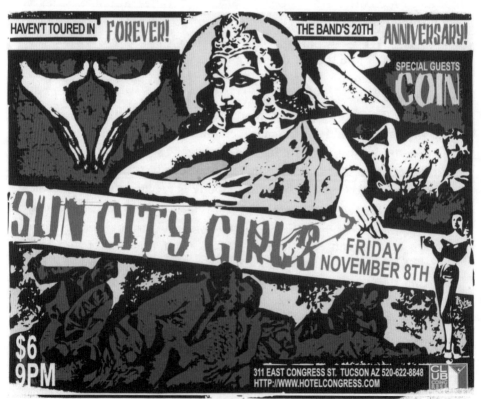

HAVEN'T TOURED IN FOREVER! THE BAND'S 20TH ANNIVERSARY!

SPECIAL GUESTS COIN

SUN CITY GIRLS FRIDAY NOVEMBER 8TH

$6 9PM

311 EAST CONGRESS ST. TUCSON AZ 520-622-8848
HTTP://WWW.HOTELCONGRESS.COM

CLUB

music that we make. My head goes to places that I didn't know we could go, and I'm as familiar with the sound as much as anybody.

CHARLIE: It's a different kind of linearity—it's not one thing leading to the next like a staircase. One of the important things to remember is that like with all of the world music influences coming in, we always temper it by our own imagination. And there's nothing sacred about it, aside from being possessed by it and what it does.

ALAN: Music provides direct access on a neurological level, it's a download; it's right there. And it can be manipulated, for good and for bad. And there's plenty of bad in music.

CHARLIE: It's a commonality with everyone on the face of the Earth, ever since people have produced sound, 'cause nobody doesn't like it.

GREAT NORTH AMERICAN TRICKSTERS

ALAN: Things are good right now; things are happening. We're more active now than we've been in a long time. We're making a conscious agenda based on more activity—by touring, releasing more things, and starting the web site—not to say that we won't cut that off at some point, but for the moment the window's open basically. It's turning into self-sufficiency. We have a lot of irons in the fire. I quit my job in July to work on the Girls full time. I was director of operations for that company for twelve years but always turned down offers of ownership, because my ability to get out of it would not have been easy.

CHARLIE: For the last couple months, we've been playing every night.

ALAN: The All Tomorrow's Parties show in the UK is the first time we're playing there, which is nice. And we're going to meet people we've been corresponding with and have never met before; it's the first show in Europe. We're now working on a European tour for April to May in 2005. The timing has never been right before. For the time being, it's a new direction in terms of us being able to focus on it. We're still going to maintain our agenda everywhere we go and it's just a chance to play more live dates. We're gonna be playing throughout the year balanced with some foreign travel and we're releasing projects and researching and doing prep work on future projects and releases. We're all very excited that we have the time to do this now.

We're definitely working hard to try to create our own reality. It's not easy to do some of the things we want to do and to do them successfully. One of the keys to our success is to not set our ambitions too ridiculously high as to get caught up on "playing the game" that people seem to play. We have to be more resourceful than others because

we're refusing to participate in what most of our peers have to. It's a continual challenge to do things our way and still pull them off.

IT'S MY OLD FRIEND THE FUTURE

CHARLIE: We're talking about doing wheelchair concerts when we're in our seventies. I want an electric one!

ALAN: I guarantee that what we'll do in wheelchairs will far transcend what anyone's done in them before.

CHARLIE: It's a lot of responsibility, to maintain the fact that it's gonna go on, and stay fresh.

ALAN: All of us have so many different interests; we don't force the issue of "direction." People tend to stress in the entertainment industry "less money but you get more exposure." But exposure is only going to expose us to more people who aren't going to have anything in common with us. So, we're not out to convert them—they're going to have to convert themselves. Anyone looking for exposure has a mental aim to become popular that isn't one of our priorities so that would be no bait for us.

RICK: After we toured in November of 2002—which was our first tour in ten years—things started to pick up a bit. Continuing to release CDs and LPs has also always kept a little action happening. Now though, since the web-page launched in late January, we've suddenly started getting some of that magical Mel Gibson momentum happening (without the extra zeros in the payoff but strong nonetheless). Maybe if we start screaming of Holocaust revisionism, we'll get more attention.

ALAN: Some nights we'll just improvise, sometimes we'll play songs, some nights we'll mess with some new material that we're trying to work on. We're preparing not only for getting live but also for recording soon. In the '80s and early '90s we played a lot. And we've been traveling more since the '90s.

We'll go on David Letterman if we can do it the way we want to go on. There are so many different avenues to make things interesting for us that going to perform at controlled environment agenda gigs and having to conform to the same situation other bands have to conform to—simply getting ourselves in a habit of doing that would almost lead to a breakdown of what we stand for to begin with so we have to be very selective. We could say this or that might be letting our fans down, but really, we are our own best and biggest fans, and we're the ones that we have to impress. And if we can't impress ourselves, nothing else matters. ⊙

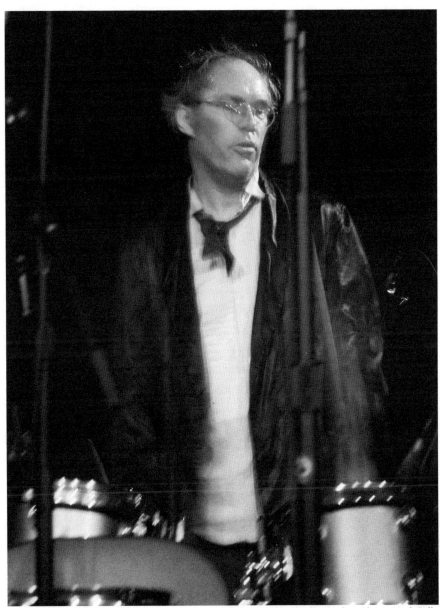

Charles Gocher. Photo, Mark Sullo

DISPATCHES FROM THE SHADOW SOCIETY

An interview with Peter Doyle

by Steve Connell

Peter Doyle may be best known to YETI readers for *City of Shadows,* the collection of photographs from the Sydney police archives that he edited. We published a selection of them in YETI 4—a fascinating mixture of defiant mug shots and crime-scene photos (many of them show the aftermath of a homicide; the ones taken after the body has been removed are the eeriest). He's now working on a second book drawn from these archives, in which all the images will be mug shots.

Before this, however, Doyle had published three novels that are among the finest crime fiction of the last decade. *The Devil's Jump, Get Rich Quick*, and *Amaze Your Friends* are much more than mysteries—in fact, the whodunit element often seems the least important part of the story, even though the books all feature elegant and unexpected denouements. They offer compelling visions of a period in Australian life just after World War II, as the country was being pulled in new directions politically by the fallout from the war, and socially by the impact of American popular culture. They explore brilliantly the links between the criminal underworld, political corruption, and the postwar explosion of sex, drugs, and rock and roll.

Doyle's recurring protagonist, Billy Glasheen, is a likeable rogue who can't settle down in the workaday world and tries to make a living as best he can on the margins. But his schemes always manage to interfere with the plans of Sydney's big players, an unholy trinity of crooks, bent cops, and politicians on the make. The events in *The Devil's Jump*, whose opening chapter is reprinted

elsewhere in this issue, take place just after the war has ended, as all the players jockey for position in a world in flux. In *Get Rich Quick*, Billy's working on a horseracing/gambling scam, trying to keep track of a fortune in stolen jewels until he can fence them, and at the same time keeping the wheels greased on Little Richard's hair-raising tour down under (which Doyle brings vividly to life).

This interview was conducted in August, 2008, and is followed by a preview of images from the forthcoming mug-shot collection, *Crooks Like Us*.

Why did you decide to set your crime novels in the past rather than the present? Was there a certain narrative of that era in Australian history that you felt needed to be corrected or supplemented?

The present is so ephemeral, so hard to get a fix on. To hell with it, I say. The past, on the other hand, is deep and complex—and full of story. And never what you think it'll be . . . There's a set of assumptions and clichés about the not-so-distant past that we sort of take on, but then when you start poking around, you're constantly having your expectations thwarted. In a good way. At least mine were.

In the case of Sydney, my home town, in the years after World War II there were traces of so much more going on than I had ever been led to believe. Stuff that seemed to belong to thirty years *later*. Like many people born in the 1950s, who came of age in the '70s, I guess I'd assumed that the past was this monochrome lump, that all was squaresville until whenever.

I don't do true historical research, I just browse the newspapers, read autobiographies and such, but even at that superficial level of delving I was continually hit with surprises. For one thing, there seemed to be a lot more sexual complexity in everyday life than I'd been led to believe. And in Sydney right after the war, there was a surprisingly left-of-center politics. The '50s in Australia, as elsewhere, are largely remembered for the blandness of early modern consumer society, man-in-the-gray-flannel-suit conformism and all that—the whole pre-counterculture mindset. But it's obvious just reading the tabloids of the day that there was a lot more going on—jazz, rhythm and blues, youth excess (in a naive sort of way), female restlessness after the relative freedom of the war years—and on the other side a surprisingly tentative tone of voice from the conservative forces. At least in the late '40s.

And then there was the absolutely true fact of a large, secret arch-right-wing army in Australia, terrified of a socialist federal government, ready to do whatever. It's in the history books, well documented, but it's not at all present in the popular memory. In fact, it's weird how

this strange period of right-wing secret armies on the one hand, lefty militancy, strong anti-authoritarian beliefs, pacifism, and anti-nuclear sentiment on the other, has been forgotten.

Then for me there's that simple fantasy pleasure thing of imagining the places you know well as they were, or might have been, just before your own time.

You can learn a lot about history from the best crime fiction—religious cults in 1920s Los Angeles from Hammett, corrupt police and offshore gambling boats in Long Beach from Chandler, marathon dances from Goodis, etc.—but it's mostly American history, and that history is something we've all absorbed from American novels and movies, even if you grew up in England, as I did. I'm presuming that's true of Australian readers, too, and

I wondered if one of your purposes in these novels was to say—hey, we had our own homegrown low-lifes, with their own battles, while also acknowledging the obsession with American stuff that came as a result of the war and the presence of US troops (and the culture they brought with them) in Australia.

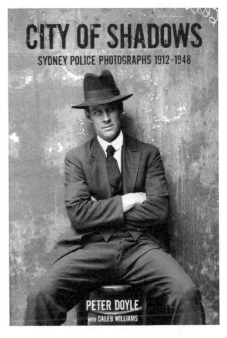

CITY OF SHADOWS
SYDNEY POLICE PHOTOGRAPHS 1912-1948

PETER DOYLE
WITH CALEB WILLIAMS

That's part of it, sure—the desire to find some tiny trace of hipness or whatever in your own backyard, which seemed pretty much the antithesis of hip. But in the case of Sydney in the '40s and '50s, it was surprising how much really did go on. For example, there was this wartime reefer and jump-band culture—up to a quarter of a million US servicepeople were stationed in Australia during the Pacific War, many of them billeted in inner Sydney. And a lot of them were black, worked in the stores and so on, so there were clubs run by the Red Cross specifically for black personnel in Darlinghurst, in inner Sydney. And due to some local Musicians' Union rules, local jazz guys had to provide the music. They were scared shitless, playing for punters who they knew maybe only a month before might have been dressed in zoot suits, wigging out to Louis Jordan or Count Basie on Central Avenue. There was quite a bit of discussion of it in the local music press actually, the terror of it all from a musician's point of view.

Some pretty good players were out here too, in uniform. Lester

Young's brother, the drummer Lee Young, for instance. And quite apart from the people in the local jazz scene, the US cultural presence represented a kind of aspirational pole: my late stepmother, who worked in a radio station at the time and frequented clubs, told me how much it meant then to be into, say, Count Basie or Duke Ellington or Cab Calloway, rather than the stiffer, less swinging British dance bands (Victor Sylvester, Joe Loss and such).

Being into Americana was a deliberate, self-conscious statement, I guess, the way it was later on in the rock'n'roll era. But to me it's interesting how it played out locally: the way the bits and pieces which happened to fit with what was already going on were adapted. Jeans and the juvenile delinquent thing, the way petty criminalia and street con-artistry played off the American presence.

The great thing about crime fiction, to me, is that you get to read about low life, in the sense Luc Sante uses it in his book of that title, and how much more intense and dramatic that life can be than the life of the squarehead, to use your term. And how invariably that world is closely—if subterraneously—linked to the world of economic and political power and privilege in all kinds of ways (drugs, prostitution, gambling).

I guess the great conceit of crime fiction is that it measures that hidden pulse: the secret rivers of desire, aspiration, need, desperation. Everything that is present but not quite expressed or not quite enacted in everyday straight life is fully manifest in the low life. The mirror society thing. Except . . . it's not actually set apart or hermetically sealed off from the straight life.

You know how even the straightest, most law-abiding place—a little village in the backblocks, or whatever—will have its bad land, its no-go zone. It's an imaginal thing really. But it's always closer than you think. In Sydney, like maybe everywhere else, you don't have to go far to find it. Step into any pub—who's there's drinking in the middle of the day, with no job to go to? Or who's hanging out at the track, midweek? Who's the person who knows somebody who knows somebody? Who can you buy drugs from? It's a romantic notion really, that underneath or beside this world of strictures observed and upheld there's this other, more or less coherent world of license and disinhibition, and it has its own structure and form, and it endures.

Of course, since the counterculture came along that divide doesn't mean as much, and in the hyper-consumption mode of late capitalism (I love saying that) it means less. But before the '60s, it really was other, secret but near.

What you also show in your novels is the way people use the styles of

another culture to create an identity for themselves and express distance from things they don't like in their own culture. It happens everywhere, I guess—like the white rastas on the West coast of the US, who worship Bob Marley alongside the Grateful Dead—but Billy proudly going to a high-toned event in his best zoot suit, or Max fanatically keeping up with the latest imported swing records, the kids in the milk bar desperate for real American jeans . . . it's about wanting more out of life, isn't it, in every possible way?

Yes—wanting more, and being willing to struggle to attain it. For the past few decades, a lot of stuff from American low and trash culture has been more or less fully incorporated into marketing strategies—adverts for Levis refer to James Dean films, or something like that. Early rock'n'roll history is as hackneyed as anything can get. All those nostalgia and retro packages and ensembles. It's hard to find anything about such commodity culture that is outside *anything*, in any way.

It wasn't always this way, though. These days, no public figure worth his or her salt would be unable to give an opinion on whoever's on the charts, or in the gossip mags. Whereas it would have been unthinkable, even in the sixties, for a serious public figure to deign to offer an opinion about, say, the Beatles, or Bob Dylan. They were completely different worlds. More than that, they were different *categories* of world. So those fringy, exploitation, trash undercultures were relatively open fields, in a way that's hard to comprehend now.

Levis, rock'n'roll, comics, hillbilly music, pulp novels—none of them used to be marketed by referring to their own legendariness. So that material culture stuff played differently for people. Genuine US-made jeans were fetish items for a small number of people in Sydney and Melbourne and Brisbane—the three biggest cities here—back in the pre-rock'n'roll days. Records were traded like precious artifacts, especially among the jazz buffs. Even car parts, motor bike parts, and so on. A tailor who could make a flash sports coat or do a drape shape, or a barber who could cut a duck's arse—they mattered a lot, I gather, if only to a small bunch of people. The combos who could play a fair version of Louis Jordan–styled jump-band rhythm and blues—there were a couple of them—had huge audiences.

The term that was used in Australian cities to describe that first wave of post-WWII delinquents, louts, petty criminals, thugs and such was "bodgie," which was an older slang word—still used in fact—meaning "fake." The reference books now say that the term was originally "bodgie Yank," later contracted to bodgie. The funny thing is, by the late '50s that stuff had been so indigenized that it seemed totally au-

thentic, local Australian. I've read references to Australian bodgies in the fifties recognizing Elvis as a fellow bodgie, wondering how come he knew all about it from all the way over there. There was a resident Gene Vincent type in every milk bar in Sydney by the late fifties—or so it seemed to my juvenile perception.

The music seems particularly important to you in all this—Little Richard's tour is a major part of Get Rich Quick, *for example, and that really was a huge event in the development of Australian youth culture, right?*

I went looking in the local papers for reports of the Little Richard/ Eddie Cochran/Gene Vincent tour of 1957. It was the first ever serious,

"If Elmore Leonard came from down under, his name would be Peter Doyle."
—KINKY FRIEDMAN

GET RICH QUICK

a novel

PETER DOYLE

no-bullshit international rock'n'roll tour, and it kicked off in Australia— in Sydney, in fact. That was the tour during which Little Richard freaked and renounced rock'n'roll as the Devil's music, threw his jewelry into the river. It was the first death of rock'n'roll, you could almost say. There was hardly any promotion here, but huge numbers of people turned out, everywhere the show went. And they were seriously riotous. The press didn't know which bunch of freaks they should be reporting on – the visitors or the local bodgies.

How did you come to play music yourself, and what kind of music do you play? Were you involved in the scene that developed around the wave of US servicemen on R&R from Vietnam? And how much do you draw on your own musical background for the novels?

I started playing in bars in the early '70s. A jug band–type thing (no jug!), then a blues band, then a loud rock band, after that various blues, hillbilly, C&W, rockabilly bands, with touches of Hawaiian, fake jazz, soul, gospel, and what have you. I started just after the Vietnam R&R days. My involvement was more mid- and late '70s, during the rise of pub rock in Sydney. I draw on that stuff quite a bit, in small ways.

How would you outline the tradition of crime fiction in Australia?

For me, reading early-ish Aussie hardboiled and private-eye novels is a bit like listening to early Indonesian rock'n'roll, or early Aussie rock'n'roll (or hillbilly music) for that matter. There's this mix of self-consciousness bordering on outright embarrassment on the one side,

and total conviction, authenticity, absolute raw gutsiness, or whatever you call it on the other. And those bits are unique. So for me—and others may see it completely differently—you rarely find out-and-out, one-hundred-percent ripper classics. No one has managed to turn up the lost Aussie James M. Cain or Charles Willeford to my knowledge, but there are bits and pieces, passages, moments, that are really special.

Bant Singer's *You're Wrong, Delaney* has some really great stuff in it—late 1940s, a nervous guy on the run lands in a country town. Like a noir western. It really gets something true about bush town life—everything's wrong there, of course. The book starts with a first-person stream-of-consciousness narration; the guy's right in the middle of a scary police interrogation.

Peter Corris's early novels did something pretty special too. *White Meat*, I remember in particular, had some great stuff about Aboriginal boxers in Sydney, some really atmospheric stuff set in La Perouse, which is a very beautiful but dark and strange part of Sydney that no one much goes to, even though it's coastal and not far from the center. It was a special moment when that book came out—to see that people could imagine the local in that way, without contriving it.

There's a long, long tradition of Australian classic murder mysteries, by the way, going back to the nineteenth century. There were plenty of titles of which both predated and in some cases far outsold Sherlock Holmes. Ken Gelder and Rachael Weaver have a really interesting collection, *The Anthology of Colonial Australian Crime Fiction*, and they give the story about that in their intro. Some other things that come to mind right now: the first Chopper Read book, Dave Warner's *City of Light*. Shane Maloney and Peter Temple have international readerships, very deservedly. But I really think the best Aussie hardboiled stuff is on screen: a mini-series from the eighties called *The Great Bookie Robbery*. Anything Ian David does is superb: the mini-series he wrote called *Blue Murder* really gets it right, in so many ways. I understand the real lowlifes therein depicted, both cops and villains, have pretty maximum respect for his work! And the movie *Chopper* gets something dead right about a very Australian type of psychopath. The director Andrew Dominick went on to do *The Assassination of Jesse James by the Coward Robert Ford*. So Brad Pitt sort of inherited a bit of that very particular Australian psychopathology too. It makes me proud to think that we can export that.

Who are your favorite (crime) writers?

For crime fiction I keep coming back to Charles Willeford. He's got all the elements I like; there's always weirdness and surprise. In one of the

Hoke Mosely series, for example (I forget which), there's this plot thing where you think you're going into a *Cape Fear*–type man-to-man fight-to-the-death set piece, but he takes it somewhere else entirely. And he's always funny. Not like playing for laughs, just funny. And it's at all levels: from the obvious stuff like dialogue—Hoke's sex-education lesson to his teen daughters in *New Hope for the Dead* is magic—but the plot turns are funny, too, in their way. Willeford is completely without sentimentality but never cold. I had a dream a week or so back that I met him, except in the dream he was Warren Oates. And he was extremely scary: he knew this bad voodoo. He could eat people. Don't know what to make of that.

Daniel Woodrell's books just keep getting better. How come he isn't a household name? *Winter's Bone* should be a big Hollywood film. Elmore Leonard and James Crumley, of course. Jim Thompson and David Goodis. One of my all-time favorite crime novels is Dan J. Marlowe's *The Name of the Game Is Death*. It's unrelenting. Of its time, late '50s, early '60s. First-person lone drifter/killer driving from one side of America to the other. It has three interwoven story layers. And it has that great trope of the shadow society—the guy knows who to talk to in every town he hits, knows how to find a croaker, or buy a gun, or sell some hot merchandise, or whatever. It's pure paperback pulp, but it surprises. It has a really fleshed-out, non-stereotypical woman lead character, too.

Did the work at the Sydney Police Museum, which led to the book City of Shadows, *come about because they had read your novels, or did you hook up with them earlier, while you were researching the books?*
The novels came first. A guy I know named Ross Gibson had done some research at the Justice & Police Museum, on their photo archives, and he curated a fantastic exhibition for them called *Crime Scene*. He was moving on and when they asked him if he had any ideas for a guest curator for the upcoming *Crimes of Passion* show, he put them on to me. Once I got there, started acquainting myself with the collection, it was really uncanny—the sort of stuff I'd being trying to imagine for *The Devil's Jump*—rough, mean postwar Sydney housing; the austerity thing; even the counterfeit ration coupons—they were all there in the archive!

Ross had told me back in the late '90s about all their pictures of interiors—a nail hammered into a doorframe to hang a coat on, a fruit box on its side used as a chair, the greasy surfaces, the absence of fresh paint, that whole pre-consumer city-life thing—and that had really resonated for me. The pictures were so close to what I'd imagined, even some of the streets I'd put the action in seemed to turn up again and

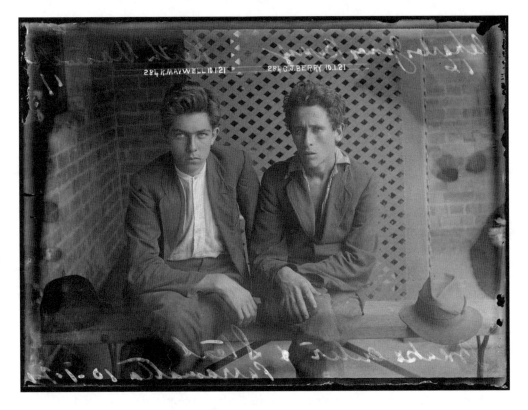

SPECIAL PHOTOGRAPH NO 284 OF K. MAXWELL AND G. J. BERRY DATED 10 JANUARY 1921
[FP07_0037_005], Courtesy, New South Wales Police Forensic Photograph Archive, Justice
and Police Museum collection, Historic Houses Trust, Sydney, Australia.

Keith Maxwell (17) and Charles Berry (16) were charged with breaking, entering and stealing 17 dozen drills
and 12 dozen scribbling blocks, valued at £25, from a Sydney warehouse. They pleaded guilty, and were bound
over to be of good behaviour. Three months later, in March 1921, Berry was sentenced to a year in jail after a
break-in at a Sydney public school.

again. I'd set a murder in *The Devil's Jump* at a spot at the foot of the
high sandstone cliffs in the Eastern suburbs of Sydney, a wild and scary
fishing spot called Rosa Gully. Sure enough, there's a series in the archive taken exactly there, at about that time (mid-1930s), with pictures
of cops in suits creeping along the mossy ledges above the rocks. (It's
a bit Hitchcock, actually). The vibe of that particular series is totally
homicide (you can sort of guess after a while which ones are homicides)
although I haven't been able to link it back to a specific case yet.

So the archive work came after the novels, but it was connected, in
strange ways.

And now you're planning a whole book of mug shots?

I'm working now on a book about middle-ranking criminals in Sydney
in the 1920s. It'll combine mug shots and true stories, and should be
published in mid-2009.

A few years ago, when I was contracted to the Justice & Police

Museum in Sydney, I had the privilege of working through this truly immense, Borgesian archive of police photographs—130,000 forensic negatives, going back to the nineteen teens. It was a mess—the negs were in no special order, and there was virtually no paperwork with them, not much information at all.

I kept coming across these portraits of men and women. A lot of them were quite well-dressed. Men in good suits, hats worn at a jaunty angle. Women sometimes looking coquettish. Plenty of the subjects were grinning. Or scowling. Or looking elaborately unconcerned. I included quite a few in the book I did in 2005, *City of Shadows*, and in the exhibition of the same name.

The mug shots were only a small part of that project, but they punched way out of their class—people in Sydney really responded. For a few weeks big posters and banners of the mug shots were plastered all over the city, as part of a promo thing. The photos traveled weirdly too—Karl Lagerfeld was reported to be a fan of them, and the fashion-photography blogger the Sartorialist waxed rhapsodic about them—about the mugs, I mean.

They're hard not to respond to. The subjects make this incredibly direct address to the camera. Here in Sydney people were gassed to see such a record of very urban, very hip types, and a whole bunch of people came forward to claim various individuals as their ancestors; some proved to be correct, but others were wishful thinking.

So for the next book, *Crooks Like Us*, I've selected a couple of hundred of the most interesting mug shots, and chased up as much of the stories behind them as could be found. That's been a lot of fun. A lot of the yeggs turn out to be middle-order thieves, con artists, pickpockets and "spielers" (as the cops called them then), and the like. Although the press didn't report crime in any detail then, sometimes you can find full transcripts of their court cases in the state archives. Which is gold—everything they said is recorded, verbatim. The asides, the arguments, the bluster, the denials, admissions, or whatever, and all the little details that court cases dredge up, which are normally too boring to report—what they had for their dinner on the day in question, what brand cigarettes they bought, what the landlady said to them that morning and so on. When you've got this incredibly engaging photo, and then you find a transcription of the person's speech (and often then they were pretty bolshie), the effect is amazing. And then you find out person X was a pal of person Y, of whom you already have a photo . . . a whole world begins to materialize. ○

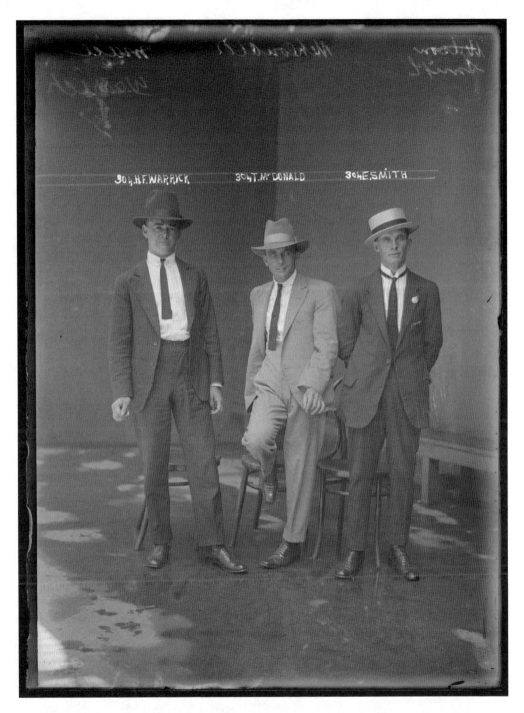

SPECIAL PHOTOGRAPH NO. 304 OF H. F. WARRICK, T. MCDONALD AND E. SMITH [FP07_0039_007].
Courtesy, New South Wales Police Forensic Photograph Archive, Justice and Police Museum collection,
Historic Houses Trust, Sydney, Australia.

Howard Warwick, Thomas McDonald and Edward Smith were charged in early 1921 with assaulting and
robbing a man of a 'metal watch' and the sum of £1, (total value of £2). The three were represented by
Sydney's best criminal lawyer at that time, R D Meagher, and were acquitted of all charges.

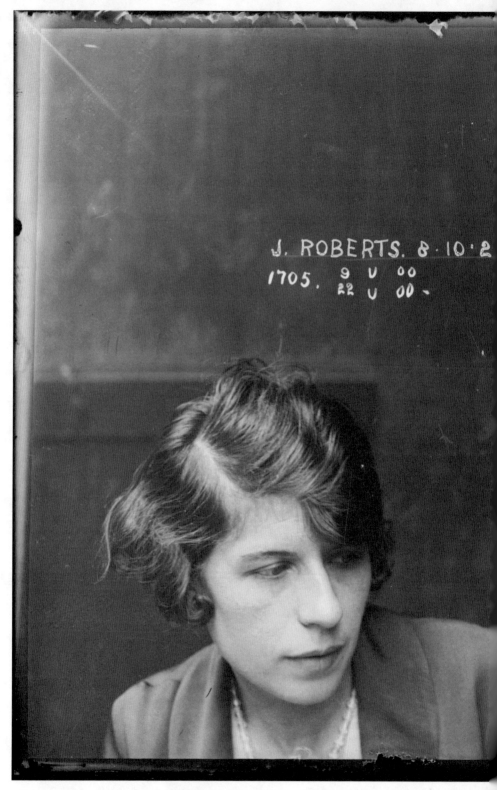

SPECIAL PHOTOGRAPH NO. 1705 OF J. ROBERTS DATED 8 OCTOBER 1928 [FP07_0128_014]. Courtesy, New South Wa...
Police Forensic Photograph Archive, Justice and Police Museum collection, Historic Houses Trust, Sydney, Australia.

No police record for Jacqueline Roberts has been found, but a copy of this photograph in a surviving police portrait collection is annotated "vagrancy", the charge then routinely applied to prostitutes and cocaine sellers.

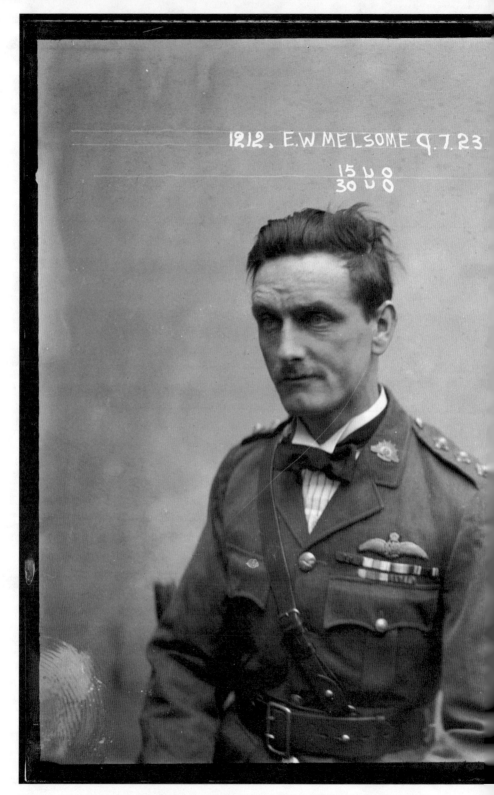

1212. E.W MELSOME 9.7.23
15 ∪ 0
30 ∪ 0

SPECIAL PHOTOGRAPH NO. 1212 OF E. W. MELSOME DATED 9 JULY 1923 [FP07_0099_005]. Courtesy, New South Wales Police Forensic Photograph Archive, Justice and Police Museum collection, Historic Houses Trust, Sydney, Australia.

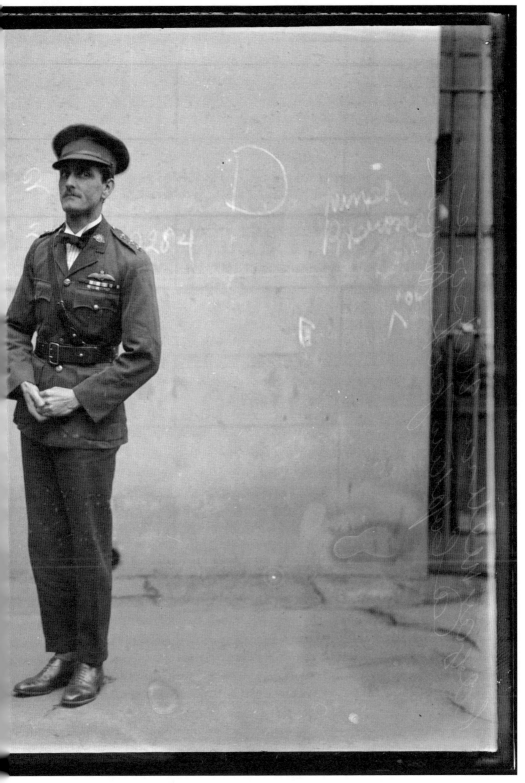

In 1923 Edgar Melsome, posing as World War I airman "Captain Davies" (and claiming to be the brother of Hollywood actress Marion Davies) swindled matrons in the elite Sydney suburb of Mosman by claiming that he was collecting for the construction of a local war memorial.

WE SORTA REMEMBERED THAT WE NEEDED TO DISCO

An interview with Thom Bullock

by Andy Beta

Late last year, I researched a piece for a national music magazine about disco music. My intent wasn't so much *why* it was returning (see: 30th anniversary of *Saturday Night Fever*) but rather, how it had somehow switched places with its twin musical form, punk rock. Whereas punk in the 21st century is wholly in the domain of mall culture, disco is now more scummy, seedy, and underground. Talking to Thom Bullock seemed crucial to understanding that change.

It would be foolish to try and encapsulate the musical peregrinations of Thom Bullock here, so for brevity's sake, we'll just say that Bullock plunged down taproots for San Francisco's hallowed Wicked Crew (along with DJ Garth, Jeno and Markie Mark) and New York City's scum-fuck rockers A.R.E. Weapons. He also branched out to form a boogie-rock band with DJ Harvey (Map of Africa), deployed his edit project (Otterman Empire) to funkify the Doors and Dire Straits, and also helped nurture a decidedly skuzzy slant on disco with his DJ partner Eric Duncan in Rub-N-Tug.

This interview was conducted late on a Sunday night in November while Bullock strolled through the East Village with Lauren "Gaffy" Gaffiero in search of a Morrissey-themed dance party.

"The hipster kids love to dance to disco. It's great fun seeing all the wonky white kids show up and jump around and enjoy the disco music.

It has to happen. For me, there's no real [dichotomy]; disco is not like, "good or bad," it's just whether you disco. It's not good or bad, or in or out—there's only disco. Like, nothing can really replace disco. It's something you do. Some people choose it like church. It's there. Do you go to the gym or don't you go to the gym? Do you watch porn or don't you watch porn? Do you disco or don't you disco? There's no alternative."

"Disco does this thing that nothing else does: you dance for a looong time, same tempo, you get all these funny feelings. I think that's like, every generation of wonky white folk, wonky white rockers have always shown up at the disco at one point. Johnny Lydon fucking loved the disco. There's a disco scene in *The Great Rock 'n' Roll Swindle*. Know what I mean? Mick Jagger went disco mad once he got taken to the disco. You get taken to the disco, there's no going back. So James Murphy got taken to the disco and now fucking all the kids in Idaho and Ohio are going to the disco. Heh heh."

"I don't know why it would fade in and out. You *can* get too much of a good thing, knowwhaddamean? Heh heh. I'm just turning into too much of a well-rounded, groovy kind of person. I'm gonna get aggro for a bit. I stepped away from the damned disco for a minute. For awhile there, taken to [David Mancuso's club] The Loft—a long time ago, when it was on Avenue B and 13th Street. And I had to step away from the disco in '96. I was doing, like, punk rock here in downtown."

"I stepped away from the disco and started doing A.R.E. Weapons. I needed a bit of aggro, to get a bit of a balance. Disco is always there. And punk rock is always there! It's like, new kids step into the shoes; the outfits are all the same. Pants are black and tight, shoes are pointy. After you've done that for a bit, you want your trousers loose and shoes all round. You step from one to another. That's what's so exciting, when something else comes between. How much can you get in-between? You can't step to the party in cellophane and tinfoil all the time. Punk rock and discotheque—they've always been there, and for so long now, it's as if they've been there forever."

"With Rub-N-Tug, we totally brought some aggro action to the dance floor, put the two together—that's what happened there, in 1999. Me and Eric [Duncan AKA Eric D] were hanging downtown, part of whatever, the punky arty-farty scene. And everyone needed to disco! That is literally what happened. We sorta remembered that we needed to disco. What's missing? Both me and Eric knew how to do it. I've been doing it for years, really. It just caught on like wildfire. People weren't doing proper disco. We took it to The Loft, it went all night, it was covert."

"Disco had a very kind of schmaltzy appearance at that point. The house music phenomena just became so banal, it was like everyone's parents were going to the fucking club, it was so drab. We used to call it "dinner house" at that point. Something where you get a fish dinner and a glass of white wine with it; the music was sooo bad. So me and Eric, we needed to disco—our friends needed to disco—as we felt it should be done. It's what everyone needed. That was a coup. That came together nicely."

"Today, you get regional variations and I think that's very healthy. Depending on where you are in the world, you get your local version. Whatever, *Vice* magazine disco, which is what we're talking about in a way, there is a regional variation. The New York variation is the one I like the most, which is things go slow, things go long, you play the whole tune, that kind of style. Mancuso is the *ultimate*. He epitomizes the New York sound, the New York style. If you live in Oslo, you've got to try and create some excitement. In New York, if you're playing for 12 hours, you need to go long, you need to go slow. Going out in Oslo, it's only on for three hours, so it's all frenetic. In Italy—I love the regional aspects of it, yeah."

"Disco on the Internet is pretty trainspotter, it's really anorak. Disco edits are fascinating. The story with the edits is that disco, in a way, was created by edits. It goes back to the old theory of extending the break. [Like with] Tom Moulton, who was actually a big-shot engineer. Moulton's story is he did the very first disco mix. I interviewed him once. He's great to talk to. I couldn't get him off the phone. He was really bitchy, a real queen. It was fun. Walter Gibbons was an early

edit master. Tape edits—it's an interesting thing, the whole super re-emergence of disco edits, 'cause it's a bit overkill but ultimately it's a really important part of disco. And it suits the current moment of free-for-all with the computers and moving material around. It suits the chop-it-up and regurgitate culture we have at the moment."

"But the whole concept of extending the music and making things rare, making things unavailable, that was a big part of disco and the original re-edit. There was only one reel. You played it at the club; it was your cut. And if they wanted to hear your cut—you know. That's beautiful, and there is an element of that, the re-edits are limited editions, that kinda thing. That's really exciting. It's definitely part of the heritage and I think it's cool that it still goes on. I do Otterman Empire as my edits, and I do edits through Rub-N-Tug. I totally see that Harvey and Jerry Rooney single-handedly brought back in the re-edit phenomenon with the Black Cock edit series—about '91, I think, maybe '92. Black Cock records, they single-handedly brought the concept back in. It's had long legs since then."

"Harvey was in a punk rock band when he was 12-years-old; who knows when that was? Yeah, he's a bit older than me. That was way back in the day. We have our band, Map of Africa. A heavy rock disco band, real boogie. It's heavy metal disco in a real old, grebo style. I'm really feeling vocals again. It's all there. You go through a phase. You need a bit of one, you go and get a bit of the other. You come up with something magical, a rare combination that really hits the nail on the head. Like Rub-N-Tug is for me."

"I get over disco now and again. Right now it's interesting. The Italo stuff—that was a breath of fresh air. I turned on to that quite a long time ago: Chris Brick and those Smile On Nylon tapes. It was refreshing. It was bearded and it was white. It drank martinis, it was sleazy, it was heavy, and it wore shades. That felt good. It was a change from rainbow knee-highs and platforms. That was why a lot of people had gone for it. They like the darker aesthetic, the sleazier aesthetic, the Italo sound. It's all synth-y, so that appeals to the wonky white guys." ⭕

POEMS ABOUT SAINTS

by Pierre Albert-Birot

From what I've read, French author Pierre Albert-Birot (1876-1967) seems to have been a very happy dude. Being a good-natured, enthusiastic person in the world of avant-garde literature has never been a good idea if you want to be successful, of course. But being one in the years that led up to the First World War? That was downright unheard of—even in the case of Apollinaire.

Albert-Birot's delightful mirth is there in his work, right at the surface—*Grabinolour*, his only full-length work translated into English, is an amazingly joyous work. I've always described it as a "Surrealist superhero novel" to my skeptical friends (never mind that it was published in 1919, before Surrealism had been codified or even named). The book is heir to Lawrence Sterne's rakish, shaggy-dog meta-classic *Tristram Shandy*. Atlas Press (UK) and Dalkey Archive Press (US) both published Barbara Wright's swell translation of it. Like Alexander Trocchi—who could be seen as his polar opposite except both were brilliant—Albert-Birot is best known today for having edited a literary journal featuring many future fancy-pants writers: between 1916 and 1919 he edited *SIC*, an acronym for "Sons Idées Couleurs" ("Sounds Ideas Colors.")

These poems might seem as quaint today as Russian absurdist Daniil Kharms' ridiculous take-downs of "the greats" of Russian literature. But they would have been viewed with far more vehemence by much of the reading public back then, given the power of the Catholic Church in France at the time.

There's an obvious resonance between the following poems, written in the 1920s, and those of the New York School poets of the '60s and '70s—Frank O'Hara, Joe Brainard, John Ashbery, Ted Berrigan, Larry Fagin, etc. The following translations originally appeared in Fagin's excellent 1974 collection *Rhymes of a Jerk*.

ST. NICHOLAS

A sound
Goes through the wall
And the wall lets it pass
I can't see exactly where
Now it's going through me
And this poem is coming
Out

ST. THOMAS

They're asleep
Soon I'll be asleep
But who will know it
Maybe my wicker chair
Who cries when I'm not sitting there
My typewriter doesn't care

ST. MARCEL

The blue
Of my socks jumped into my head
I'll keep it forever
It's Thursday night
A dog will open its jaws for a thousand years
And my socks will still be blue

ST. ANTOINE

I slide
From night into day
Like an ice skater making figure eights
Hands in my pockets
While bombs explode
All over town

ST. ADOLPHE

I have a whole army in my head
 With a street
Houses horses people
They come in through my ear
 Drums rolling

ST. GERARD

 The sea is a grey sky
 And the sky is a landscape
There's no blue in it
 Because the sky
 Has given it all
To the little boy's T-shirt

ST. AMEDEE

 As soon as we leave
 We think about coming back
Because we don't want to miss anything!
 Bells ring birds fly
 Above the trees
 Where are they going

ST. AVIT

Do you like to bear your soul completely
 For me it's quite enough to show
 Mine in its underwear

STE. REINE

 When they walk these morons
 Have to put
 One foot in front of the other
 Whereas I can move both feet
At the same time

ST. IGNACE

Between a floor
Four walls and a ceiling
I wrote 100 poems
And the room
Remained the same
Though sometimes I opened
The window

ST. AIME

The pot of ink is round
And the ink is black
Why do these letters come out
In so many different shapes and colors
Though I was born in a cabbage patch
My nose is pointed
Besides I write with a pencil

ST. MEDARD

Most people spend their lives
Opening their shutters in the morning
And closing them at night
I never close mine
For when the sun's not shining on the earth
It's shining on the moon

ST. GUY

During the next eclipse
I'd like an astronomer
To tell me exactly
Where I should stand
So the man in the moon can see me
Waving my arms

RECENT ART
by E*Rock

"The truth is I'm not really a musician or an artist or a designer. I'm not an animator or a music video producer and I don't want to be a record-label dude. I do all these things, but they're all part of the same activity. Sometimes I get in trouble when crossing the border or meeting new people and they ask what I do, because I can't give a simple answer or give the same answer twice. I make drawings more like a musician, I design a bit like a painter, and my music is more like collage and is very visual to me; but it's all about trying to force ideas into different shapes in as clear a manner as possible with what's available around me. I'm out to create, not make a career, so it's more a lifestyle. Sorry if my description isn't a neat little package. Maybe that will be my next upcoming project, making a neat package out of it all?

"In the work on the following pages, I'm trying to get new contexts from stream of conscious drawing. I like drawing a lot and also haven't had much time, or have been traveling too much to work on any larger format work, other than a one-off oil painting I made in L.A. with my homie Matt Chambers.

"The excerpts from the *Knurd* #1 'zine were recently collected from notebooks while I was trying to put together a 'zine; just getting into these super amorphous shapes that looks like Nerds candy, because it's fun to draw and for whatever reason I'm drawn to these forms. I go through this phase every other year since, like, grade school, drawing slime or whatever. My friend Corey pointed out that the shapes are also like micelles/liposomes and water-based life forms, so it must be a primal thing.

"The collaged marker drawings, also from 2008 . . . I got into destroying draw-
ings and rebuilding them—also an old urge—but it's also about changing up
the marks that I would normally make and getting back into abstraction. I'm
into the fragmentation.

"The collaged drawings on wood are from the "Super Heroes" show in Tokyo
where I showed with Mumbleboy in 2007. These were sort of the lead into
getting into the collage-style drawings. They're still representational, but
starting to put drawings into new contexts, creating new orders out of bits
and pieces.

"I'm doing a full US tour with Ratatat for the rest of the summer, but when I
get back I want to finish an album of my own music. There are lots of new
things coming out on my label Audio Dregs, but it's been so long since I re-
leased any of my own music. Maybe it would go faster if I was releasing for
someone else. I'm working on some large-format pieces, some collage that I
might make into prints and some large paintings (that's for a show sometime
with Josh Kermiet and Lucky Dragons), as well as lots of new video work."

CREDITS

Pages 161 and 163-165: Untitled collaged marker drawings, 2008
Pages 166-167: Excerpts from *Knurd* #1 zine (magic marker drawings), 2008
Pages 168-174: Collaged drawings on wood (from the "Super Heroes" show in
Tokyo with Mumbleboy), 2007

ALL THINGS CAN BE BROKEN
BUT NOT ALL THINGS CAN BE
FIXED

CONTRIBUTORS

TED BARRON lives in Brooklyn, New York and makes photographs of the people and world around him. His work has appeared in many publications and recently on record covers by Steve Earle and Laura Cantrell. He sometimes writes about music and culture at boogiewoogieflu .blogspot.com . . . **ANDY BETA** is a wonky white rocker who discos. He writes for the *Village Voice, Spin, Stop Smiling,* the *Believer, Resident Advisor,* sews up his own poetry chapbooks, and maintains the Beta Blog . . . **STEVE CONNELL** was co-publisher of *Puncture,* and is now co-publisher of Verse Chorus Press and managing editor of YETI . . . **PETER DOYLE** is the author of *Echo & Reverb: Fabricating Space in Popular Music Recording, 1900-1960,* as well as three award-winning novels—*Get Rich Quick, Amaze Your Friends* and *The Devil's Jump.* He also compiled and edited *City of Shadows: Sydney Police Photographs 1912–1948.* He teaches writing at Macquarie University, Sydney . . . **E*ROCK** is a multi-disciplinary artist and electronic musician. He lives in Portland, Oregon where he runs the record labels Audio Dregs Recordings and Fryk Beat and produces music videos with the Wyld File crew as well as his own artwork. So far this decade his work has appeared in exhibits across the world (Hanna in Tokyo, Little Cakes in NYC, Impakt in Utrecht/Netherlands, Nu in Athens, CCA in Glasgow, Trudi in Los Angeles, etc.) appeared in books (*Radical Album Cover Art, This is a Magazine* compendium, *Dot Dot Dash*), and featured in magazines (*Res, Plazm,* the *Fader, Afterhours*). His work has appeared on the covers of numerous CDs, LPs, inside DVDs, magazine covers and on MTV2. He has toured the USA, Japan and Europe as an electronic musician and done numerous remixes for other artists . . . **DOUG ELLIOTT** was raised by a pack of ferrets in western Ohio. He currently resides in north Brooklyn, where he'll research the 1950 Exxon oil spill while seeking stable employment. Send him job opportunities at http://populationdoug.blogspot.com . . . **KEVIN J. ELLIOTT** lives in Columbus, Ohio with his wife (from Brazil) and his dog (from the Franklin County Animal Shelter). He is currently the associate editor of the webzine *Agit Reader* (www.agitreader.com) His work has appeared

in *Stylus* magazine and various local weeklies not worth mentioning here. When he's not writing he enjoys Agitation Free, the Cincinnati Reds, and Werner Herzog . . . **LARRY FAGIN**, a New York City native, is the author or co-author of fifteen collections of poems. He co-edits Adventures in Poetry books and teaches at the New School . . . **DAVID FAIR** writes: "I am six feet, five inches tall and wear size 15 shoes. I was born in Michigan one day before Robin Williams. After college I moved to California for two years and then to Maryland. I was a bookmobile librarian for 24 years and a children's librarian for 6 more. I am happily married and have a son in college and a daughter in preschool. I have written several books, a few magazine articles and hundreds of songs. I have recorded music as Half Japanese, Jad and David Fair, Coo-CooRockinTime, the Glorywhores, the Abraham Lincolns, XXOO, Nine Lives Pussy, and the JunkTinklers. I have appeared in four documentary movies. My paper cuttings have been displayed in galleries in Austin; Boston; San Francisco; New York City; Paris, France; and Waxahatchi, Texas. In the fifth grade I placed second in a national poster contest. I can write backwards and upside-down with my eyes shut, I never even read the questions when I took the SAT test and I stopped eating meat over forty years ago." . . . **JAMES GREER** is the author of *Artificial Light* (Little House On The Bowery/Akashic) and *Guided By Voices: A Brief History* (Black Cat/Grove) . . . **ERIC ISAACSON** helps run the Mississippi Records store and label in Portland, Oregon, watches a movie a day, and rarely leaves his neighborhood. He aspires to a career as a sushi chef but can't seem to escape the lure of music and art . . . **TIM LAWRENCE** is the author of *Loves Saves the Day: A History of American Dance Music Culture, 1970-79* (Duke, 2004) and *Hold On to Your Dreams: Arthur Russell and the Downtown Music Scene, 1973-92* (Duke, forthcoming 2009). He runs the Music Culture program at the University of East London and is a founding member of the Centre for Cultural Studies Research. Along with Jeremy Gilbert and Colleen Murphy, he has been staging Loft-style parties with David Mancuso since June 2003. More information at www.timlawrence.info . . . **MIKE McGONIGAL** is the author of a book on My Bloody Valentine's *Loveless* published by Continuum (33 1/3). A collection culled from his old 'zine *Chemical Imbalance* will be published a year from now, as will his *'Buked & Scorned: The* YETI *Guide to Sanctified Blues & Gritty Gospel.* Today, Mike's readying releases for his new label Social Music (distributed by Mississippi Records) and compiling a three-CD set of raw gospel for Tompkins Square . . . **LUC SANTE**'s books include *Kill All Your Darlings, Low Life,* and *The Factory of Facts.* His blog, Pinakothek, is at ekotodi.blogspot.com . . . **ROB SIMONSEN** is currently thinking about getting a new cat. Other than that, he can be found working far too many jobs in Portland, Oregon—including freelance music writing and running indie-pop label Skywriting Records.

KILL ROCK STARS FALL 2008

The Shaky Hands "Lunglight" cd / lp / download
Horse Feathers House With No Home" cd / lp / download
Deerhoof Offend Maggie cd / lp / download
Marnie Stern This Is It ... cd / lp / download

visit "http://www.killrockstars.com" for
news, mp3s, tour dates, mailorder, etc.

The Carpark Family of Labels

www.carparkrecords.com
www.paw-tracks.com
www.acuterecords.com

Coming Soon
Dan Deacon *Bromst*, Dent May and his Magnificent Ukelele, Black Dice, Ecstatic Sunshine, Belong, Tickley Feather

Lesser Gonzalez Alvarez
Why Is Bear Billowing? CD
A testament to the beauty of simplifying your life, Lesser Gonzalez Alvarez delivers his songs with a sense of whimsical earnestness, garnering comparisons to Nick Drake, John Fahey, and Donovan.
Out now on Carpark

Adventure *Adventure* CD
Adventure is an advanced, dance-floor friendly take on the music of early video gaming. Let the epic quest for the master sword begin!
Out now on Carpark

Eric Copeland
Alien in a Garbage Dump 12"
Part of the forthcoming album from the prolific member of Black Dice is over-loaded, over-processed, and over-dosed music that's rooted in the public sounds, but a giant leap from anything in the public mind.
Out October on Paw Tracks.

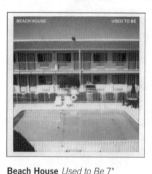

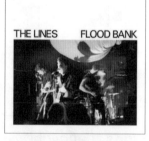

Beach House *Used to Be* 7"
The very first Beach House seven inch single! Carpark and Beach House present a ltd edition single featuring the new song "Used To Be" from the Baltimore duo.
Out October on Carpark

The Lines *Flood Bank* CD
Flood Bank is equal parts sonic experiment and beautiful, often melancholic songwriting. The band never lost sight of the subtle yet infectious pop hooks that made their earlier singles so fresh and fearless.
Out November on Acute

FORCED EXPOSURE

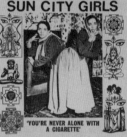

Exclusively Distributed Labels (select list):

ABDUCTION	EM RECORDS	MONIKA ENTERPRISE	SHITKATAPULT
AGF PRODUCKTION	ESKIMO	MORR MUSIC	SILENCE
ANTICIPATE	ESSAY RECORDINGS	MULE ELECTRONIC	SKAM
AREAL RECORDS	FLEDG'LING	MUSIC MAN	SOUNDWAY
ASH INTERNATIONAL	FONAL	MUSIQUE RISQUÉE	STAUBGOLD
ATP RECORDINGS	FREUDE-AM-TANZEN	MY BEST FRIEND	SUB ROSA
AUDIOMATIQUE	HÄPNA	NO MORE RECORDS	SUBLIME FREQUENCIES
BASIC CHANNEL	HONEST JON'S	NONPLACE	SUBLIMINAL SOUNDS
BEDROOM COMMUNITY	HUUME RECORDINGS	OSTGUT TON	SUNBEAM RECORDS
BLAST FIRST PETITE	HYPERDUB	OUT HERE RECORDS	SYSTEMATIC
BOMBAY CONNECTION	KARAOKE KALK	PHOENIX RECORDS	TECTONIC
BORDER COMMUNITY	KLANG ELEKTRONIK	PLAYHOUSE	TEMPA
BO'WEAVIL	KOMPAKT	PLUS 8	TIGERSUSHI
BPITCH CONTROL	LEXICON DEVIL	POKER FLAT RECORDINGS	TIRK
BURIAL MIX	MAN RECORDINGS	PSYCHIC CIRCLE	TOUCH
CADENZA	MARINA RECORDS	QDK MEDIA	TRAPEZ
CHICKS ON SPEED RECORDS	MAXERNST	QUATERMASS	TRUNK RECORDS
CITY CENTRE OFFICES	MELODIC	RASTER-NOTON	TWISTED VILLAGE
COCOON	MIASMAH	REKIDS	TYPE
CROSSTOWN REBELS	MINIMISE	REPHLEX	UKW RECORDS
DIAL	M_NUS	RHYTHM & SOUND	WACKIE'S
DISKO B	MOBILEE	RUNE GRAMMOFON	WERK
DUST-TO-DIGITAL	MODERN LOVE	~SCAPE	+ many more
EDITIONS MEGO	MOLL-SELEKTA	SHADOKS MUSIC	

available at fine independent record stores and online at **www.forcedexposure.com**
Retailers: request wholesale information from fe@forcedexposure.com

179

eat
records
vinyl
food coffee
open daily

selling new and used vinyl,
serving local/organic
food

124 meserole avenue
greenpoint, brooklyn
718.589.8085

HUSH ARBORS

"Keith Wood/Hush Arbors is a truly remarkable artist, whose songs, voice and guitar work all create some of the most haunting and powerful music I have ever heard. I don't know what else I can say beyond this: that Keith is one of the last unfound treasures of sound."
David Tibet/Current 93

October 21, 2008

RELIGIOUS KNIVES

"Sweet and elemental, Religious Knives engage their environment like nocturnal Sufi sifus with a will to flower. It's a brave escape, a calm walk into the fire."
Mike Wolf/Time Out

October 14, 2008

Ecstatic Peace!

purifying action vision

COMING: Sunburned/Four Tet Collab, Northampton Wools, Wooden Wand, Little Claw, Menstruation Sisters, more... www.ecstaticpeace.com

The Dutchess & The Duke
She's the Dutchess, He's the Duke

The Moondoggies
Don't Be A Stranger

Pretty & Nice
Get Young

The Pica Beats
Beating Back the Claws of the Cold

hardly art
PO BOX 2007 Seattle, WA 98111
www.hardlyart.com

LINELAND
LOGOS FOR LOVE

MELODIUM
Cerebro Spin

NEW RELEASES FROM
AUDIO DREGS:

Lineland
Logos for Love CD

Strategy
Music for
Lamping CD

Melodium
Cerebro Spin CD

Ambient Not Not
Ambient CD
featuring:
E*Vax, White Rainbow,
Mudboy, Bird Show,
Dania Shapes, Yellow
Swans, WZT Hearts,
Sawako, Grouper,
Nudge, AM/PM,
Smoke & Mirrors,
E*Rock, Freeform,
Chris Herbert,
Lucky Dragons
& Valet.

AUDIO DREGS
www.audiodregs.com

IRON & WINE
www.ironandwine.com
Updated website, Fall 2008.
Select US dates in November 2008.

THE SWELL SEASON
www.theswellseason.com
Academy Award winners Glen Hansard & Markéta Irglová.
Select UK/Europe dates through 2008.

PLAYED LAST NIGHT
www.playedlastnight.com
Exclusive concert downloads from Iron & Wine and The Swell Season.

new album of ambient metallic drone

the endless coming into life

BLACK BOWED ANGEL

www.20buckspin.com

The Dead C
Secret Earth LP/CD

October 2008 US Tour Dates:

Date	City	Venue
10/12	Philadelphia	Johnny Brenda's
10/13	New York	Bowery Ballroom
10/15	Seattle	Nectar Lounge
10/16	San Francisco	Great American Music Hall
10/19	Chicago	Empty Bottle

BA DA BING badabingrecords.com

let the bad times roll...

prisonshake
Dirty Moons

scat66, 2LP/2CD, out now. Field notes, voyages, invocations, quests and getdowns from the exile, 1995-2007, all analog, all "new." True double LP designed for long-term use, a tapestry of fluent rockings like no other.

SCAT RECORDS if it isn't Scat, it ain't shit!

FIELD MUSIC PRESENTS
THE WEEK THAT WAS

A MILESTONE ON THE PATH TO A NEW PROGRESSIVE POP
MOJO ALBUM OF THE MONTH • THE TIMES ALBUM OF THE WEEK

"Brewis has built his thumpy, string'n'piano-laden compositions from the soil upwards, painting layers of Ashes To Ashes-dusted synth creeps, Kate Bush ivory-punch dramatics, and Sufjan Stevens-esque string-dives.... TWTW's beauty is obvious when it first hits your ear— one of the curveball LPs of the summer. 8/10." (NME)

A MEMPHIS INDUSTRIES RELEASE mi CD / ltd. ed. LP / download

SLUMBERLAND RECORDS 2008

CRYSTAL STILTS
"ALIGHT OF NIGHT"
LTD LP/CD
OUT OCTOBER

CAUSE CO-MOTION!
"IT'S TIME!"
CD ONLY
OUT OCTOBER

THE LODGER
"LIFE IS SWEET"
LP/CD
OUT NOW

SINGLES OUT SEP/OCT:

SEXY KIDS
"SISTERS ARE
FOREVER" 7"

THE PAINS OF BEING
PURE AT HEART
"EVERYTHING
WITH YOU" 7"

BRICOLAGE
"TURN U OVER" 7"

SLUMBERLAND RECORDS
PO BOX 19029
OAKLAND, CA 94619

INFO, BLOG, SHOP, MP3s:
WWW.SLUMBERLANDRECORDS.COM

BLACK TAJ (ex-Polvo)
Beyonder **CD**

"Imagine Ted Nugent getting hired to write a soundtrack to Mahfouz' Adrift on the Nile. It's that good and that meaty"
-**Stop Smiling**

Upcoming releases
Son of Earth LP
Metabolismus CDEP
Metal Mountains CD
Bird Show LP

AMISH
RECORDS
www.amishrecords.com

WIPERS – *Is This Real?* LP

Remastered from original tapes, the LP is pressed on audiophile grade vinyl and housed in a deluxe hard cardboard sleeve. Complete with a printed insert that replicates the original inner sleeve, the Jackpot Records reissue of *Is This Real?* is a lavish tribute to one of the greatest recordings of the last 30 years. *($14.95)*

JANDEK – *Ready for the House* LP

Jackpot Records is proud to announce the first ever Jandek vinyl reissue of *Ready for the House.* The 1978 release of *Ready for the House* began one of the most compelling, disturbed, and singular legacies in musical history. Beyond stark, beyond oblique, beyond outsider even. *($15.95)*

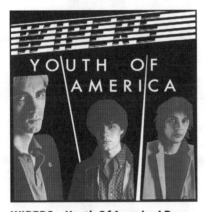

WIPERS – *Youth Of America* LP

Youth of America is pressed on high-quality vinyl at RTI and packaged in a sturdy, old-fashioned tip-on sleeve. The tracks have been mastered from original tapes by Greg Sage himself, and the cover is identical to the original sleeve as issued in 1981. *($14.95)*

BEAUREGARDE – *Beauregarde* LP

Recorded in 1971 this record is classic underground private press psych. Featuring the guitar work of then 17-year-old Greg Sage, this record has been reissued from the master tapes. A must for any fan of the early Wipers recordings. Rare photos and lyrics included. *($14.95)*

Available now at www.jackpotrecords.com

JACKPOT RECORDS Portland locations:
203 SW 9th Ave & 3574 SE Hawthorne Blvd

Coming Soon . . . **WIPERS – *Over The Edge* LP**
NEW DAWN – *There's A New Dawn* CD w/ unreleased tracks

FALL 2008!

MAX RICHTER
24 Postcards In Full Colour

TEN KENS
Ten Kens

HAUSCHKA
Ferndorf

GREGORY & THE HAWK
Moenie & Kitchi

fatcat-usa.com

coming soon from yeti

THE ART OF TOURING
Edited by Sara Jaffe and Mia Clarke

A book of art, photographs, and writing reflecting life on the road, plus a DVD of live footage. Over 50 contributors, including: Devendra Banhart, Carla Bozulich, Jem Cohen, Electrelane, Erase Errata, the Ex, Explosions in the Sky, Le Tigre, Matmos, Tara Jane ONeil, Sonic Youth, Yeah Yeah Yeahs

also available:

LUC SANTE
Kill All Your Darlings

"Tough in his thinking, empathic in his analysis, and liberated in expression, Sante selects barbed details, tunes in to danger and suspense, and dispenses wry humor and sure insight."—**Booklist**

TARA JANE O'NEIL
Wings. Strings. Meridians.

Art and music together in one beautiful six-inch-square package. 96 pages of paintings and drawings, plus a CD of live songs, home recordings and film scores.

JANA MARTIN
Russian Lover and other stories

"Joining the ranks of female fiction writers such as Amy Hempel and A.M. Homes."—**Bust**

yetipublishing.com

193

 THURSDAY / ENVY
SPLIT 180 GRAM LP+CD

 YOUNG WIDOWS
OLD WOUNDS CD / LP

 GRAILS
DOOMSDAYER'S HOLIDAY CD / 180 GRAM LP

TEMPORARY RESIDENCE LTD. NEW YORK / USA / EARTH ORDER ONLINE AT WWW.TEMPORARYRESIDENCE.COM

OUT NOW
ON
WOODSIST

crystal stilts
s/t CD/12"

MENEGUAR
The In Hour
CD/LP

VIVIAN Girls
tell the World 7"

PINK REASON
Winona 7"

coming soon~
Magic Lantern - s/t - LP
BLANK DOGS - 2×7" + tape
Meth Teeth - 7"
christmas Island/WAVVES
VIVIAN Girls - cassette
Idle Times - 7"

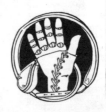

WOODSIST.COM

BONGO BEAT

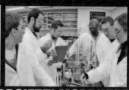

I'm a writer and writers is what my label is about. Ralph Alfonso

BEDSIT POETS
RENDEZVOUS

Edward Rogers, Amanda Thorpe and Mac Randall return with their second wonderful jangled folk pop endeavour full of the "Heartaches and harmonies" that MOJO Magazine rated 3 Stars!

"avant folk-rock featuring the tangled, hushed vocals of both performers (Amanda Thorpe & Edward Rogers). Haunting tracks...." - Boston Globe.

"The Bedsit Poets...deliver tender originals that have an early-sixties innocence." - The New Yorker.

Includes a brilliant cover of Big Star's "I'm In Love With A Girl."

THE FRANCO PROIETTI MORPH-TET
morphology

The former alto sax player from the lamented Kobayashi manages to make you forget the past on his new band's debut disc. Proietti reclaims the elements that made Kobayashi so captivating when its horn-hip hop fusion first emerged on the Montreal music scene. That means the kind of crazy-like-a-fox experimentation that gives every track a distinct identity, including the beautifully-arranged jazz-rap opus "Bushido", the dense and fiery "Verte de Fougerolles", which tastes a little like the immortal "Bitches Brew", the horrific blues of "Bottle Shaped Cage" and the deeply weird cautionary tale/circus waltz "Chorophobia". Wonderful stuff. **** (4 out of 5 stars)
BERNARD PERUSSE, MONTREAL GAZETTE

 C.R. AVERY magic hour sailor songs	Deluxe digipak with bonus book of poetry. A remarkable definitive piece that breaks all convention about what a hip hop beatbox blues harmonica spoken word americana album is supposed to be. On tour in FRANCE in October.	 **JOHNNY DOWD** a drunkard's masterpiece	"a creative car crash of...rock, rap, screaming metal... sex, marriage, more sex, adultery, original sin, unoriginal sin, God, Mary, Jesus, more adultery, death, love, masturbation." MOJO - 4 stars!	 **IAN FERRIER** what is this place?
 KEVIN KANE how to build a lighthouse	The second solo album by **Kevin Kane** of **The Grapes of Wrath**. It sounds exactly like you think it sounds and better. **HEAR HIS COVERS ALBUM NOW AVAILABLE ON ITUNES**	 **MERYN CADELL** angel food for thought	Now includes the video for "The Sweater" plus lyrics and bonus tracks from the original sessions. With Bob Wiseman, and members of The Barenaked Ladies, Rheostatics. Remastered with new liner notes and extra stuff.	 **KATRINA & THE WAVES** CD+DVD 1983-1984
 PLASTIC HEROES escape the lower end	UK based power pop trio distill a manic Berlin/Paris/London New Wave noise through a Buzzcocks and Generation X blender. Mixed by Sami Yaffa (Hanoi Rocks, New York Dolls). Mastered at Abbey Road. Videos on YouTube!	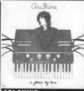 **ARI SHINE** a force of one	Winner of the John Lennon Songwriting Contest. Loud hip shakin guitar rock and roll from Los Angeles produced by Earle Mankey (Sparks, Concrete Blonde, Beach Boys, Dickies, The Three O'Clock, etc).	 **JEB LOY NICHOLS** now then
 FRAZE GANG fraze gang	Singer/guitarist/writer Greg Fraser teams up with his ex-Brighton Rock bandmate Stevie Skreebs to carry on where they left off - hard rock anthems, good times, and no apologies.	 **DAVE RAVE & MARK McCARRON** in the blue of my dreams	Intelligent pop by vocalist Dave Rave (Dan Lanois, Teenage Head) & guitarist Mark McCarron. Recorded in New York with the city's underground jazz players and woodwinds from the Toronto Symphony. Cover painting by Tom Bagley.	 **bongo beat** WWW.BONGOBEAT.COM visit our store in Second Life $12 ($15 Europe) postage paid Bongo Beat Records, 2049 Melrose Ave, Montreal, QC, Canada, PAYPAL: ralph@bongobeat.com

JAY REATARD
Singles 06—07
Double LP / CD/DVD
Seventeen track collection of all
of Jay's rare and out of print
vinyl in one beautiful package.

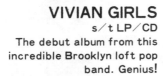

VIVIAN GIRLS
s/t LP/CD
The debut album from this
incredible Brooklyn loft pop
band. Genius!

DAVILA 666
s/t LP/CD
The debut album from Puerto
Rico's leading rock n' roll band.

www.intheredrecords.com

197

IT'S ON. VINYL!

SWEET RE-RELEASES TO MAKE YOUR MOUTH WATER.

EMM launches its first series of classic vinyl treasures. These limited edition gems are fully restored as originally released, and manufactured on 180-gram vinyl for premium sound! Some have not been available in over 30 years.

Available for your listening pleasure
9.2.08

▶ **Also coming your way**
9.16.08

Paul McCartney
+Wings
Band On The Run

John Lennon
Imagine

Jimi Hendrix
Band of Gypsys

In stock and on sale at these fine establishments:

52.5 RECORDS *Charleston, SC* • **ATOMIC RECORDS** *Milwaukee, WI*
BOO BOO RECORDS *San Luis Obispo, CA* • **CD CENTRAL** *Lexington, KY*
CRIMINAL RECORDS *Atlanta, GA* • **CULTURE CLASH** *Toledo, OH*
END OF AN EAR *Austin, TX* • **EXILE ON MAIN ST** *Branford, CT* • **GOOD RECORDS** *Dallas, TX*
GRIMEY'S *Nashville, TN* • **GUESTROOM RECORDS** *Norman & OKC, OK* • **HOT POOP** *Walla Walla, WA*
JACK'S MUSIC SHOPPE *Red Bank, NJ* • **JACKPOT RECORDS** *Portland, OR*
LANDLOCKED MUSIC *Bloomington, IN* • **LUNA MUSIC** *Indianapolis, IN* • **M-THEORY** *San Diego, CA*
ROCK-A-BILLYS *Utica, MI* • **SHAKE IT** *Cincinnati, OH*
SLOWTRAIN *Salt Lake City, UT* • **SONIC BOOM** *Seattle, WA* • **STINKWEEDS** *Phoenix, AZ*
VINTAGE VINYL *St. Louis, MO* • **VINYL FEVER-TAMPA** *Tampa, FL*

AVAILABLE NOW:

SBR-001: **The Hunt** *One Thousand Nights* 7"
SBR-002: **Blank Dogs** *Diana (The Herald)* 12"EP
SBR-003: **Hunchback** *Werse Houses* 7"
SBR-004: **Factums** *The Sistrum* LP + 7"
SBR-005: **The Pink Noise** *Dream Code* LP
SBR-006: **Dead Luke** *Record One* 7"
SBR-007: **Nice Face** *Record One* LP
SBR-008: **Blank Dogs** *On Two Sides* CD
SBR-009: **Zola Jesus** *Soeur Sewer* 7"
SBR-010: **Dead Luke** *Thing in My Head* 7"
SBR-011: **His Electro Blue Voice** *Duuug* 7"

COMING SOON

The Rebel *Weird Vegetable* LP
Children's Hospital *Alone Together* LP/limited CD
13th Chime LP/CD
The Cultural Decay LP/CD
Gary War 7"
Naked on the Vague 7"
Christmas Island/Meth Teeth *Split* 7"
Spirit Photography 7"
TV Ghost 7"
Daily Void 7"
The Pink Noise 7"
Nice Face 7"

SACRED BONES RECORDS
144 N. 7th St. #413
Brooklyn, NY 11211
sacredbonesrecords.com

LOS LLAMARADA
MONTERREY MEXICO

NOTHING PEOPLE
ORLAND CALIFORNIA

LAMPS
LOS ANGELES CALIFORNIA

KRYSMOPOMPAS
BERLIN GERMANY

A FRAMES
SEATTLE WASHINGTON

OZZIE
SACRAMENTO CALIFORNIA

HIROSHIMA ROCKS AROUND
ROME ITALY

DAN MELCHIOR UND DAS MENACE
DURHAM NORTH CAROLINA

SLICING GRANDPA
LOS VEGAS / SEATTLE

CHEVEU
PARIS FRANCE

WOUNDED LION
LOS ANGELES CALIFORNIA

NEIL GOEDHALS
JOHANNESBURG SOUTH AFRICA

S-SRECORDS.COM

S-S RECORDS

THE SOCIAL REGISTRY

GANG GANG DANCE
SAINT DYMPHNA

SIAN ALICE GROUP
59.59

GROWING
ALL THE WAY

VISIT OUR WEBSITE FOR LIMITED MAILORDER EXCLUSIVES AND OUR ONGOING FREE PODCASTED LIVES SERIES

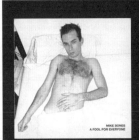

MIKE BONES
A FOOL FOR EVERYONE

BLOOD ON THE WALL
LIFERZ

DOUGLAS ARMOUR
THE LIGHT OF A GOLDEN DAY,
THE ARMS OF THE NIGHT

WWW.THESOCIALREGISTRY.COM

PETER DOYLE

WINNER OF TWO NED KELLY AWARDS FOR CRIME FICTION

Set in Australia in the years following World War II, Peter Doyle's novels brilliantly explore the criminal underworld, political corruption, and the postwar explosion of sex, drugs, and rock 'n' roll.

"If Elmore Leonard came from down under, his name would be Peter Doyle."
KINKY FRIEDMAN

"Think of a hopped-up James M. Cain."
KIRKUS REVIEWS

"Peter Doyle does for Sydney what Carl Hiaasen does for Miami."
SHANE MALONEY

"Besides his deft dialogue and endearing anecdotal style, there's a finger-poppin' riff running through Doyle's work which keeps the story jumping."
GQ

THE DEVIL'S JUMP
paperback, $14.95

GET RICH QUICK
hardback, $23.95

A **Criminy!** book, Published by Verse Chorus Press, versechorus.com

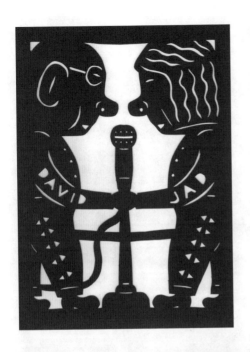
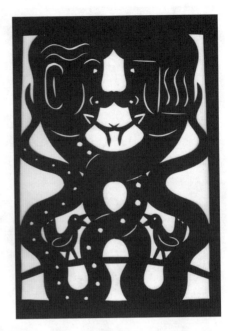

DAVID FAIR
Paper cut art available at

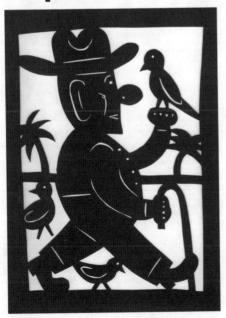

YARD DOG
1510 S Congress Ave
Austin, TX 78704
512.912.1613
gallery@yarddog.com
YARDDOG.COM

PAST LIVES
features ex-members of THE BLOOD BROTHERS & SHOPLIFTING
"Strange Symmetry" CD/LP
OUT NOVEMBER 4th, 2008
www.myspace.com/pastlivesmusic

These Arms Are Snakes
"Tail Swallower & Dove" CD/LP
OUT OCTOBER 7th, 2008
www.myspace.com/thesearmsaresnakes

sBACH
is SPENCER SEIM (HELLA/ THE ADVANTAGE)
"sBACH" CD
OUT NOW
www.myspace.com/sbachband

HUMAN HIGHWAY
IS JIM GUTHRIE & ISLANDS' NICK THORBURN
MOODY MOTORCYCLE CD/LP
OUT NOW
www.myspace.com/humanhighway

Suicide Squeeze
RECORDS
www.suicidesqueeze.net
PO Box 80611 Seattle, WA 98108

204

BTV 2008/9

BOSQUE BROWN
BABY
CD/LP
WINTER 2009

UNWED SAILOR
LITTLE WARS
CD/2XLP
OUT NOW

SOPORUS
24,110
CD
AUTUMN 2008

YNDI HALDA
ENJOY
ETERNAL BLISS
CD/2xLP
OUT NOW

ERIK ENOCKSSON
FARVÄL FALKENBERG
CD (U.S. RE-ISSUE)
WINTER 2009

EFTERKLANG
ONE-SIDED LP
LP
OUT NOW

NOW: ONE-SIDED LPS FROM EMPEROR X, JUNE PANIC, & ISOLATION YEARS
SOON: ONE-SIDED LPS FROM BIRCHVILLE CAT MOTEL, HALF-HANDED CLOUD,
& STEPHEN R. SMITH

BURNT TOAST VINYL
P.O. BOX 42188
PHILADELPHIA, PA 19101
WWW.BURNTTOASTVINYL.COM

Quality sonic artifacts since sometime in the 90's

Featuring 180 Gram Audiophile Quality Vinyl from these fabulous artists....

M. Ward
The Decemberists
Norfolk & Western
Laura Viers
Nick Jaina
Wow & Flutter
STIFFWIFF
Kind of Like Spitting

180 GRAM audiophile vinyl

As well as equally stunning musical edeavors by the likes of...

Kaia (of Team Dresch and The Butchies)
Kelly Blair Bauman
Carcrashlander
Tractor Operator
The Valiant Arms
Hutch & Kathy (of the Thermals)
and many many more... www.jealousbutcher.com

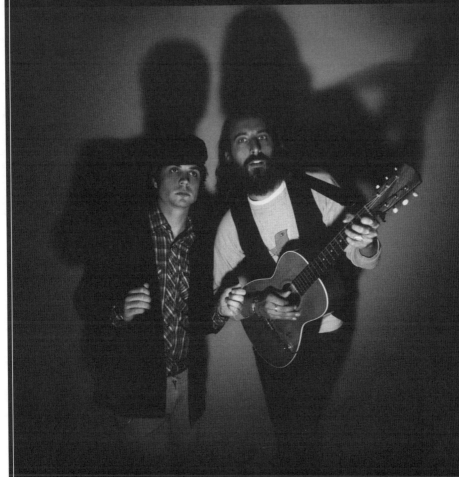

RODRIGUEZ
Cold Fact
(CD, LP, Digital)
Late sixties psych-folk masterpiece
"Buried Treasure"
- MOJO

STEPHEN JOHN KALINICH
A World of Peace Must Come
(CD, Digital)
Never before released
1969 poetry album co-produced by Brian Wilson

lightintheattic.net

CAKESHOP
152 LUDLOW STREET NYC
CAKESHOP
152 LUDLOW STREET NYC
CAKESHOP
152 LUDLOW STREET NYC
CAKESHOP
152 LUDLOW STREET NY
CAKES
152 LUDL C
CAKESHOP
152 LUDLOW STREET NYC
ALL WORLD. COME VISIT. NEW RELEASES ON CAPE SHOK RECORDS!
KIRSTEN KETSJER THE ROCK BAND+AIR WAVES+HOLOGRAM+MORE!

WILLIAM PARKER QUARTET
PETIT OISEAU CD / 2xLP (AUM050)
AVAILABLE OCTOBER 14, 2008 (SOONER DIRECT FROM AUM)

the new studio release from this incomparable group:
William Parker bass, cedar flute, composition
Hamid Drake drums, balafon, frame drume
Rob Brown alto saxophone, B-flat clarinet
Lewis Barnes trumpet

"Riveting, nimble and innately listenable, the quartet never falters." - DOWNBEAT

".. irresistable and nourishing .. this is extroverted, vibrant front porch music of the highest order." - SIGNAL TO NOISE

WILLIAM PARKER & ORCHESTRA
DOUBLE SUNRISE OVER NEPTUNE CD (AUM047)

A revelatory groove-driven 16-member orchestral work of universal tonality; designed to mesmerize.

"one of the year's few truly profound recordings."
- POINT OF DEPARTURE

"a kaleidoscopic tour-de-force .. cosmic groove music with a global flair—a seamless merger of Eastern and Western traditions conveyed with passionate conviction."
- ALL ABOUT JAZZ

"it feels truthfully, tenderly, prophetic." - THE WIRE

also released by AUM Fidelity in 2008:
ERI YAMAMOTO TRIO REDWOODS (AUM049)
ERI YAMAMOTO DUOLOGUE (AUM048)
BILL DIXON 17 MUSICIANS IN SEARCH OF A SOUND (AUM046)
ROY CAMPBELL ENSEMBLE AKHENATEN SUITE (AUM045)
ROB BROWN ENSEMBLE CROWN TRUNK ROOT FUNK (AUM044)

www.aumfidelity.com

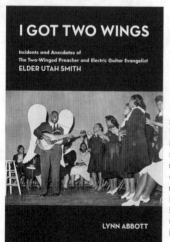

I GOT TWO WINGS: INCIDENTS AND ANECDOTES OF THE TWO-WINGED PREACHER AND ELECTRIC GUITAR EVANGELIST
ELDER UTAH SMITH BOOK+CD (CASE104)

BY LYNN ABBOTT (CD PRODUCED BY KEVIN NUTT/CASEQUARTER)
128 PAGE PERFECT BOUND BOOK WITH ALBUM-LENGTH CD
AVAILABLE NOVEMBER 11, 2008 (SOONER DIRECT FROM AUM)

For decades, virtually no biographical information on the dynamic guitar-playing Church of God in Christ pastor Elder Utah Smith has been available. Lynn Abbott's I Got Two Wings finally reveals Utah Smith as a sanctified celebrity whose revivals and appearances were as well known and anticipated in his time as any other sacred or secular musician or performer. The Elder Utah Smith did not appear out of thin air but was firmly established within the Pentecostal and sanctified Church of God in Christ tradition and its large and influential repertoire of songs and musicians. I Got Two Wings is filled with personal anecdotes and stories and rare and previously unpublished photographs. Included is a CD with 19 performances including 7 previously unknown Elder Utah Smith songs.

also released by CaseQuarter:
REVEREND CHARLIE JACKSON GOD'S GOT IT (CASE101)
ISAIAH OWENS YOU WITHOUT SIN CAST THE FIRST STONE (CASE102)
THE SPIRITUALAIRES SINGING SONGS OF PRAISE (CASE103)

210

SEBASTIEN GRAINGER & THE MOUNTAINS
CD/LP/DIGITAL::OCTOBER 21ST

<DEBUT FULL-LENGTH FROM DEATH FROM ABOVE
1979'S SEBASTIEN GRAINGER. ON TOUR THIS FALL>

SOME ARE LAKES
CD/LP/DIGITAL::OCTOBER 7TH

<DEBUT FULL-LENGTH AND FOLLOW UP TO
2006 EP *APPLAUSE CHEER BOO HISS*.
ON TOUR WITH BROKEN SOCIAL SCENE THIS FALL>

ELEPHANT SHELL
CD/LP/DIGITAL::NOW AVAILABLE

<ON TOUR WITH WEEZER THIS FALL>

WWW.SADDLE-CREEK.COM

HARVEY MILK

MY LOVE IS HIGHER
COURTESY & GOODWILL
THE PLEASER

ALL ON DELUXE DOUBLE VINYL FOR
THE FIRST TIME IN OVER TEN YEARS.

GET IT UP & GET IT ON.

ALSO OUT NOW:
CHUNKLET #20 &
THE ROCK BIBLE

CHUNKLET.COM

BIRDMAN
HAS GOT THE BLUES

BISHOP PERRY TILLIS*OTHA TURNER*R L BOYCE*GREG ASHLEY

JIM DICKINSON*BROTHER JT*MODEY LEMON*SPECTRUM*SPIDER BAGS

BOB LOG III*PETER WALKER*MAHIKARI*GRIS GRIS*LOTTIE MURRELL

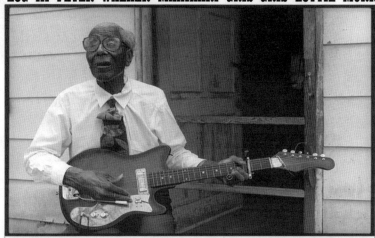

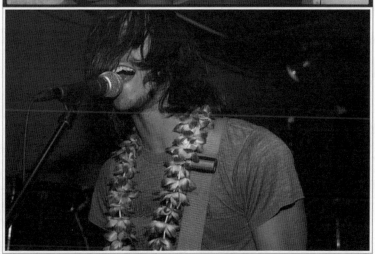

*END OF YEAR SPECIAL*ORDER FROM THE BIRDMAN WEBSITE
AND MENTION "YETI" TO RECEIVE A FREE GIFT!

WWW.BIRDMANRECORDS.COM

Custom
Audio
Mastering

STEREOPHONIC MASTERING

Timothy Stollenwerk
(503) 407-2521
www.stereopho.com

I am proud to
have worked with:
 Daniel Menche,
Evolutionary Jass Band,
EAT SKULL, Animals & Men, Karl Blau
OLD Time Relijun, YACHT, Mirah,
Pwrfl Power, Grouper, AU, The Rats,
Sad Horse, Thee Oh Sees, Hooliganship,
Strategy, Jib Kidder, Crazy Dreams Band,
The Watery Graves, Lloyd & Michael,
Reporter, White Rainbow, Country Teasers,
Melodium, Eezy Tiger, Suishou No Fune,
Ora Cogan, Jimmy "Duck" Holmes, Lineland,
Blue Cranes, Tu Fawning, Red Herring,
Why Are We Building Such A Big Ship,
Joe E. Neubauer, Ghost to Falco, Munch Munch,
The Ohioan & Native Kin, Narwhal vs Narwhal,
The High Violets, 7 that Spells, Blue Giant,
Baby Dollars, States Rights Records,
(And many more!)
 Yeti Magazine, Holy Mountain,
 Mississippi Records...

214

MAGIC MARKER

Music to wear your mini skirt by...

the Manhattan Love Suicides
Burnt Out Landscapes

The Manhattan Love Suicides wear their influences on their sleeves and never has Phil Spector's Wall of Sound met so cohesively with Jesus and Mary Chain's.

Minisnap
Bounce Around

It isn't often that a member of one of your favorite bands (The Bats) steps from supporting to lead role and completely bowls you over. Kaye does so with her angelic voice and heart filled songs.

Boat
Topps 7"

BOAT "Topps" comes with hand drawn baseball cards, bubblegum and 4 sloppy pop masterpieces.

MagicMarkerRecords.com

216

217

FOR AN APPOINTMENT, PLEASE SQUAT IN THE STREET

Liner notes to the Yeti 6 CD

by Mike McGonigal

1. GRASS WIDOW: "To Where"—The members of this East Bay–based trio all sing; Hannah is on bass, Lillian's on drums, and Raven plays guitar and trumpet. "To Where" is my favorite song with the word "fjord" in its lyrics. It was recorded in 2008 by Winston Goertz-Giffen and engineered by Stew and is previously unreleased.

Folks understandably harsh on MySpace; it's clunky and way overmonetized. They way they sell their home page to the shittiest corporate products—

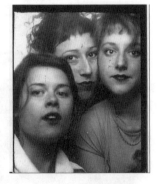

and it's a different experience each time you log on—is a textbook case of how to wreck a web site. That said, it's still a great way to hear bands before they have records out. It's because of MySpace that I heard Grass Widow; they had the featured song on Andy Bodor's Cake Shop page one day so naturally I went to their own page (www. myspace.com/grasswidowmusic). I saw that they were due to play Portland a week later at a bar downtown called Valentine's. I went to see them, bought their cassette, and they let me use one of their newer songs on this disc. I believe it's their first non-tape release. Someone really needs to do at least a single with these guys; they're awesome.

2. THE GREAT UNWASHED: "Sense of Balance" —Speaking of cassettes, this here track is from a very limited-edition cassette released in 1988 on Bruce Russell's Port Chalmers–based Xpressway label. That tape has some recordings from the group's very first Clean gig as well as later tunes as the Great Unwashed;

TIMES NEW VIKING

the common thread there is, of course, the enormously talented Peter Gutteridge. I can't believe no one's ever reissued Gutteridge's Xpressway cassette *Pure* on vinyl before; I haven't heard the whole thing in years but I recall it fondly as sort of a one-man-band Spacemen 3. This song hasn't been released in twenty years and here it makes its non-tape debut.

3. BLANK DOGS: "Spinning"—According to the vaguely anonymous Mr. Blank Dog, "Spinning" was "recorded in 2008 above a funeral home." So maybe it's sung by ghosts, and that's why the voice is so warbly and spooky? Probably. The song was originally included on a two-song cassette tape that came with some copies of his hard-to-find *Troubleman* LP. The group will have played out for the first time by the time you read this, and they have a double album/full-length CD called *Under and Under* due in December 2008 on In The Red.

Web sites are the future: www.blankdogs.blogspot.com.

4. SAD HORSE: "That's Safe"—Sad Horse is the new-ish project from multi-instrumentalist Elizabeth Venable (of the band Venable) and guitarist Geoff Soule (of the band Fuck). This and the other Sad Horse track on this CD are from the group's demo, which was "recorded in Elizabeth's attic in North Portland, Spring 2008." Please visit www.supermegacorporation.com for more information and free music and lots of pictures of naked furries at the beach (dude, don't judge).

5. ILYAS AHMED: "Returned Prayer"—Ilyas Ahmed is handsome, probably single, and resides in Portland, OR. He seemed surprised I like this song despite the fact that there's "no picking on it." And yeah, the guy can pick but every

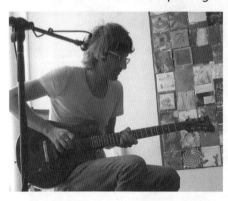

once in a while I am able to enjoy pickless jams like this previously unreleased song. "Returned Prayer" was played and recorded in 2008, and mastered by Pete Swanson (who's also handsome, but taken). Ilyas is having quite a year. Dude writes that "in addition to a recent CD/ LP on Time-Lag records and a double CD reissue on Digitalis, a new full length, *Goner*, will be released later this year on Root Strata."

6. SUN CITY GIRLS: "X+Y = Fuck You"—This song is from the *Kaliflower* album, released in 1993. *Kaliflower* was the first album on Alan Bishop's own Abduction label. Copies came and went pretty quickly; supposedly there was a CD version a year later but I've never seen it myself. I used to have this song on a cassette tape from before its official release, back the first time I had a failed record label (See Eye, via Shimmy Disc—only two seven inches and two CDs were ever released). I really wanted to compile an LP of the most success-

ful words-plus-music exercises ever recorded—and naturally that album would have been named after this amazing cut. Understand, though, that I dream up and talk about projects for years, and many of them never happen, or haven't yet anyway. I'm sort of the world's slowest busy guy. I still think *X+Y=Fuck You* is one of the best titles ever, for anything. I'm incredibly grateful the band allowed us to stick the song on here.

7. E*ROCK + MAT BRINKMAN: "Lazerproof Jacket"—This song is from a CD-R called *Drobomatic Drabulations* which was released in an edition of 65 copies. It was recorded in the Spring of 2008 when Brinkman visited Portland. E*Rock writes that the *Drobo* CD-R "is more like a conceptual various artists collection." He adds that "I started writing him to trade 'zines and get *Paper Rodeo* and then would send him comics for *Paper Rodeo*; we finally met in person in 2006 when we both went to Europe for the Dramarama fest."

8. CRYSTAL STILTS: "What Happened, Ray?"—So many of my friends have traveled in the last few years to big rock shows and outdoor festivals. These tend to feature a mix of young bloods and rock-and-roll reunion shows. Increasingly, however, groups play an entire "classic" album of theirs from start to finish. To me, this is wrong in so many ways; it's just so weirdly entitled to

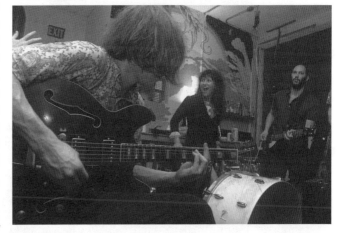

even *ask* a group to do this. If you like those albums, that's cool. You can listen to them—they're there, forever—but to ask a band to be their own simulacrum, their own cover band—that's worse than a bad hookup with an ex, knowmsaying?

Sorry, I'm about to sound like friggin' Bob Lesfetz or worse. The whole reason I bring this up is that I booked a flight to NY late last year as soon as I heard that the Clean were going to play some shows at the Cake Shop. A few well-meaning folks on this NY-centric yuppie indie music e-mail list I'm on warned me against that spot, saying that it was just a small basement with a basic PA in it. But I was psyched as, in my experience, a garage band always sounds best in a garage-like environment. At the first show the opening band was Crystal Stilts. Hamish had asked them to play the show. Immediately I was super psyched as they sounded a lot like Yeah Yeah Noh to me, one of my favorite mid '80s British acts (who of course the band has never heard).

"What Happened, Ray?," a cover of the Great Unwashed song, was (accord-

ing to J.B. Townsend) "recorded on a really cheap 4-track in the summer of 2006 at my apartment in Brooklyn. I did all the overdubs and sang. I hadn't listened to the song for a while and I did everything in pretty much one take. You'll notice that I only did one of the "And your world has vanished" choruses instead of the original two; this was not deliberate. I also thought he said 'And your world *is* vanished,' even though it makes no sense.

"I think I subconsciously chose to record that one instead of a more up-beat song like "Through the Trees" or "Hold on to The Rail" 'cause I liked the mystery of the lyrics. I thought the feel was kind of uncharacteristic compared to a lot of their other songs. I was thinking, 'Who the fuck is this Ray?' so I wrote David to tell him that I botched his song. And he said: 'That song is about a guy called Ray Columbus who had a band called Ray Columbus and the Invaders, a mid-60s New Zealand act whose most famous song was "She's A Mod." They even toured with the Stones, I believe—pretty cool—in the '60s. Ray ended up doing dodgy country stuff and a bit of schlock in the '70s and '80s—hence the song.'"

9. MINGERING MIKE: "I Need Assistance"—Dori Hadar writes: "This was re-corded in '74 or '75 on a Norelco tape recorder. It's a MM solo recording, and it's about a person who can't deal with the trials and tribulations of everyday life... and, uh, needs assistance! 'I Need Assistance' is one of Mike's favorites to this day (he says he finds himself humming the tune even today)."

If I'm not mistaken, this tune marks the first "official" release of MM's music on the soon-to-be-wholly-obsolete compact disc medium. Your home for all things Mingering Mike can be found at www.mingeringmike.com.

10. WAY OF THE ANCIENTS: "The Heart of my Bum"—Anyone who's ever chuckled at the fact that "it's 4:20, man" knows the song this swell number is based on, "(Set the Controls for) The Heart of the Sun," by the Pink Floyd, a young group based out of London who've been setting the famed under-ground UFO club on fire with their swinging performances! This not-really-a-cover was done by Thom Bullock in his Way of the Ancients guise. He explains: "THE HEART OF MY BUM is its working title, as it's my name, THOMB . . . It's a section of a soundtrack for a film made by P.A.M., an Australian art team. Gavin Brown Enterprises are gonna release a limited 12-inch run."

11. GRANT + ELLA: "John Saw the Number"—This is from a private-press seven-inch single. It comes our way via Kevin Nutt, the great gospel music ar-chivist. Nutt writes that "it's on the Trumpet label out of Atlanta, Georgia. 'PO BOX 62 ATL, GA,' says the label. And 'Druid Music.'" There's no other info, and the act does not appear in any known discographies.

12. COLLECTIONS OF COLONIES OF BEES: "Birds" (Pluramon remix)—This is a remix by Pluramon (Marcus Schmickler—www.pluramon.com/wp/) of a song from their album *Birds,* done for the Japanese-only version of that

record. The group edited it for time for us.

Now, I'm deathly allergic to math—both in life and in the music I listen to. I implore the youth of today not to partake of the incipient early-nineties math-rock revival. Please! What we *do* need are bands like Collections of Colonies of Bees more closely aligned to the experimental classical musicians who fused the pulses of rock and minimalism in the 1970s and '80s.

13. THE CLEAN: "In Love with These Times"—This song, which comes to us from the band's recording engineer Tex Houston, was multitrack-recorded at a club called The Studio in Auckland on March 17, 2007. For me, the Clean's throwaway songs are better than the entire best songs ever that Radiohead or Fleet Foxes or the Beatles ever recorded. Just kidding about Fleet Foxes— they're soooo great! They can really sing! I like the fake German guy schtick Hamish does here at the end. Don't you? Extra points if you didn't have to Google the Wikipedia to get the title reference—*one of us*!

This tune—one of the earliest the band ever wrote—was inspired by the Modern Lovers' "I'm in Love with the Modern World"; Hamish Kilgour adds: "It's a song about the scariness of the modern world."

14. CAUSE CO-MOTION!: "And I Wonder" (live)—This song was written by Arno Kleni/Cause Co-Motion! and recorded live by Carla Shotwell on May 17, 2008 at a show played with Blood on the Wall. Josh from the band writes: "We've got two records out soon, both on Slumberland—a 7-inch EP called 'I Lie Awake,' and then a singles compilation CD called *It's Time!*"

The band spell their name fIREHOSE style, as caUSE co-MOTION!, but fuck, I'm not going to do that. It's more than enough to add the exclamation point at the end. That is totes as far towards LOL textspeak as I'm willing to wade.

15. TIMES NEW VIKING: "Anything Could Happen"—I had heard that these lovable Buckeyes perform this song live. Anyone who's seen them live knows their covers are particularly great, so I asked them to record it and they did—and holy hell, this is so good! The song was recorded in early August, 2008 "on a summer day in Columbus, Ohio on a boombox by Times New Viking. Rich Horseshit played drums as well, but you can't hear him. We learned this song on the road, and actually got to witness the Clean play it. Monumental night—the Clean beat us in competition." I should note that the Clean have failed steroid tests on three separate occasions, which nullifies their competitive band wins.

16. EAT SKULL: "Stuff Reverse"—"Non-single version—first time through, with Rod on electric guitar." That's all the information Scott Simmons provided us, and it's all we need.

17. SAD HORSE: "Inner/ Outer Space (In Your Mind)"—Sad Horse will have a single out on Mississippi Records as part of their Portland series (*represent*). So, you might think that everyone who lives in Portland is under thirty, skinny and vegan and actually wears neon hoodies and Kanye robot slat sunglasses like they're an extra in one of Dan Deacon's dreams, works either as a barista or at a hip advertising concern, creates art that is somehow based on crafts and used to feature wolves and unicorns and crystals and clouds but lately is more about rainbows and lightning bolts, looks at you like you just kicked a baby if you forget to bring your own bag to the grocery store or cross against the light, used to be a stripper, is white but frequently complains about the place's "lack of diversity," believes that their bicycle has magical powers but is afraid to tell anyone except when they're high, and will actually be incredibly surprised when Barack Obama loses the presidential election (here I pray to be wrong) despite the fact that they've Netflixed a dozen separate documentaries about the vote-rigging and dirty tricks that our corporate overlords resort to. And yeah, you'd be right. What, you got a problem with that or something?

18. BROTHERS UNCONNECTED: "My Painted Tomb" —The proper name of this project is *Alan Bishop & Richard Bishop Present "The Brothers Unconnected."* The song was recorded by Randall Dunn in March of 2008. The tune is unreleased; it was intentionally left off of the tour CD for inclusion here. The tune is pretty much perfect, as you can hear for yourself. The Brothers Unconnected tour in the summer of 2008 was the most beautiful tribute or "goodbye tour" event I've ever witnessed, done with characteristic craziness, class, and poor taste. Afterwards it really hit me that I'd never see the Sun City Girls again.

19. THOKO + ALMON: "Untitled"—Sounds kind of like a track off of (John Storm Roberts' awesome Original Music release) *Kenya Dry*—but it's not! And as with Grant and Ella, I'm drawing a complete blank as to what it is or who or where or… anything! I do know where I originally got it. It was included on a WFMU premium from the start of the century, on a DJ premium disc compiled

by Pat Conte of the awe-inspiring *Secret Museum of Mankind* series. Whatever happened to those anyway? I could use another dozen right about now.

20. MEGAPUSS: "Crop Circle Jerk 94" (YETI mix)—Megapuss is the new project by the musicians Gregory Rogove, Fabrizio Moretti, and Devendra Banhart. Gregory writes that the song "is about falling in love with an alien in a Jewish deli—it matters not if the alien is within or without—it's the fuzzy road where above and below become one and the same." I am going to guess that these dudes are not Scientologists as from all the evidence I have assembled, they're not in fact self-hating gays. But damn that description sounds positively Hubbard-y.

"Devendra and I wrote a few joke songs while on the road and when we returned home we had more than 16 tunes ready to record," Gregory relates. "We spent a week or two recording ourselves in a shack on the backside of Los Angeles." As I understand it, Megapuss allowed themselves only thirty minutes per recording, with one take only per song, which is hard to believe and awesome. Their debut record is of course called *Surfing*. I like this song a lot but, damn. If that's not the worst band name since MGMT, what is? L.A. bitches need to hire me on as a name consultant!

21. DIXON BROTHERS: "When Gabriel Blows His Trumpet For Me"—A song from 1938 by the Carolina-based Dixon Brothers. According to Professor Eugene Chadbourne, they were hillbilly communists, which is one of the cool-

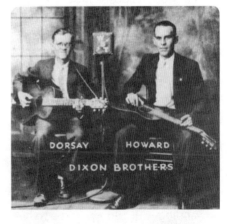

est things you could possibly have been in the 1930s. There are quite a few "Gabriel" songs in both the black and the white gospel traditions. Like this one, most of them celebrate the angel Gabriel blowing his trumpet to announce the Lord's judgment. Gabriel was an archangel who, according to the Book of Daniel, served as a messenger from God. But he's so important because he's thought to be the unidentified angel in the Book of Revelation who blows the final trumpet announcing Judgment Day Revelation.

The Book of Revelation, also called Revelation to John, Apocalypse of John, and Revelation of Jesus Christ, is the last canonical book of the New Testament. It is the only biblical book wholly composed of apocalyptic writings. The first vision the author, John of Patmos, receives is related by "one like unto the Son of man" wearing "a golden girdle", who speaks with "a great voice, as of a trumpet." The second vision, which makes up the rest of the book, from chapters 4 to 22, begins with description of "a door . . . opened in the sky" and it goes on to describe what some might call the end of the world—or more properly, the end of the age, in which Satan's rule through Man is destroyed by the Messiah.

These scary-ass events are predicted in the Book of Revelation: the Great Tribulation, the Campaign of Armageddon, the Second Coming of the Messiah with the restoration of peace to the world and His thousand-year reign, the imprisonment of Satan (portrayed in the text as a dragon) until he is "loosed" for the final rebellion, and then you have God's final judgment over Satan, the Great White throne judgment, and the ushering in of the New Heavens and New Earth. Alternately, according to Preterist theory, the events of the latter part of the Apocalypse of John are interpreted to have been fulfilled by events in the first century. Wikipedia tells us that "to this day it remains the only book of the New Testament not considered part of the Divine Liturgy of the Eastern Orthodox Church." But if you watch Pat Robertson, Billy Graham, or one of their many clones on TV some Sunday morning, you could be forgiven for thinking that Revelation, along with select parts of the Old Testament, makes up the entirety of the Bible: the fire to come and the brimstone of a vengeful God, none of that peace and love crap to be found.

It's important to note that this song is from a time before the modern idea of "the Rapture" existed at all—that gross misinterpretation by Biblical literalists, which something crazy like eighty percent of Americans believe in, has gained so much credence thanks to the wildly popular series of "Left Behind" novels. (That Palin person has often been referred to, quite properly, as "the Rapture candidate.") This error is the sole reason evangelical Christians are so concerned with Israel; these nutjobs think they can help to force John of Patmos' crazed, hallucinatory vision to happen, as then they'll rise up into the great giant Hooters in the sky (it's always open!) while we rot down here.

22. THE CLEAN: "Getting Older"—Tex Houston tells us that "Getting Older" was recorded off the FOH mixing desk at the Regent Theatre in Dunedin in February of 2007. I don't know what an FOH mixing desk is either, but I don't understand half of what's going on in *Tape OP* magazine.

23. FRANKIE ROSE: "Where Do You Run To"—It's been years since I was as in love with new rock-based music as I have been in the last nine months—a few of these groups I'd not even heard when the last YETI came out in March of 2008. Frankie Rose herself introduced me to a handful of these bands.

I like the symmetry in starting the disc with a song called "To Where" and ending with a song named "Where... To." Yes, it's nice that I think that I'm clever. There's more of a connection than that, even, as two of the girls from Grass Widow used to be in a band called Shitstorm with Ms. Rose, who herself is in the band Crystal Stilts and is formerly of the Vivian Girls. This is one of the songs she wrote that Vivian Girls recorded.

This solo rendition was done in early 2008. Frankie writes that it was "recorded on my really outdated computer on Garage Band. I am playing everything on the recording—guitar, vocals, and tambourine." She adds that "I plan to continue working with Crystal Stilts and am currently working on a recording of my own which I do not yet have a name for." ◗